BOTANY FOR ARTISTS

BOTANY FOR ARTISTS

LIZABETH LEECH

THE CROWOOD PRESS

First published in 2011 by
The Crowood Press Ltd
Ramsbury, Marlborough
Wiltshire SN8 2HR

www.crowood.com

British Library Cataloguing-in-Publication Data
A catalogue record for this book is available from the British Library.

ISBN 978 1 84797 278 1

Front cover: *Tropaeolum majus* – Nasturtium. (Liz Leech)
Frontispiece: Orchid Nelly Isler 'Swiss Beauty'. (Liz Leech)

Dedication
For my parents, Christine and Basil, and my maternal grandparents, Poldi and Heinz. Their interest in all beautiful things inspired my youth. They never failed in their encouragement of my love of botany and botanical painting. They are much missed.

Typeset by Sharon Dainton, Isis Design.
Printed and bound in China by Everbest Printing Co. Ltd

CONTENTS

Pisum sativum

ACKNOWLEDGEMENTS

My thanks to members of the Hampton Court Palace Florilegium Society (HCPFS) for the many questions that led me to write this book. I should also like to thank those members who have so generously allowed me to include their paintings; their names and pictures are listed individually as Appendix IV. Preceding this list, I have included a short introduction to the HCPFS. A big thank you goes to Mark Haslett of Essex Carnivorous Plants, who allowed me to photograph his large collection of these exciting and decorative plants. He is a National Collection Holder of *Dionaea* and *Sarracenia* and is more than willing to share his time and enthusiasm for all types of these strangest of plants. My thanks to Peter Mitchell, of the Institute of Applied Plant Illustration (IAPI) and of Sheffield University's Botany Department, for reading sections of this book and for his encouraging and helpful comments. Thanks also to Valerie Oxley for her exhortations to get on with it and to go into print. I have taken her advice. Finally, I would like to thank my daughter Katie for her constant encouragement and touching faith, and my great friend, Carolyn Fullager, for her forbearance, her knowledge of grammar and her able clerical assistance in the compilation of seemingly endless lists. However, I am pleased to note that her knowledge of botany has burgeoned!

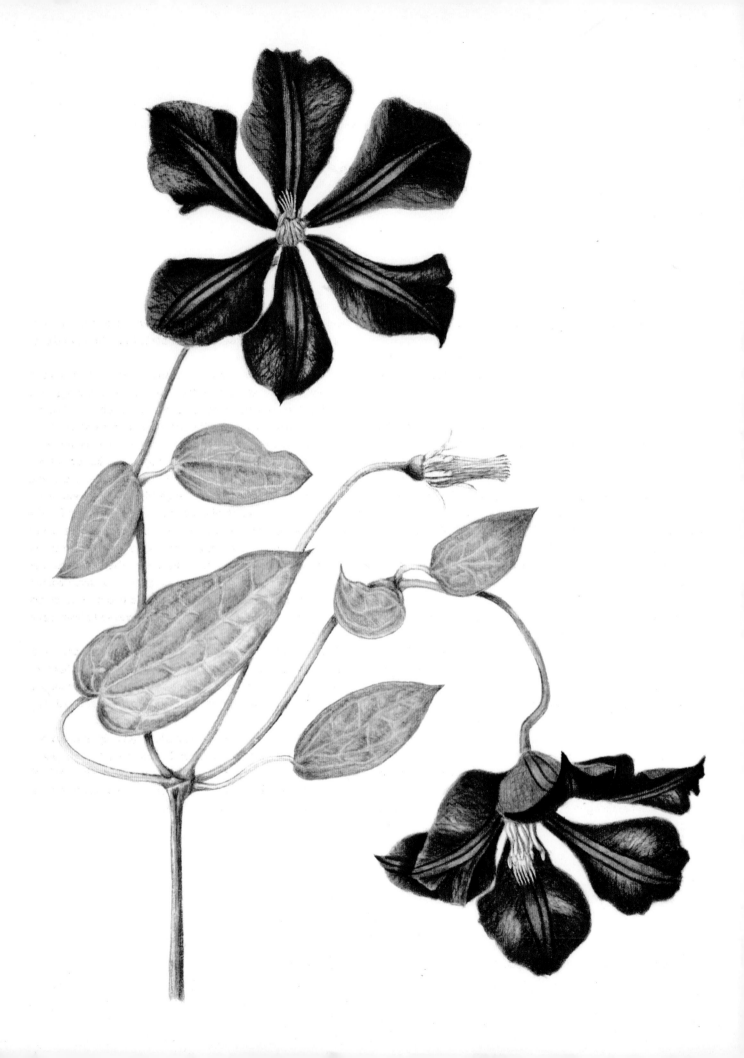

PREFACE

A flower is an entire world, and a leaf is a ray of enlightenment.

An inscription in the garden of the
Wild Goose Pagoda, Xi'an, China.

Botanical illustrators provide a botanically definitive record of a species and therefore include all relevant details. They have developed their flower dissection skills and are botanically knowledgeable enough to recognize what they are looking at and are able to draw it accurately and to scale, in order to enhance the completeness of their record. The most important attribute of the resulting illustration or painting is first and foremost accuracy. It may also be beautiful – depending on the subject and the artistic flair of the illustrator. This is frequently, but not always, the case.

Botanical artists may also be illustrators, and generally aim to paint a plant species as accurately as possible, enhancing its most obvious features, whilst producing a picture of great beauty. They are often attracted to their subject matter by the perceived artistic worth of some plants which may be showy, bold, architectural or a good design subject. This does not necessarily mean that modern 'budding' botanical artists have any real academic botanical knowledge when they start.

Having originally trained as a botanist and having completed a Diploma in Botanical Art at the English Gardening School (Chelsea Physic Garden), I have come to realize that many of the artistically talented botanical artists produced by these courses find it difficult to recognize the diagnostic or important features of their particular plant 'subject'. This is largely due to the demise of old-fashioned basic botanical knowledge as a requirement of the school curriculum or as part of a well-rounded education.

This book sets out to address this knowledge gap in a user-friendly fashion, explaining the botanical terminology and keeping it to a realistic minimum, so that the subject is less off-putting than many very worthy and more erudite texts. By helping botanical artists to a greater understanding of what to look for in plants, flowers and fungi, it is hoped that important features will soon become more easily recognizable. Close and accurate observation and knowledge all help the development of what an old professor of mine used to call 'the eye of faith' – if you know what you are looking for, you will find it! This in turn should lead to more informed and accurate plant portraiture with botanical as well as aesthetic value. The art course has taught me to look for apparent changes in a uniform colour, due to differing amounts of light, so that the form of an object is enhanced. I now know what to look for and so I observe and paint in a more three-dimensional way.

I very much hope that you find the information and help-sheets in this book useful, as well as informative, and that they help you to observe, recognize and identify the important features of your plant subjects, prior to drawing and painting them.

Greater familiarity and understanding can only lead to a real appreciation of the intricacies and relationships of the plants you are depicting. I hope you will find inspiration in the detail and excitement in recognition, as well as achieving more accurate paintings of your plant subjects.

LEFT: Clematis 'Star of India'. (Liz Leech)

INTRODUCTION

The structure of this book

This book includes diagnostic details of many common plant features, groups and families, so that they can easily be recognized and thus provide a starting point with things to look for in a specimen and to include in a picture. To this end, I have devised various specific 'observation helpsheets' to give direction to your observations and to act as observational aides-mémoires. Paint colours could also be added to the sheet for use when you actually paint the specimen. Completed exemplars of each helpsheet are included in the appropriate chapters, whilst blank copies for photocopying can be found in Appendix 1.

On occasion, I have not used the botanically accepted word endings for some of the non-flowering groups, but often the more familiar abbreviated endings. Also, depending on the age of a reference book, plant classification can vary quite markedly in the number of kingdoms and phyla divisions detailed. The main general groupings, which I shall use, remain valid, however.

I have included a chapter on fungi in this book, although they are not, strictly speaking, plants in a botanical sense. Within this chapter there is a short section on lichens, as they are inseparably linked and named for their fungal partners. I have not included the simplest group of plants, the algae, however, on the assumption that anyone wanting to paint them accurately will either be a seaweed enthusiast or will find sufficient, easily understood information on them.

The flowchart (page 10) gives a brief overview of the first twelve chapters and how their content is linked. I have started with flowers, since this aspect of the subject is usually of most interest to botanical artists and the flower-bearing plants represent the highest evolutionary form of the plant kingdom (as do mammals in the animal kingdom). Trees have been divided into separate chapters: those with flowers and those without (such as the cone-bearing trees and shrubs). The cone-bearing trees and shrubs link also with the more primitive non-flowering plant groups, such as the ferns and mosses. The fungi lack the green pigment, chlorophyll, and have no leaves, stems or roots – they are therefore completely separate from plants as we know them.

At the end of Chapter 9, I have attempted to list the salient features of plants belonging to the families included in the Gymnosperms, which includes the Conifers. I hope that this will provide you with a checklist of features to look out for when you first observe them. It is intended to be a help rather than a com-

LEFT: Parrot tulips. (Sara Bedford)

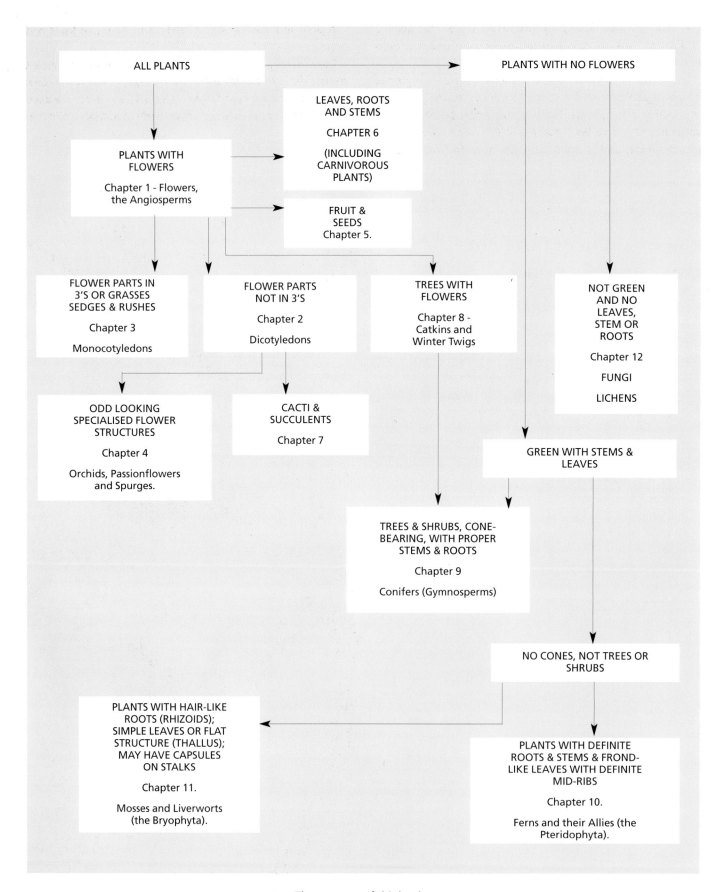

ALL PLANTS

PLANTS WITH NO FLOWERS

LEAVES, ROOTS AND STEMS

CHAPTER 6

(INCLUDING CARNIVOROUS PLANTS)

PLANTS WITH FLOWERS

Chapter 1 - Flowers, the Angiosperms

FRUIT & SEEDS
Chapter 5.

FLOWER PARTS IN 3'S OR GRASSES SEDGES & RUSHES

Chapter 3

Monocotyledons

FLOWER PARTS NOT IN 3'S

Chapter 2

Dicotyledons

TREES WITH FLOWERS

Chapter 8 - Catkins and Winter Twigs

NOT GREEN AND NO LEAVES, STEM OR ROOTS

Chapter 12

FUNGI

LICHENS

ODD LOOKING SPECIALISED FLOWER STRUCTURES

Chapter 4

Orchids, Passionflowers and Spurges.

CACTI & SUCCULENTS

Chapter 7

GREEN WITH STEMS & LEAVES

TREES & SHRUBS, CONE-BEARING, WITH PROPER STEMS & ROOTS

Chapter 9

Conifers (Gymnosperms)

NO CONES, NOT TREES OR SHRUBS

PLANTS WITH HAIR-LIKE ROOTS (RHIZOIDS); SIMPLE LEAVES OR FLAT STRUCTURE (THALLUS); MAY HAVE CAPSULES ON STALKS

Chapter 11.

Mosses and Liverworts (the Bryophyta).

PLANTS WITH DEFINITE ROOTS & STEMS & FROND-LIKE LEAVES WITH DEFINITE MID-RIBS

Chapter 10.

Ferns and their Allies (the Pteridophyta).

The structure of this book.

plete and definitive listing – you will still find further generic and specific differences and features among the 'oddities' within each family.

I have also included chapters on groups of plants that are not botanically linked but are frequently grouped together, such as the cacti and succulents. Plants with specific peculiar flower structures have also been covered in the chapter on orchids, passionflowers and spurges. Other chapters deal with specific variations in leaves, as well as roots and stems, or fruits and seeds.

Chapter 13 gives general information that may be of interest to botanical artists. However, I have made no attempt to deal with specific painting and drawing techniques; these have been covered in detail by many, very competent authors trained in fine art.

Teasel. (Margaret Hatherley-Champ)

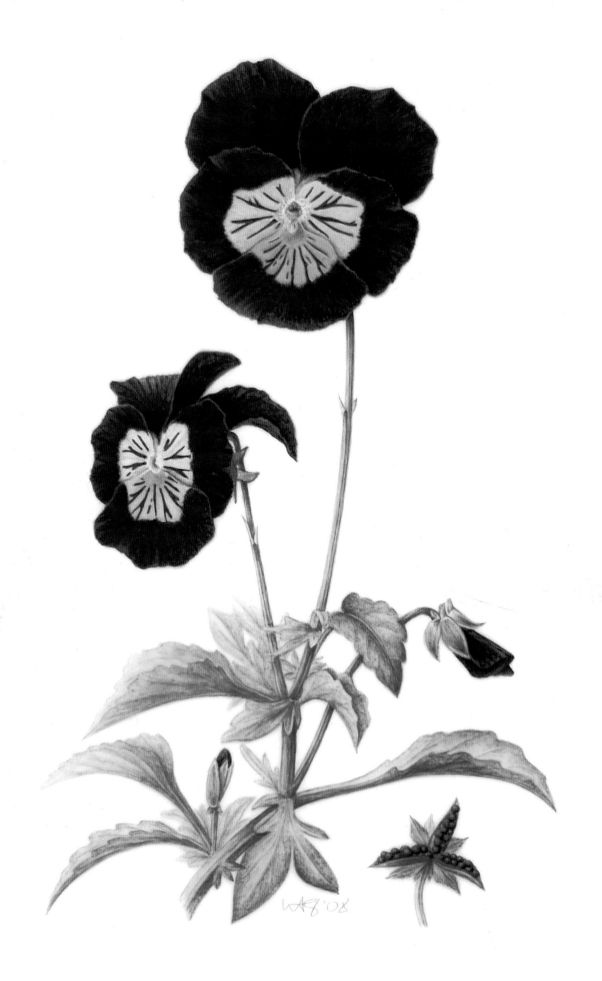

FLOWERS

Why flowers exist

Flowers exist solely for the successful sexual reproduction of flowering plants. Beautiful and exotic, boring and drab, or sinister and repellent, flowers are all designed to ensure that male pollen, the plant equivalent to animal sperm or male sex cells, meets and fertilizes a female egg cell in the ovary so that their DNA and genes mix to give their offspring some genetic variation between individuals of the same species.

This naturally occurring genetic variation is desirable as it may confer characteristics that allow the survival of an individual plant when others succumb to adverse conditions; an example of evolution in the making. On the other hand, this variation may result in the development of the new varieties that are so desirable to gardeners and horticulturalists.

Tulip with petal-like bract.

How flower parts have developed

Flower parts are thought to have developed from modified leaves. Proof being the fact that you often see the odd petal that may look rather like a leaf and the occasional leaf that looks like a petal. Similarly, the reproductive cone-like structures in the pine and conifer plants (the gymnosperms) have also developed from modified leaves.

Due to being literally rooted to the ground, plants have developed flowers to ensure the successful transfer of their pollen grains (male sex cells) to the waiting, receptive, female part of a flower – the stigma. This transfer is called 'pollination'. The chosen method of transfer determines whether a flower is flamboyant and showy or small, reduced and bordering on insignificant.

LEFT: Pansy. (Leigh Ann Gale)

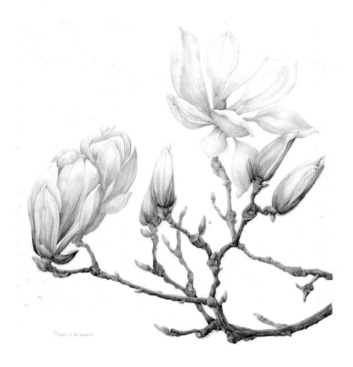

Magnolia soulangeana. (Shirley Slocock)

Plants with flowers – the angiosperms

This group of plants includes all those that have their reproductive parts forming a flower.

After pollination and *fertilization*, the egg cell grows into a seed containing the 'baby' plant and its food store. The seeds are not naked (like gymnosperms) as they are enclosed in the remains of the ovary, which later may develop and form the fruit. The ripe fruit aids seed dispersal away from the 'parent' plant (*see* Chapter 5).

There are thousands of different shapes and arrangements of the flower parts, giving a huge variety of flower types. These have evolved at different times and have therefore developed their own strategies for successfully accomplishing the pollination of their flowers. Many have evolved in tandem with a single particular *pollinator* but this is a very risky strategy as the flowers will not be able to pollinate and produce seed if the pollinator becomes scarce or, in a worst-case scenario, extinct. This is the case with many of the South American orchids such as the Bucket Orchid, which relies on a particular type of bee. Other plants have evolved flowers that rely on a wider group of pollinators – thus reducing the potential risk of losing all the pollinators. Some may have evolved for a group of pollinators that share a feature, such as a long tongue or a particular body shape.

Flowers relying on insects (*insect-pollinated flowers*) or other animals (e.g. mice, birds, possums, etc.) to carry their pollen are more obvious, larger, and often colourful and scented. Flowers relying on the wind to carry their pollen (*wind-pollinated flowers*) are often less obvious, smaller, and with protruding male and female parts that 'dangle' in the wind – these don't usually feature in a bouquet! Grass flowers and catkin flowers are common examples of these reduced flowers. They always produce an excess of pollen as so much is wasted on the wind and doesn't get to a female flower – it just gives us hay fever instead! Wind pollination is less complex and is also used by the male and female cones of the gymnosperms (*see* Chapter 9).

Distinguishing flowering plants

Due to the huge number of different flowering plants, herbalists, botanists and horticulturalists have tried to group flowering plants in such a way as to make naming and recognizing them easier. This led to many confusing systems of grouping or classification until Linnaeus devised his system based on grouping similar flower features and giving them universally accepted and recognized Latin names, rather than common names which varied from region to region and country to country (more of this system in Chapter 13). The flower is the only feature that is consistent: the leaves and the rest of the plant may vary in shape, size and type depending on where the plant grows and the environmental rigours (drought, grazing, seasonal changes, soil type) that it has to contend with, as well as geographical factors such as desert, tundra, or high altitudes. The structure of flowers does not usually vary in the arrangement and number of parts and so is the feature used to group plants into families and different species and for recognition.

To further assist in the easy recognition of flowering plant families, they can be divided into two main categories with instantly recognizable features: the arrangement of the leaf veins and the number of each type of flower part. The main two groups of flowering plants are the dicotyledons and the monocotyledons.

The dicotyledons

These are explored in the next chapter and include the oak, horse chestnut, buttercup, dandelion, rose, wallflower, pea, clematis, spurge, cyclamen and cactus. All have *net-veined* leaves and the number of flower parts are not three or any multiple of three, that is to say, one, two, four, five, seven, eight, ten, etc.

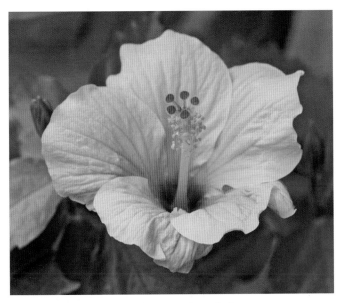

Hibiscus flower, a dicotyledon.

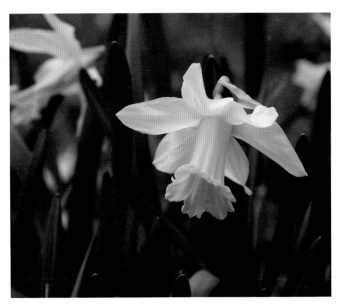

Daffodils, monocotyledons.

The monocotyledons

These are discussed in Chapter 3 and include rushes and grasses, bamboo, bluebell, lily, crocus, iris, daffodil, palm tree and orchids. All have *parallel-veined* leaves and flower parts in threes or multiples of three.

Observations of *Leycesteria formosa*

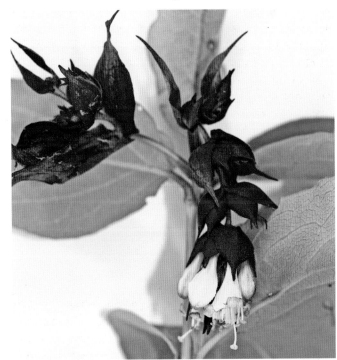

1. Twig with inflorescence.

2. Detail of flowers.

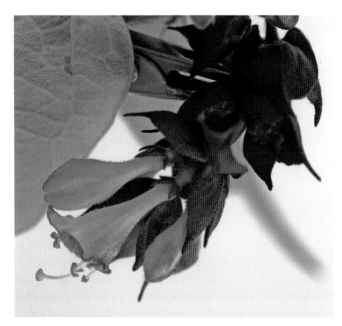

3. Detail of sepals with bracts pulled back.

5. Detail of fruits and bracts.

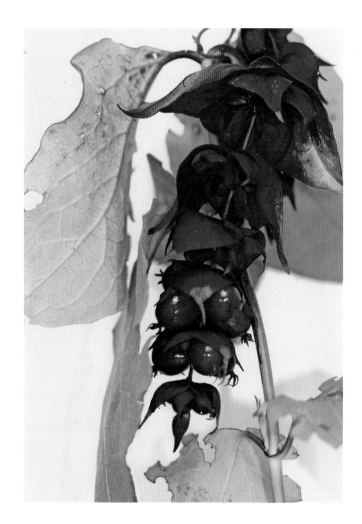

4. Inflorescence with fruits.

6. Detail of ring at nodes.

HELPSHEET 1 : Collecting and Looking at a Flowering Plant.

Be sure to collect a bud, a newly opened flower, a dying flower or one where the flower has shrivelled (so

that the swelling ovary is more obvious), any ripe fruits, and enough of the plant to show the leaf

arrangement.

Things To Note Whilst Collecting the Specimen.

Plant Name. Common Name ... Himalayan Honeysuckle/ Pheasant Berry.

Latin Name ... Leycesteria formosa

Plant Family. ... Caprifoliaceae

Habitat i.e. where it grows? ... gardens / shrubberies / S.W. China.

habit of plant – how it grows? ... Erect shrub up to 2m tall. Stems replaced from roots after 4-5 years.

any other obvious feature – spines, thorns, hairs, swollen joints? ... Soft, hollow, upright, green stems.

leaf shape – simple, compound? ... Simple, oval – lanceolate with pointed tips. Underside of leaf feels rough to touch.

leaf veins – (parallel, net-veined)? ... net – veined.

whether the leaf is stalked or grows directly from the stem joint? ... stalked – 1-2 cm long stalk.

leaf arrangement (phyllotaxy- opposite, alternate, spiral)? ... opposite – leaves dark above, pale beneath.

shape of the stem – round, oval, square? ... angular and ridged beneath.

whether the stem is ridged, has pores or is smooth? ... ridged. No apparent hairs – feels smooth.

whether the flowers are solitary or in an inflorescence? ... inflorescences. Flowers surrounded by bracts.

type of inflorescence (if flower not solitary)? ... racemes that are long and hang. Flowers in whorls (verticillate).

which flowers open first (at top, middle or bottom of the inflorescence)? ... top of inflorescence (free end).

number of petals in each flower? ... 5. United into tube at base. White with purple.

whether flowers are borne on old or new wood? ... new wood.

* Fruits. – berries, purple – red to black. Hairy and glandular. +1 cm diameter. Calyx of 5 sepals persists at free end of berry.

Any other obvious feature. ... leaf – stalk bases flattened and united to form ring round the node.

Monocotyledon or Dicotyledon? ... Dicotyledon.

* Ovaries inferior.

leaf blade.
petiole
ring at node

Completed Helpsheet 1. Pheasant Berry *Leycesteria formosa*.

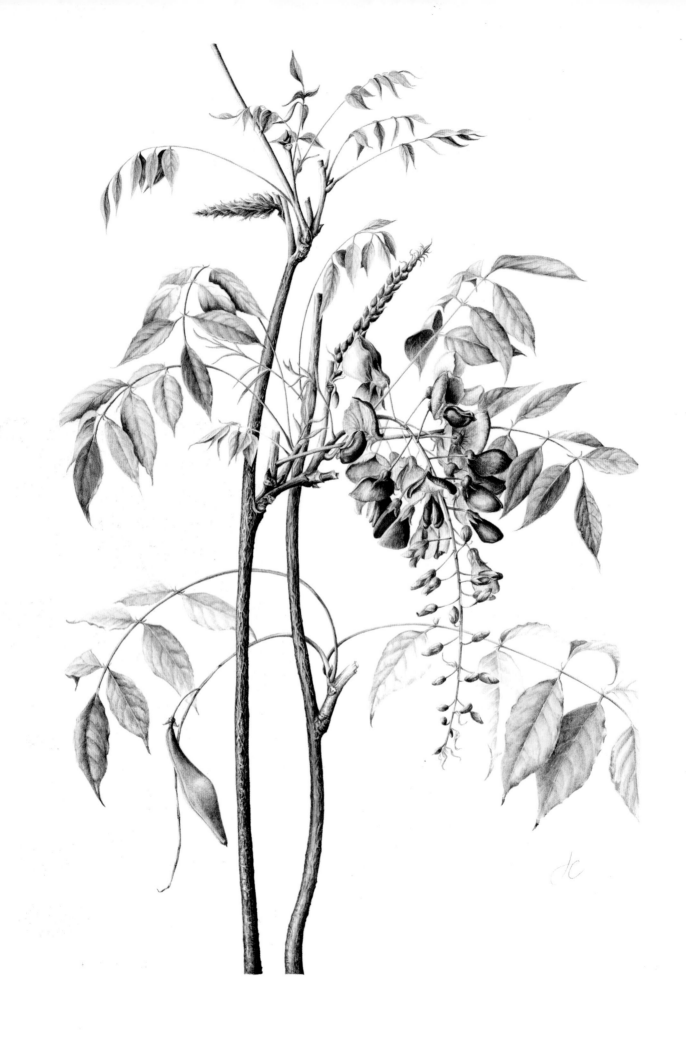

DICOTYLEDONS

RECOGNIZING A DICOTYLEDONOUS PLANT AND ITS FLOWERS

- The number of each type of flower part (e.g. sepals, petals, etc.) is not divisible by three (e.g. one, two, four five, seven,etc.).

- There are two 'seed leaves' or *cotyledons*, forming part of the embryo plant, in the seed.

- The plant's leaves are obviously 'net-veined'.

- The younger stems have a circle of veins (*vascular bundles*) when looked at through the microscope.

- The roots usually consist of a main tap root with smaller side roots off it.

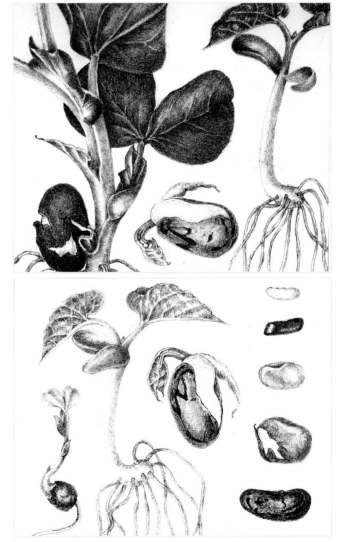

Flower structure

Flowers and their constituent parts vary enormously in size, colour, shape and smell to appeal to and to accommodate their various pollinators. Flowers may also provide the pollinating animal with food (pollen and nectar) or shelter or some other commodity as payment for *pollination* services rendered.

To understand the standard parts of a flower, the descriptions here are based on simple, more showy, insect-pollinated,

LEFT: Wisteria. (Jackie Copeman)

Bean pencil study. (Shirley Richards)

Portulaca.

Poppy.

dicotyledonous flowers such as magnolia, rose, wallflower, sweet pea, clematis, primula, etc.

The arrangement of parts in each type of flower has evolved over millions of years to ensure that the flower's sex organs are protected until they are ready, and the flower opens; the male pollen is easily collected by the correct *pollinator* (pollen-transporting insect or animal, which has had to be attracted to that particular sort of flower) and the pollen is easily transferred to the correct bit of a female part of another similar flower for *pollination* and subsequent *fertilization* (setting of seed). Other parts of the flower then develop into a fruit (in the true botanical sense) to disperse the seeds efficiently when they are ready.

Looking at a flower

The best way to observe flowers is to pull a young flower or bud apart systematically – starting with the outside layer. This is a useful way to start looking at a particular specimen, so you can see how the parts relate to each other.

Make sure you look at all ages of the flower, including a bud, where possible, as some parts may 'fall off' or wither before the others, so you might miss seeing them. Also, beware of deformed or mutant flowers. Many cultivated, double and more exotic varieties of flowers have been 'selected' by horticulturalists for their differences and may be atypical or sterile or both. Examine several flowers to make sure they are all similar on the plant and not just a one-off 'odd' one.

Finally, collect and look at the dropping, withering flowers to see the developing fruit with seeds. These structures are easier to distinguish as they are swelling and enlarging.

Flower structure in detail

Flowers are borne on a stalk called a *pedicel*, which may have an oddly shaped, modified small leaf or *bract* attached to it. The free end of the flower stalk broadens and forms the *receptacle*, to which the flower parts are attached.

The flower parts consist of four main rings or *whorls* of parts: the sepals, petals, stamens and carpels. These are attached to the receptacle in a prescribed order. So always start your observations with a bud or look underneath the flower to see the outermost layer of parts.

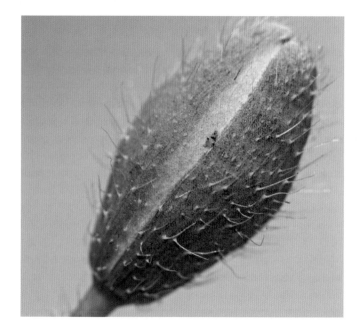

Poppy bud showing sepals.

and form a ring halfway down the flower stalk. In the Malvaceae (mallows, hibiscus, etc.) the ring of sepals has a distinct outer, smaller ring forming an *epicalyx*.

In many fruits the remains of the sepals may be apparent. Less usually, the sepals enlarge and change colour, after the rest of the flower has withered, so as to protect the developing fruit and then to attract animals which will ultimately disperse the ripe fruit and seeds. An example of this is the Cape gooseberry.

Keep an open mind: look for the outer ring of parts but be prepared for the unexpected.

Strip away the sepals to reveal the next layer of parts.

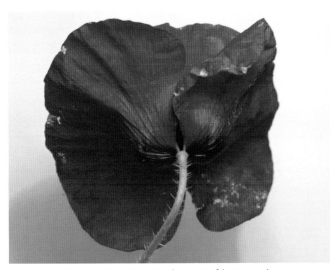

Poppy showing attachment of lost sepals.

Sepals

The sepals make up the outermost whorl or *calyx*. The main job of the sepals is to protect all the inner, more important parts of the flower (the sex organs) when the flower is still maturing in the bud, i.e. before it opens. The number is specific depending on the species of flower. They may be free of each other or united for some or all of their length to form a tube-like structure, in which case the number of teeth at the outer edge of the tube may indicate how many sepals there are. Sepals may be green or another colour. They may be hairy or glandular and may persist, change shape or drop off once the flower opens. In some cases (poppies, for example) they drop off before the flower opens. In flowers like the Christmas rose the sepals are like petals (*petaloid*) and it is only their position as an outer ring of parts that 'tells you' that they are sepals.

In some instances there is no distinction between the sepals and a 'ring' or *involucre of bracts*, e.g. in carnations and pinks, where the outer whorl is four united bracts at the base of the sepals. In many anemones, the bracts look like foliage leaves

Cape gooseberries. (Jackie Copeman).

Petals

The petals, collectively called the *corolla*, make up the next ring of parts. The main job of the petals is to attract insects (pollinators) so that they arrive to inadvertently pick up pollen grains and then transfer them to another flower of the same species.

Size, colour and arrangement of petals are all critical to attract particular types of insect and it may have taken thousands of years of parallel evolution for the flower to develop into the bloom that you are looking at. In some cases a flower has become so 'evolved and specific' that extinction of its pollinator insect will lead to the demise of that species of flower.

Petals may be free, so that it is easy to remove each individually, or joined to form a complete tube, or just fused for a short way along their length. Where the petals are joined, and it is difficult to tell how many there are, count any 'teeth' at the free

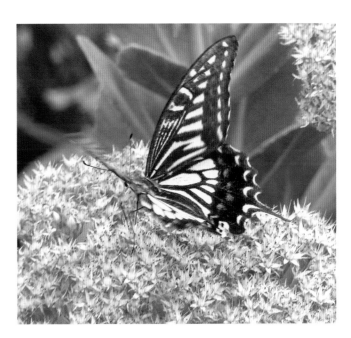

Swallowtail butterfly pollinating and feeding on *Sedum,* China.

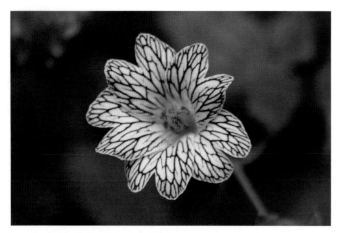

Geranium petals showing guidelines.

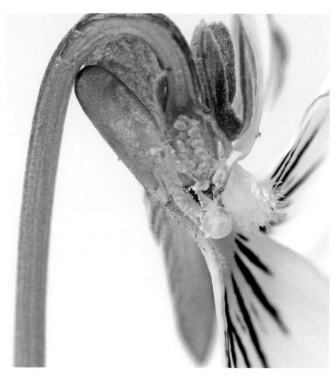

Viola half flower showing petal spur and nectary.

edge. This often gives an indication of their number. Long petal tubes often mean that the specific pollinator has a very long 'tongue' to reach any nectar – no smaller insect or those insects and birds with shorter 'tongues' can do the job of pollinator (although some animals and insects, like bumblebees, for example, cheat the plant and bite holes in the petal tube).

Other features of petals may include differently coloured or raised *guidelines*, which 'signpost' the route the flower wants the insect to follow, or *nectaries* which are variously shaped glands that produce sugary *nectar* with which the flower 'pays' the insect with food for the job it is to do, i.e. pollen transfer). In the Christmas rose (*Helleborus* sp.), the petals themselves are reduced to tubular nectaries. (Nectaries may also form from other parts of the flower, such as the stamen filaments, the base

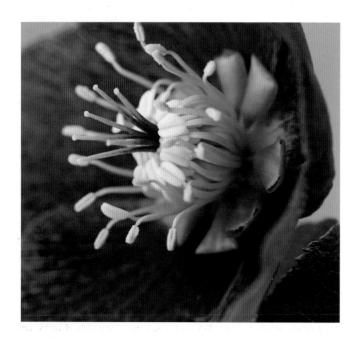

Hellebore: young flower showing green tubular nectaries.

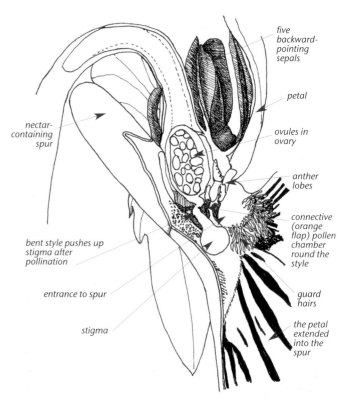

five backward-pointing sepals

petal

ovules in ovary

anther lobes

connective (orange flap) pollen chamber round the style

guard hairs

the petal extended into the spur

nectar-containing spur

bent style pushes up stigma after pollination

entrance to spur

stigma

Viola half-flower.

THE PERIANTH

Petals and sepals together constitute the *perianth* (parts outside the male anthers). They may all be petaloid (identical to the petals) and may be called *tepals* in more modern books. Examples can be seen in the snowdrop, bluebell, lily, crocus and daffodil. In other cases they may all be like sepals (*sepaloid*), or both whorls of the perianth may be missing, that is to say, no sepals or petals!

Take care to observe whether the perianth parts meet edge to edge (uncommon) or whether they overlap. The outer layer represents the 'sepals'.

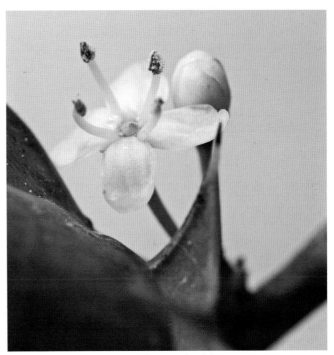

Holly flowers (male).

of the ovary, and from the calyx (sepals). In some cases the flower is modified to store nectar in several variations of the *perianth* (see above), e.g. pouches or *spurred* petals.

Petals may also produce scent, which attracts the insect to the flower. These scents may be pleasant or positively revolting. In the case of the dead horse arum, the scent mimics the smell of rotting meat! They may also mimic an insect's *pheromones* and offer a false promise of sex to the frustrated insect. Where the shape and colour of the petals are like a female insect and the pheromone-type scent are found together in a flower, the male insect may try to mate with the flower and thus pick up and then deposit pollen the second time it is fooled by the flowers. This is true of some orchids, which have evolved this devious disguise.

Stamens

The *stamens* make up the third ring of parts and are collectively known as the *androecium* (from the Greek words meaning 'male house'). Stamens are the male sex organs of a plant and their number and arrangement are again specific for different types of flowers. They consist of a stalk or *filament* that holds the *anther*, where the pollen grains are made and stored until released when the ripe anther opens and sheds its pollen (*dehisces*). The anthers are the plant's equivalent to an animal's testicles.

Some flowers may be lacking stamens altogether; others may have sterile stamens with small, non-functioning anthers. Some flowers are *monoecious*, with unisexual flowers on the same plant (e.g. hazel); others are *dioecious*, with the sexes segregated on separate plants (e.g. holly).

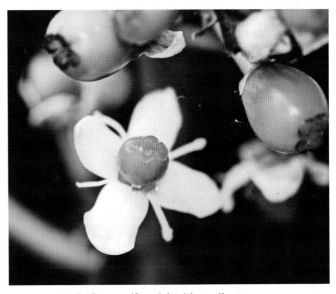

Holly flowers (female) with sterile stamens.

The length of the filament and where in the flower the stamen is attached is specifically designed so that the anther is in the correct place in order to make sure the pollinator (insect) has to brush past the ripe anther, thus picking up pollen grains somewhere on its body, ready for transport to a receptive virgin flower.

In some flowers, like the primrose, there may be more than one arrangement of the stamens in different flowers of the same plant. Pin-eyed flowers encourage *cross-pollination* with pollen

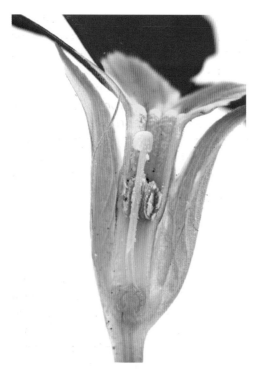

Pin-eyed primula – half flower picture.

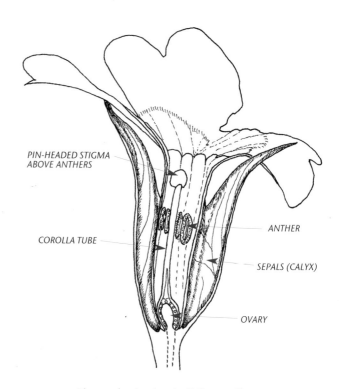

PIN-HEADED STIGMA
ABOVE ANTHERS

COROLLA TUBE

ANTHER

SEPALS (CALYX)

OVARY

Pin-eyed primula – half flower diagram.

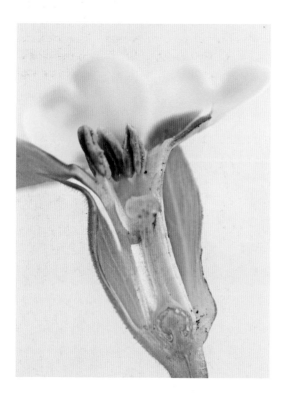

Thrum-eyed primula – half flower picture.

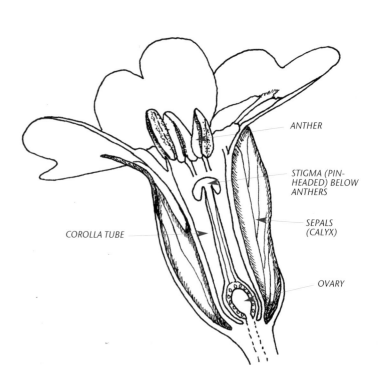

ANTHER

STIGMA (PIN-
HEADED) BELOW
ANTHERS

SEPALS
(CALYX)

COROLLA TUBE

OVARY

Thrum-eyed primula – half flower diagram.

from another plant, whilst thrum-eyed flowers encourage *self-pollination* with its own pollen as it can just fall out of the anthers onto the receptive female surface (*stigma*). This is a fail-safe strategy that ensures some seed is set whether there are pollinators around or not.

Some stamens are fused together in various ways. In the Malvaceae (e.g. mallow and hibiscus) the filaments fuse together to form a tube lower down and form a characteristic ring (look-

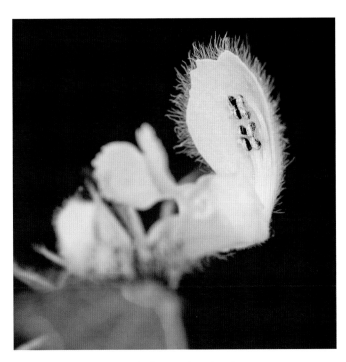

White dead nettle flower showing four stamens.

deadnettle genus (*Lamium*). Dorsifixed anthers of grass flowers are attached by insubstantial tissue so that they wobble in the wind to help them shed their copious pollen onto the breeze.

Ways of opening of the ripe anther also vary and follow lines of dehiscence – a bit like 'tearing along the dotted line'. These lengthwise lines of dehiscence are usually on the outer surface (extrorse) but may occasionally be on the inner surface (introrse). Rarely, as in Alchemilla, dehiscence is transverse, or may take the form of a short slit that opens as a pore at the apex of the anther, e.g. the heather family (Ericaceae). The berberis family (Berberidaceae) e.g. Mahonia, have lateral valves.

Carpels

The *carpels* make up the innermost whorl and are collectively known as the *gynoecium* (from the Greek word meaning 'female house'). Carpels are the female sex organs of a plant, equivalent to the reproductive system in an animal, and their number and arrangement are again specific for different families of flowering plants. They are one of the main characteristics that Linnaeus used to group plants in his classification system, and therefore a very important part of the flower to get correct when painting.

A carpel consists of one or more *ovules* (egg cells) enclosed in an *ovary*, with a stalk called the *style* that ends in the stigma. Styles are outgrowths from the ovary wall which end in the stig-

ing like a bottle-brush) of free filament tips bearing the anthers. The castor oil plant (*Ricinus*) is rare in having genuinely branched filaments. St John's wort (*Hypericum* sp.) has bunches of stamens joined at the base of the filaments.

Finding stamens that are attached to petals in some way is also not uncommon. An extreme case is mistletoe (*Viscum album*), where the anther and petal are hardly separated. Finding stamens attached to the female parts, such as on the underside of the style, occurs in orchids and *Aristolochia*.

How anthers are attached to the filament may also vary and is again specific to a plant to ensure appropriate shedding of the pollen – so have a good look! They may be attached at the base (*basifixed*), at the back of the anther (*dorsifixed*), or at their apex (*apicifixed*) – this latter form of attachment is unusual e.g. in

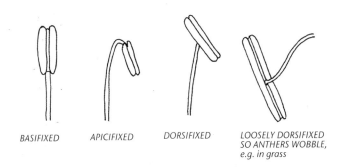

BASIFIXED APICIFIXED DORSIFIXED LOOSELY DORSIFIXED
SO ANTHERS WOBBLE,
e.g. in grass

Anther attachments.

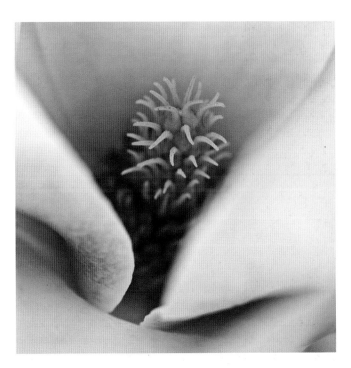

Magnolia carpels.

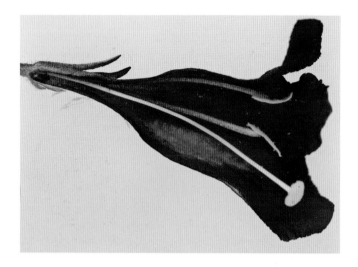

Weigelia half flower showing long style and stigma.

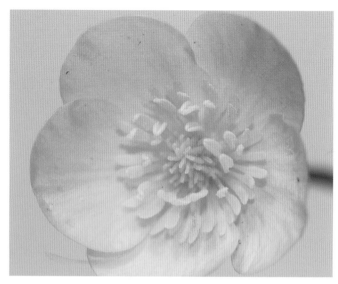

Buttercup flower – petals, stamens and carpels.

ma. The length and shape of the style is determined by the fact that the stigma must be held in the correct position for the pollinator to transfer pollen onto it.

Stigmas constitute the surface where the pollen is deposited. When mature they are sticky and receptive. Each species of flower produces a particular combination of sugary chemicals on the ripe stigma. These sugars stop alien pollen from fertilizing the ovule whilst actively encouraging the correct pollen to grow down through the styles, to fertilize the ovule's egg cell by growing a long thin 'pollen tube' that digests its way through the style, through the ovary wall, and across the gap and into the ovule.

Shapes of stigmas vary from being like a pin head (*capitate*), long or lobed, or feathery or rounded, and are specific to the type of flower and its pollinator. The positioning of the stigmas has evolved so that they are in the correct position to pick up pollen from their 'chosen' pollinator.

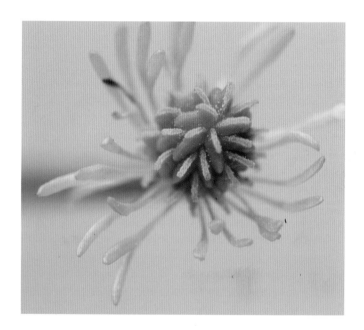

Buttercup carpels developing into achene fruits.

ARRANGEMENTS OF CARPELS IN A FLOWER

Some flowers, e.g. buttercup, avens, etc., have a mass of easily separated, individual carpels, each with a single ovule, in their centre. This simple arrangement has always been considered to be an evolutionarily primitive arrangement.

Carpels with more than one ovule or united, compound carpels, are considered more complex arrangements and therefore evolutionarily younger.

LOOKING AT UNITED CARPELS AND THEIR OVARIES

When observing an ovary that is made up of more than one carpel joined together, it is a good idea to look also at older flowers (often where the petals are dead/dropping off) which have been pollinated and where the resulting seeds and ovary are developing into the 'fruit'. In the newly opened flower it may be difficult to make out the structures. Counting the styles

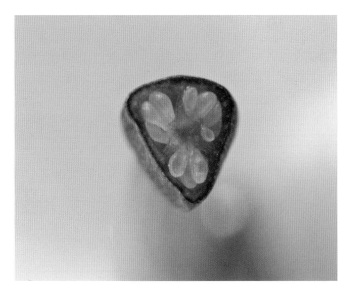

Daffodil cross-section through three-chambered ovary.

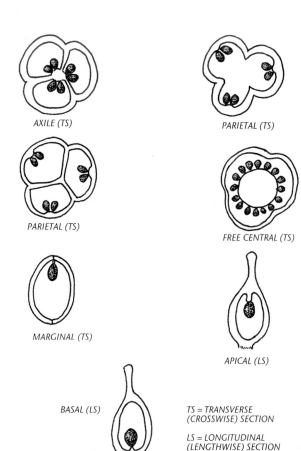

AXILE (TS)

PARIETAL (TS)

PARIETAL (TS)

FREE CENTRAL (TS)

MARGINAL (TS)

APICAL (LS)

BASAL (LS)

TS = TRANSVERSE (CROSSWISE) SECTION

LS = LONGITUDINAL (LENGTHWISE) SECTION

Placentation.

and stigmas often gives a good indication of the number of carpels united to form the 'ovary'. The number of carpels may also be reflected in the number of divisions or lobes of the stigma.

It is also a good idea to cut the ovary across, transversely, and down, longitudinally, to see where the space in the ovary is divided by internal dividing walls (*septa*), into spaces called *loculi*. The number of loculi may reflect the total number of carpels present. The number of carpels may well be less than the number of parts in other whorls.

Looking at sections through the ovary also allows you to see where the 'seeds' are attached (*placentation*) and where the other flower parts are attached in relation to the ovary/carpels.

WHERE IN THE OVARY ARE THE OVULES ('SEEDS') ATTACHED?

In terms of drawings, this characteristic is only really relevant to detail needed in botanical illustrations. However, it is also useful when drawing and painting ripe fruits which may open to shed their seeds. It is glaringly obvious if the seeds are attached to the wrong bit.

The ovules or seeds are always attached to a part of the ovary (*placenta*) with veins in it – these veins provide the nutrients for the developing seed, in much the same way as an animal's placenta provides the growing 'baby' with all it needs before birth. Again, various types of plants have developed different places in the ovary for ovule attachment and their development into seeds.

The types of placentation are known by the physical position of the ovules in an ovary and are therefore easy to remember:

- *Axile placentation* is where the ovules are attached to the central axis of the ovary where the septa connect, e.g. citrus, aloes, hibiscus.
- *Parietal placentation* is where the ovules are attached to the middle (centre) of the wall of the carpel, e.g. in begonia.
- *Free central placentation* found in the carnation family (Caryophyllaceae), e.g. carnations and pinks, and the primrose family (Primulaceae), e.g. cyclamen, primula. Here the central column or axis of tissue does not extend to the top of the ovary wall and is therefore 'free'. The ovules are distributed all over this.
- *Marginal placentation* is where the ovules are attached to the edges of the carpels, i.e. where the walls of two carpels join, e.g. in the pods of peas and beans.
- *Apical placentation* is where the ovules arise from the upper edge of the single-chambered ovary, e.g. *Morus*

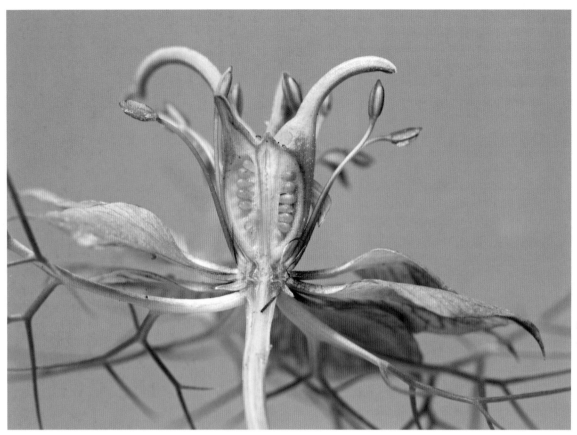

Love-in-a-Mist section through ovary.

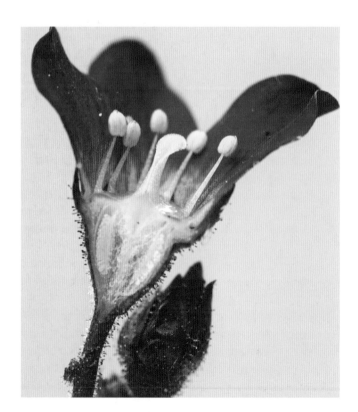

Saxifrage half flower.

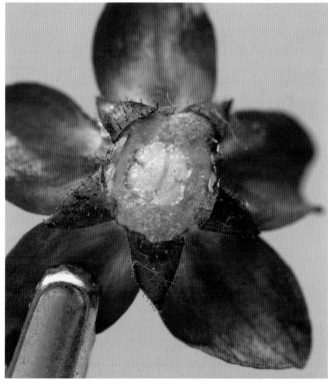

Saxifrage cross-section through the ovary below the petals.

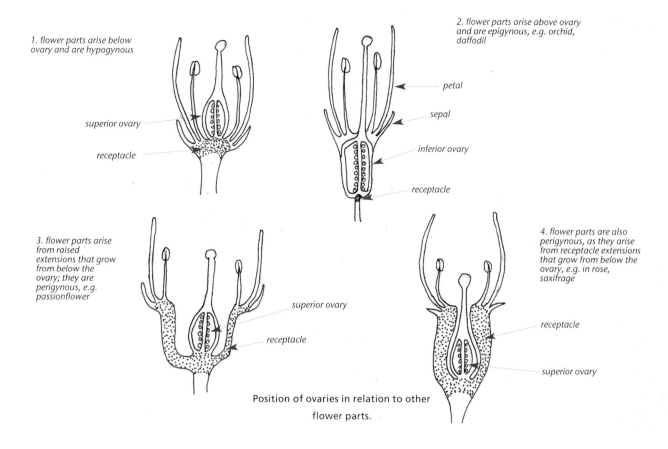

1. flower parts arise below ovary and are hypogynous

2. flower parts arise above ovary and are epigynous, e.g. orchid, daffodil

superior ovary

receptacle

petal

sepal

inferior ovary

receptacle

3. flower parts arise from raised extensions that grow from below the ovary; they are perigynous, e.g. passionflower

4. flower parts are also perigynous, as they arise from receptacle extensions that grow from below the ovary, e.g. in rose, saxifrage

superior ovary

receptacle

receptacle

superior ovary

Position of ovaries in relation to other flower parts.

FLORAL FORMULAE

This is a shorthand way of recording the essential facts about each of the four rings of parts of a flower. The sepals (calyx) are represented by the letter **K**; the petals (corolla) by the letter **C**; the stamens (androecium) by the letter **A**; and the carpels (gynoecium) by the letter **G**.

For each ring of parts the actual number of sepals, petals, stamens and carpels in a flower are counted, and the number written after the appropriate letter. If the number of parts is more than ten an infinity symbol (∞) is used instead of a number. So, for example, in the lesser celandine, the floral formula is **K3 C8 A∞ G∞**, i.e. three sepals, eight petals, numerous stamens and numerous carpels.

You will notice that there is a line below the infinity symbol for the carpels (**G**). A line below the number (or symbol) denotes that the carpels' ovaries are superior, i.e. they have developed from the receptacle, above the other flower parts. If the line is above the number, or symbol, it denotes that the ovary is inferior, i.e. it has developed from the receptacle below the other flower parts (e.g. **G∞**). In the snowdrop, where the three

carpels are united in the 'ovary' the number is put in brackets to show that the carpels are united as well as inferior (e.g. **G (3)**).

Where the sepals and petals are sepaloid or petaloid and therefore called the perianth, the letter used is **P** (not K and C) but the two rings of parts are numbered separately with a plus sign (+) between. In the snowdrop the perianth (petals and sepals) are all petal-like but there are 3 of each, denoted as **P 3 + 3** in the floral formula (three outer white sepals and the three smaller, inner heart-shaped white and green petals. The snowdrop's overall floral formula is **P3+3 A3+3 G (3)** .

The final symbol found in a floral formulae is a large horizontal bracket between the two layers of parts that are united, for example when the stamen filaments arise from the petals. In a foxglove flower there are five united sepals, five united petals forming a tube, four stamens attached to the petal tube, and two united carpels, so the floral formula is **K(5) C(5) A4 G(2)**. This is the tube we all used to put on our fingers as 'finger gloves' when we were children!

(mulberry) and *Ficus* (fig).

- *Basal placentation* is where the ovules arise from the base of the single space in the single-chambered ovary (*unilocular*), e.g. *Berberis, Rumex*.

LOOKING AT THE POSITION OF THE OVARY IN THE FLOWER

Once again, this feature is an important and distinctive characteristic of each plant family and has evolved over many millennia. There is no other way of explaining the reason for the differences in the arrangement of the flower parts, in the same way as there is no apparent reason for the different types of vertebrates (such as fish, reptiles, amphibian, birds, and mammals) in the animal kingdom: they are the product of thousands of years of evolution from a common ancestor.

The best way to observe the position of the ovary is to pull a flower apart and also to cut a flower in half lengthwise (longitudinally). A usually fool-proof indicator is to follow the stigma and style down through the flower to see where it attaches to the top of the ovary. The ovary may or may not be immediately obvious and may be unexpected in shape and size.

An *inferior ovary* is one where all the other flower parts arise from the top of the ovary (i.e. are *epigynous*), e.g. iris, snowdrop, daffodil, crocus, canna lily. In these cases the ovary may look like the top of the flower stalk and is often difficult to observe, until the flowers have withered and the ovary starts to swell.

A *superior ovary* is one where the flower parts arise from the top of the flower stalk (receptacle), below the ovary (i.e. are *hypogynous*), e.g. columbine or buttercup. Where the ovary is superior, but surrounded by a cup-shaped extension of the receptacle, the flower parts are borne above the base of the ovary. This arrangement is known as *perigynous* and is seen in roses, for example. In apple and pear trees, the perigynous ovary is completely fused to the surrounding receptacle, which later develops into the fleshy part of the 'false fruit' (Chapter 5).

Busy Lizzie (*Impatiens wallerana*) has been chosen as an example of a well-known and seemingly simple flower, for the completed example of Helpsheet 2 on page 34 – Recording Flower Details. This flower illustrates the importance of examining all ages of flower in order to be able to determine the probable structure of the male and female organs and information needed for the completion of the floral formula – **K**3 **C**5 **A**(5) **G**(5). It also illustrates the fact that if, initially, you can't find all the parts you expect to, then another look and a little bit of judicious research may help.

Flower symmetry

The shape of flowers depends very much on the number and arrangement of their parts. Where the parts are evenly arranged the flower is said to have symmetry, which makes drawing and painting them much easier. Once again, there is no explanation for the various arrangements beyond evolution. However, every type of flower in a particular plant family has similar symmetry.

Observations of Busy Lizzie, *Impatiens wallerana*

1. Flower, leaves, pedicel and bracts.

2. Arrangement of petals, androecial cap in centre and hole leading to nectar-containing spur.

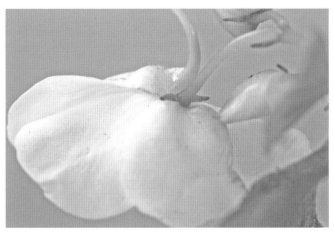

3. Impatiens from below showing two small green sepals and large, pale sepal with spur and keel-like ridge on large petal.

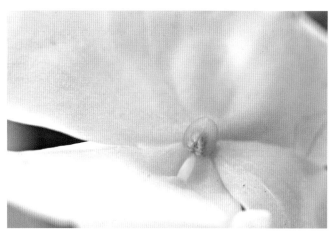

4. Detail of androecium with anthers and hole to spur.

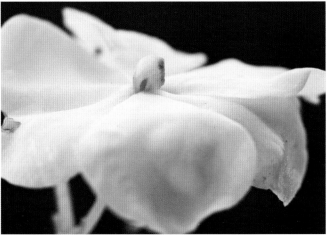

5. Androecial cap with ovary showing through filaments at base.

6. Capsule and top of stem.

Flowers with *radial symmetry* can be cut in more than one plane to give two longitudinally identical half flowers. These regular flowers are known as *actinomorphic*, and include buttercup, tulip, rose, magnolia, and geranium.

Flowers that are *monosymmetric* can only be cut in one plane to give two longitudinally identical half flowers. These flowers are called *zygomorphic*, and include sweet pea and orchids.

Flowers that are asymmetric have no symmetry and cannot be cut in any direction to give equal or identical half flowers. These flowers without symmetry are rare, and include the canna lily, iris, and grass flowers.

Ways in which flowers are positioned on a stalk (types of inflorescence)

The simplest arrangement is where there is only a single flower on the flower stalk (pedicel). In this type of arrangement the flowers are described as 'solitary', for example wood anemones, aconites, and snowdrops.

Where there is more than one flower on the main flowering stalk (*peduncle*), the main flowering stalk and its flowers are known as an *inflorescence*. The peduncle usually looks different from the main plant (which is leafy and *vegetative* and not involved in reproduction).

Try to look at the arrangement of flowers on a stalk before all the flowers come out. Once you have a riot of colour and closely packed petals in front of you, it is almost impossible to distinguish bracts and other possibly important detail. Also note which flowers open first and the buds' sequence of opening.

HELPSHEET 2 : Recording Flower Details, whilst Sketching and Annotating.

Where possible, take a bud, a newly opened flower, an older flower and a dead flower to examine in detail. The range of ages allows you to check that bits haven't already fallen off or are undeveloped and not obvious.

Always choose a typical flower – not one that looks interestingly different.

Plant Name: Common Name Busy Lizzie

Latin Name Impatiens wallerana

Plant Family: Balsaminaceae

Working from the outside of the flower:

i). Start at **bracts** – leaf-like structures that come off stem where flower stalk (pedicel) arises.

Description...... Small 3-4 mm thin and tapering to a point.

Drawing

Then look at the outside of the flower and work your way inwards from layer to layer.

ii). **Sepals** (calyx) – count them and look at whether they persist or whether they drop off really early.

K in floral formula.

Number........... 3 Persistent or not ... yes - persistant

United or free.... free If united, only at base, or forming a tube ?

Colour . 2 green 1 whitish Hairy, smooth ?...... smooth

Shape ... 2 green, long and pointed, lateral + 1 whitish larger keel shaped and abruptly constricted to a spur.

Drawing.

iii). **Petals** (corolla) – count and look at how they are arranged.

C in floral formula.

Number 5 Arrangement hole to spur

Are they all the same or different 1 = upper, largest. 4 lateral petals in pairs joined at base free 4+5 and 2+3

United or free or partly united ..

Are the stamens attached to them? ... No

Is a nectary obvious? No Describe it and its position a ridge round the rim of the sepal spur opening? or in the spur.

Are there obvious, different coloured guidelines? No

Completed Helpsheet 2. Busy Lizzie *Impatiens Wallerana*.

Drawing.

handwritten labels on diagram: sepal, ridge, Petals removed, andaroecium, gynoecium, hole, entrance to spur, keel-shaped sepal

right diagram labels: view when petals removed, 2, sepal, petal 1, sepal, Young bud, spur

Is the flower scented?No.......................................

Perianth parts are the sepals and petals. **P** in floral formula. *0*

Where the sepals look like petals or the petals look like sepals the perianth parts are called *tepals* in modern

texts.

iv). *Stamens* (male part collectively called the androecium). They consist of a stalk called a filament and

a pollen-box called the anther, where pollen grains are made.

A in floral formula.

Number*5*.....................................

Arrangement in relation to position of petals and sepals. *above the surface of the petals.*

Where are they are attached in the flower? *over the top of the stigmas and ovary.*

Filaments free of each other or fused *short and broad with fused appendages forming a cap over the gynoecium*

Anthers free or fused *adjacent anther lobes fused.*

How does the anther open (dehisce) to let out pollen – a pore, or slit opening outwards or inwards?

Slit at the top of the fused anthers. Pollen collects in the space in "cap."

Where does the filament attach to the anther (top, middle or bottom)? *unclear as all fused in "cap."*

Drawing.

left diagram labels: from behind, hole to spur through petals, anther, filament, ovary showing through between filaments.

right diagram labels: from front, Androecium Cap, anthers on front of cap, petal, petal, hole to spur

Colour of anthers and of pollen grains *Pale yellow*

v). *Ovary /Carpels* (female part collectively called the gynoecium).

G in a floral formula.

A carpel is made up of the *stigma* (receptive surface for pollen), the style (which ends in the *stigma*), and the

ovary containing the egg cells (in "pearl-like" ovules that become seeds after fertilisation).

The best way to observe details of the ovary is to look at all ages of flower – including a withered one where

the ovary is developing and is bigger and easier to see. Cut across the ovary (transverse section) and count

the chambers (number of carpels) and cut the length of the ovary (longitudinal section) to see how the seeds

are attached (placentation).

Is the **ovary** inferior (below the flower parts) or superior (arising above the flower parts) or neither?

Appears to be Superior

Drawing of half flower (cut longitudinally).

flowers horizontal away from main stem

petal 1
cap
4
5
3
ovary
pedicel
sepal spur (nearest main stem of plant).

How many **carpels** (chambers) are there 5

Are they free or united? United (Syncarpous)

Are the carpels many seeded or one seeded? Many Seeded

How are the ovules/seeds attached to the ovary/carpels? on central placenta

Drawing of ovary/carpels (cut across), to show placentation (seed attachment).

T.S. internal walls of carpels disappear

remains of stigma
ovary of 5 carpels.
pedicel.

How many **stigmas** are there ? 5

Is the stigma lobed/divided? divided but very short no styles

seeds
placentas. united.

The number of lobes of a stigma often reflects how many carpels (sections in an ovary) there are.

Do the stigmas ripen before the anthers, or at the same time or after the anthers shed their pollen ?

Anthers ripen first. Cap shrivels and gynoecium grows upwards. Cap falls off exposing stigmas. cross-pollination.

Are the **styles** (stalks that attach the stigma to the ovary) non-existent, short, long? Absent.

Any other obvious features? When ripe the capsule explodes to scatter ripe seeds by self-dispersal.

placenta and remains of stigma
seed.
top of capsule

Valves of capsule roll inwards from base to top. Capsule explodes.

remains of androecium cap still covering stigmas.
4
1
5
2
3
ovary (gynoecium growing) Older Flower

Oldest flower
4
5
1
2
3
gynoecium with 5 stigmas. androecium cap fallen off.

The names of the main types of inflorescences are no longer commonly used but may be useful for making you aware that they are recognizably different arrangements. If all else fails, the names may help in quizzes. At times, the type of inflorescence may not be clear cut; don't despair, just draw what you observe from a position of knowledge of the main arrangements.

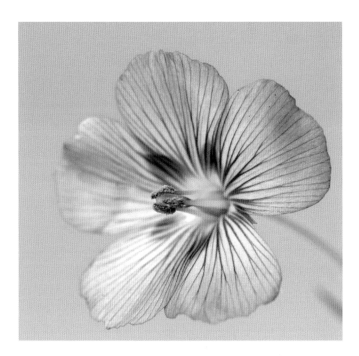

Actinomorphic flax flower.

Zygomorphic broom – pea-flower petal arrangement.

LESS OBVIOUS SPIKES OF FLOWERS

In many trees the spikes of flowers are segregated into either male or female catkins which, being wind pollinated, can dangle joyously free to shed or catch pollen.

Hazel catkins (male).

In the arum and flamingo flowers, the central spike is of tightly packed 'insignificant' male and female flowers and is called a *spadix*. It is surrounded by one large bract called the *spathe*. In this case we only grow it for the bract, which is often showy and colourful.

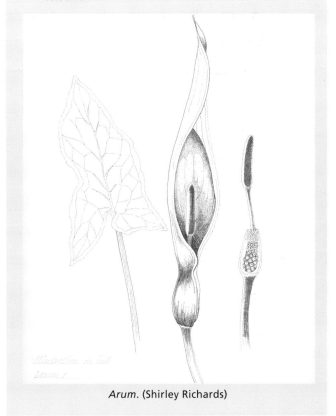

Arum. (Shirley Richards)

Solitary windflower. (*Anemone blanda*)

Umbel, primrose x cowslip hybrid.

RACEME

A *raceme* is a strong upright stem (peduncle) with single-stalked flowers arising from the 'arm-pit' (*axil*) of a leaf-like bract. The oldest flowers that open first are at the bottom and the youngest at the top, e.g. bluebell, foxglove, delphinium, Aaron's rod, snapdragon. Some plants have *branched racemes* (*panicles*) e.g. many of the grasses, and yucca. Here the axils of the bracts give rise to further racemes.

SPIKE

A *spike* is similar to a raceme but differs in that the flowers do not have stalks (pedicels) as the flowers are borne directly on the main stalk, in the axil of a bract, e.g. plantain, agrimony, and early purple orchid.

CORYMB

Corymbs are similar to racemes but the flower stalks are longest at the bottom and get progressively shorter – consequently the flowers are held in a 'plate-like' mass (rather than a spire) which is more showy and attractive to insects than each individual flower, e.g. candytuft. As the seeds develop the corymb often lengthens back into a typical raceme.

UMBEL

In an *umbel* the flowers are also massed on the same level but the flower stalks all arise from the same point – at the tip of the flower stalk (peduncle). The stalks are like the spokes of an umbrella! The youngest flowers are in the centre of the umbel,

Corymb, *Alyssum*.

Compound umbel, cow parsley.

Argyranthemum daisy – flowering head with central disc and outer ray florets.

Cardoon thistle with all disc florets and bee pollinating.

e.g. cherry, cowslip.

Some plants have *compound umbels*, where the umbel flower stalks each give rise to more stalks and another umbel of flowers. This is a very common arrangement and characterizes the family Umbelliferae, e.g. cow parsley, fennel, carrot, parsley, dill, angelica.

CAPITULUM

In a *capitulum* the free tip of the flower stalk (the receptacle) is very broad and flattened to form a platform where many reduced flowers are collected together in a 'head' – often being initially confused as one large flower, e.g. daisy, globe artichoke. The many bracts collect together around the outside of the flower head and are known as an involucre of bracts (not to be confused with sepals). This arrangement is specific to the Compositae, which is a huge family of plants including chrysanthemum, dandelion, sunflower, thistle, yarrow, aster, daisy bush, knapweed and cornflower.

The flowers are often strap- or tongue-shaped (ligulate) and called *ray florets*; other flowers are tubular and called *disc florets*. In thistles the flower heads are entirely made up of disc florets,

MORE ABOUT FLORETS

The sepals (calyx) are often reduced to a hairy tuft (pappus) which comes into its own at seed dispersal by helping the dry, ripe ovaries enclosing the seeds to fly in the wind like mini-parachutes, e.g. when you blow a dandelion clock. The florets may be sterile, single-sexed or hermaphrodite with both male stamens and female carpels – ovary, style and stigma. The anthers are often united into a tube through which the style and stigmas push as they ripen and mature.

Cyme, forget-me-not.

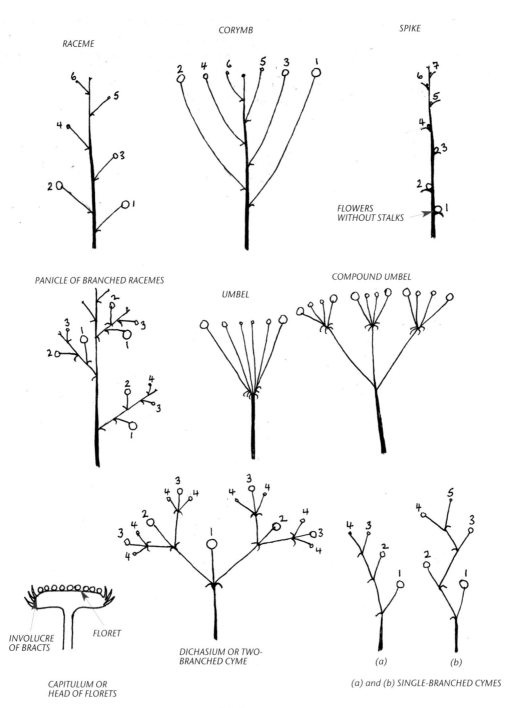

RACEME

CORYMB

SPIKE

FLOWERS WITHOUT STALKS

PANICLE OF BRANCHED RACEMES

UMBEL

COMPOUND UMBEL

INVOLUCRE OF BRACTS

FLORET

CAPITULUM OR HEAD OF FLORETS

DICHASIUM OR TWO-BRANCHED CYME

(a) (b)

(a) and (b) SINGLE-BRANCHED CYMES

Types of inflorescences.

whilst in the dandelion and lettuce flower heads there are only ray florets. In daisies, sunflowers and chamomile, there are ray florets round the outside and disc florets on the inside.

CYME

A *cyme* is an inflorescence characterized by the fact that the flower stops the growth of a stem so side-buds develop from the base of the original flower stalk (pedicel) and produce flowers, then new side-buds grow at the bases of their pedicels, and so on. Cymes may appear similar to some of the other inflorescence types – the difference is in the sequence that the flowers develop.

There are several sorts of cymose inflorescences, depending

on how many side branches develop and how they are arranged. Two-branched cymes (*dichasia*) are found in chickweed, campion, stitchwort and baby's breath. One-branched cymes (*monochasia*) occur as one of two variations of this sort of cyme depending on the arrangement of the flowers: where the new side branches (flowers) are all on the same side of the stem (e.g. in the forget-me-not); and where the new side branches alternate from side to side (e.g. in the buttercup).

MONOCOTYLEDONS

The following groups of monocotyledonous plants – the grasses, rushes and sedges – are examples of those with wind-pollinated flowers which are very reduced in form, so much so that the flower parts are often unrecognizable as petals and sepals and therefore have their own terminology.

LEFT: Wild daffodils. (Liz Leech)

Grass plants and flowers

Grasses belong to the family Graminae, one of the largest families of flowering plants, occurring in almost all areas of the world. They dominate the landscape in temperate regions (such as the British Isles) in areas where the forests have been felled for agriculture, and in the far north (in Iceland, for example) above the tree-line. There are over 10,000 species of grasses and many of them are of great importance as subsistence crops, fodder and building materials, such as bamboo.

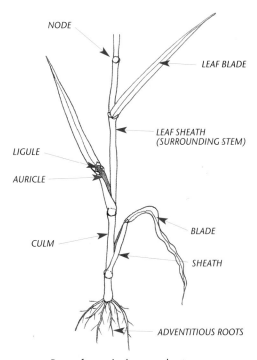

Part of a typical grass plant.

Identifying grasses can be a daunting task as few people, except botanists and horticulturalists, bother to look at them closely. In fact many reject the whole notion of there being many different grasses in a sward and prefer to label it all 'grass'. (Structural garden grasses, which are currently so fashionable, are the exception, and often vary markedly in size and foliage colour.) The problem of identification is exacerbated in that the flowers are much reduced and tiny, some of the parts have been given specialized names, and the inflorescences or flowering-heads initially look more complex than they really are. However, grasses can also be identified by vegetative features such as their stems and leaves, so ensure that you collect a representative bit of the whole plant and have a good hand-lens or dissecting microscope at the ready.

At the base of the plant stem are the fibrous roots that anchor the plant in the soil. The main growing point is at the base of the plant, just above the roots. This allows grasses to be mown or grazed without the growing point being damaged, unlike many plants of other families where the growing points are at the tip (*apical*) and removed by mowing or grazing so that the plant becomes stunted or dies. The way a grass grows may differ depending on whether it is an *annual* or a *perennial*. In annual grasses, most shoots bear flowers. In perennial grasses there are more vegetative shoots than flowering ones and there are different types of growth forms. Tufts are formed when the shoots grow either through the bases of their surrounding leaf-sheaths or grow up within their enclosing leaf-sheath. Mat-forming grasses grow over the surface of the soil using elongated, creeping stems called *stolons* (as in creeping bent grass) or underground stems called *rhizomes* (as in couch grass – the bane of many gardeners).

The flowering stem (*culm*) is usually made up of obvious, solid joints called nodes, which allow the stem to grow and thus bend towards the light; and hollow, tube-like *internodes*, which link the nodes. The ultimate culms that last for many years are exemplified by the bamboo. Leaves are arranged alternately, in two rows, and arise from the basal stem or from the nodes of the flowering stalk. The leaves consist of a cylindrical sheath, which encircles the stem, and an upper leaf-blade which may be flattened, folded along the vein, inrolled or almost solid. At the junction of the sheath and the blade there may be a species-specific, characteristic membrane (*ligule*) sticking-up, or hairs, or these may be absent (although this is rare) – these features are more clearly seen if you gently pull on the leaf-blade to detach the top of the sheath from its grip on the stalk. Additionally some species have thickened 'ear-like' projections (*auricles*) on each side of the base of the leaf-blade. The leaf-blades are long and narrow and taper to a pointed or blunt tip, or may be keel-tipped as in the meadow grasses.

Grass flowering stalks are usually relatively long, compared to the vegetative growth, and bear the flowers at their tips in flower-heads. The flower-heads are very varied in shape: they may be racemes, spikes or panicles, symmetrical or asymmetrical, and differing in size and in how closely or loosely packed the flowers are.

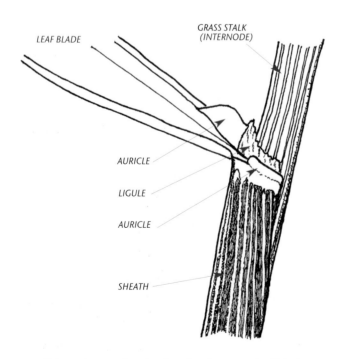

False oat grass showing junction between leaf blade and leaf sheath.

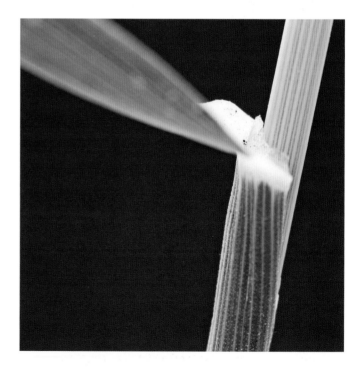

False oat grass – ligule and auricles.

False oat grass panicle inflorescence.

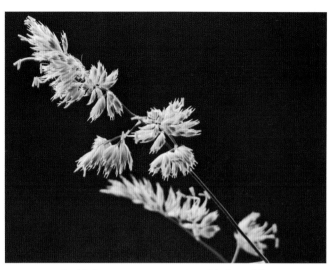

Cock's foot grass – erect one-sided panicle.

The arrangement of the flowers is similar within a genus and this helps to identify the grasses belonging to it. Most grass flowers are bisexual but there are exceptions. Maize or sweet-corn has distinct male flowers in a panicle at the tip of the stalk and spikes of female flowers growing from the axils of the leaf sheaths – recognizable by the tasselled stigmas protruding from the tip, for pollination, before they develop into the fruiting corn cob. In the pampas grass the flowers are unisexual and grow on separate plants. There are also exceptions within a flower-head of some species, where flowers may be male, female or barren, whilst the majority are bisexual.

The flowers are found in *spikelets*, the units making up the flowering-head. Whilst immature, these spikelets are surrounded by two scale-like bracts called the *glumes*. When mature, these glumes part to reveal the similarly scale-like flowers, one to many, on a thin stalk or *rachilla* in the spikelet. Each flower or

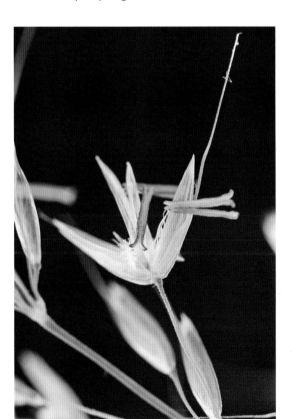

False oat grass spikelets of two florets.

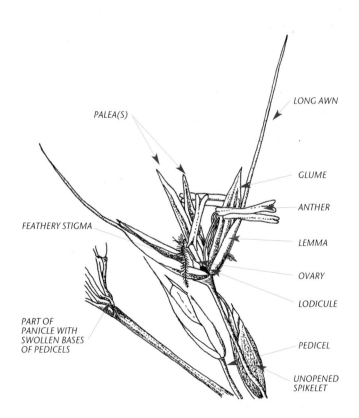

False oat grass spikelets of two florets.

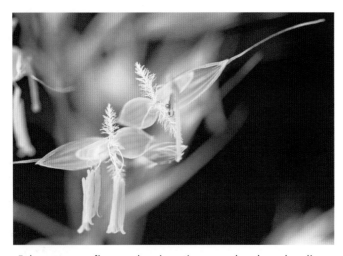

False oat grass flowers showing stigmas and anthers dangling.

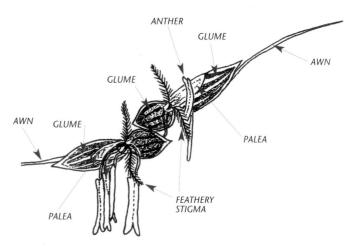

False oat flowers, from above.

floret consists of two more bracts – the lower lemma and the upper *palea* – which enclose the rest of the flower, reduced to three parts: the two *lodicules*; the stamens with large anthers; and the female ovary with its style and stigmas. The lodicules are scale-like and to one side of the ovary. On a dry day, with a high pollen weather forecast, and when the florets are mature, the base of the lodicules swells and forces the lemma and palea apart to expose the reproductive parts of the floret. The stamen filaments grow really quickly so that the anthers dangle outside the floret and split to shed their pollen into the dry air – hopefully to be carried to a female stigma. Meanwhile, the feathery stigmas lengthen and spread apart so that one dangles on each side of the floret.

After pollination, the stamens and stigmas wither, the lodicules shrivel and so the palea and lemma close around the developing ovary. The ripe fruits are known as grains and remain surrounded by the palea and lemma. The lemma often becomes modified to help with seed dispersal and its *mid-rib* may extend outwards, somewhere along its length, to form a bristle or *awn*. Awns can be straight or bent or partially twisted. In some species, uneven drying of the awn may cause the dormant seed to be literally bored down into the ground. The presence or absence of many features of the glumes and lemmas may be characteristic for the species of grass and helpful for identification. The features may include comparative size, hairs or bristles, veins, shape, thickness, teeth and so on.

There are not many groups of plants that can be confused with the grasses, except possibly some belonging to the sedge or rush families, which may also be found growing amongst the grasses. For this reason, a brief description of sedge, and then rush, characteristics will be given here.

The sedge family

Sedges, the Cyperaceae, are a smaller family than the grasses and are usually found in damp areas, although some occupy more aquatic habitats. The plants form *tussocks* or mats by producing aerial, upright shoots from underground stems called rhizomes.

The stems, unlike those of grasses, usually have solid internodes, although in some species the internode tissue is spongy and in rare instances it is hollow. The stems of most sedges are triangular in cross section and the leaves are therefore produced in three ranks – looking down on a plant, such as a *Carex* species, this is often easy to see and gives a real clue that it is very probably a sedge and not a grass. The leaves are sheathed, in their lower parts, and some are reduced to sheaths alone (without leaf-blades). The colour and texture of the sheaths are

Harvested rice grains, Yunnan, China.

Papyrus plants.

diagnostic for different species and cannot be ignored when painting sedges. Where the blades meet the sheath is a thin, colourless inner face which may be concave, straight or extended into a ligule.

Sedge ligules differ from those found in grasses, in that they are fused to the leaf-blade for most of their length. The leaf-blades are long and narrow and grass-like and often flattened – look at the leaves on a flowering stalk for the most typical examples, as those near the base of the plant may be short or non-existent. Some leaf-blades have specific shapes in cross-section; some are in-rolled, keel-shaped or folded. Teeth and hairs may be lost from older leaves so are best checked for on younger leaves or near the junction of sheath and blade.

The flowers are also very reduced and form inflorescences called spikelets, which may contain anything from one to many flowers. These spikelets may be grouped together into cyme-, panicle- or raceme-type branched inflorescences, or into spikes, or spikelets, which may be borne terminally or may even be solitary.

Carex, sedge flowers.

The flowers are either unisexual or bisexual and occur in the axils of a small bract or glume, if bracts occur in that particular type of sedge. Many have no bracts. Flower perianth parts (reduced sepals and petals) are often represented by scales or hairs or are absent completely. The male stamens are well developed, distinct and free with basifixed anthers. There are usually two to three stamens but the number often varies between one and six, or sometimes up to twenty-two. The superior ovary usually has a single space containing the ovules, whilst there may be two or three styles with two or three stigmas on each. (The number of stigmas may vary between one and fifteen.) In *Carex* species, the ovary is enclosed in a bottle-shaped structure, the *perigynium*, from which the stigmas protrude.

The fruits are usually dry, one-seeded and *achene*-like, and are *indehiscent* (not opening to release its seeds). They may be rounded, lens-shaped (biconvex) or triangular.

Not all members of this family are commonly known as sedges: cotton-grass, spike-rushes, club-rushes, bog-rush, and papyrus are all included, to name but a few. However, these are also not to be confused with members of the grass or rush families, despite their common names. They all share typical sedge family characteristics.

Rush – *Juncus acutiflorus* showing sheathing leaf bases, rhizome and rounded leaf blade.

The rush family

The rush family (Juncaceae) is a small family of monocotyledonous plants that may sometimes be confused with grasses. The rushes frequently grow in damp or aquatic conditions and can occur in arctic, temperate or tropical mountain habitats. The majority of them are perennials and are often very resilient plants whose spread is hard to control once they have started a take-over bid in a damp pasture. Their ecological range also includes sand-dune and saltmarsh habitats.

The perennial plants are usually tuft-forming and often have rhizomes. The leaves are evergreen and arise alternately, usually in three rows, but may be in two rows in some members of the family; however, unlike the sedges, the stem is not triangular and the rows are less clear initially. The leaves may have sheathing bases. The leaf-blades are long and narrow and may be round in cross-section, with pointed tips, or may be rolled, or channelled, or flattened. In *Juncus* species the blades are smooth, whilst in the woodrushes (*Luzula*) the margins of the

Rush – *Juncus effusus* showing sheathed bases and cylindrical leaves and flower stalks.

Rush – *Juncus acutiflorus* inflorescence and showing partitions in the pith of the dried leaf.

Rush – *Juncus acutiflorus* fruit capsules and remains of brown perianth parts of flowers.

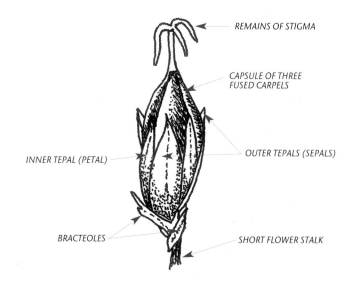

REMAINS OF STIGMA

CAPSULE OF THREE FUSED CARPELS

INNER TEPAL (PETAL)

OUTER TEPALS (SEPALS)

BRACTEOLES

SHORT FLOWER STALK

Rush – *Juncus acutiflorus* developing fruit capsule and remains of flower.

leaves are obviously hairy.

The flowers are reduced but, unlike the grasses and sedges, have a perianth of three or six parts organized into one or two whorls, and are more easily understood. Most of the flowers have male and female parts. There are usually six stamens but some members of the family have two to three. The stamen's anthers are basifixed but are stiff and unmoving compared to those of the other two families. The female ovary, of three carpels, has either one or three spaces (*loculi*) inside and is superior. There are three brush-like stigmas designed to catch pollen as it blows past. The fruit is non-fleshy and usually takes the form of a dehiscing capsule, although some species have indehiscent capsules. The flowers may be few to many and are grouped in inflorescences – cymes, heads or corymbs.

These three families of plants are monocotyledons but differ from those monocotyledonous plants with colourful, showy flowers because they are wind-pollinated. (An example of a wind-pollinated, dicotyledonous plant is the plantain (*Plantago*), where the flower petals and sepals are much reduced and the stamens hang outside the flower when ripe. Other common examples are found amongst those plants or trees that bear catkins, see Chapter 8.)

Recognizing wind-pollinated plants

Plants that rely on the wind to transfer their pollen, from the anther of one flower to the stigma of another, have adopted a rather wasteful method as they have to produce copious

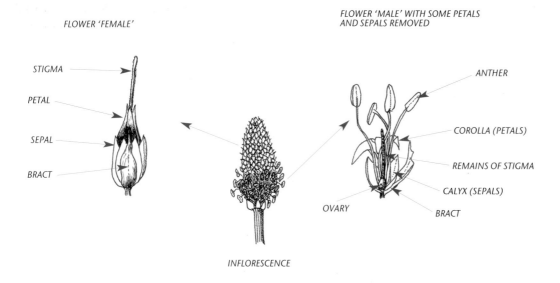

FLOWER 'FEMALE'

FLOWER 'MALE' WITH SOME PETALS AND SEPALS REMOVED

STIGMA

PETAL

SEPAL

BRACT

ANTHER

COROLLA (PETALS)

REMAINS OF STIGMA

CALYX (SEPALS)

OVARY

BRACT

INFLORESCENCE

Ribwort plantain inflorescence and flowers.

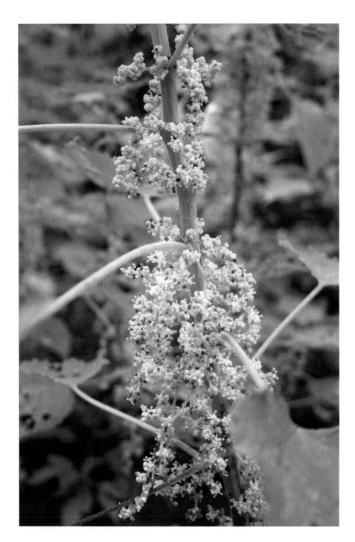

Nettle catkins, Lijiang, China.

amounts of pollen to ensure that a pollen grain reaches its target (in much the same way as fish and frogs are obliged to produce thousands of eggs and sperm to ensure that some meet in the surrounding water). In the case of animals, this waste-problem has been largely overcome by the development of internal fertilization mechanisms which have reached their peak in mammals. In plants, there is less wastage inherent in insect pollination mechanisms, but wind-pollinated species have developed various adaptations and strategies to ensure they have the best chance of effecting pollination.

Bearing flowers on a long stalk, above the main leafy plant, like the grasses, rushes and sedges, and plants such as plantains, ensures that less pollen is trapped by the leaves before it can travel far in the wind or be caught by a waiting stigma. Many trees and stinging nettles have adopted a similar strategy in that they bear their flowers in long, dangly catkins which launch the pollen away from the leaves to be trapped by a stigma of a female flower. Many deciduous trees produce their catkins before their leaves to further assist this.

The anthers are usually long and loosely fixed to the stamen stalk so that they shake the pollen grains out into the air. Many stamens are common and the anthers produce vast numbers of usually light, dry pollen grains. Some grains even have adaptations, such as wings or balloon-like structures, to help them to fly.

The flower parts, such as sepals and petals, are often severely reduced in number, size and shape and there is no need for them to be showy as the wind and air currents are incapable of attraction – they are therefore usually non-descript or drab. The stigmas, however, are usually long with lots of outgrowths, making them brush-like or hairy, and protrude outside the rest of the flower.

Wind pollination may ensure that the pollen falls on the stigma of another flower in cross-pollination, but equally may deposit the pollen onto the stigma of the same flower in self-pollination. Some plants have devised strategies to ensure that cross-pollination (out-breeding) occurs by ensuring that the male and female parts ripen at different times. The plantain has adopted this method: the lowest flowers of the spike open first in a female stage and have ripe stigmas.

Other flowers then open as female stages successively up the spike. As the lower stigmas shrivel, so the flowers enter the male state and the stamens protrude and shed their pollen; again this moves successively up the flower spike. The flowers are *protogynous*, as the female parts ripen first, and many of the grasses, sedges and rushes belong to this group. In flowers where the male parts ripen first, such as the ivy and harebell, the plant is known as *protandrous*.

These methods differ from the strategy in the primrose, where different arrangements of the flower parts in different flowers, thrum-eyed and pin-eyed, ensures self- or cross-pollination respectively (*see* Chapter 2).

Plantain spike. Female flowers with stigma open first, from bottom up, followed by male parts of flowers.

Campanula with ripe stigma and withered stamens.

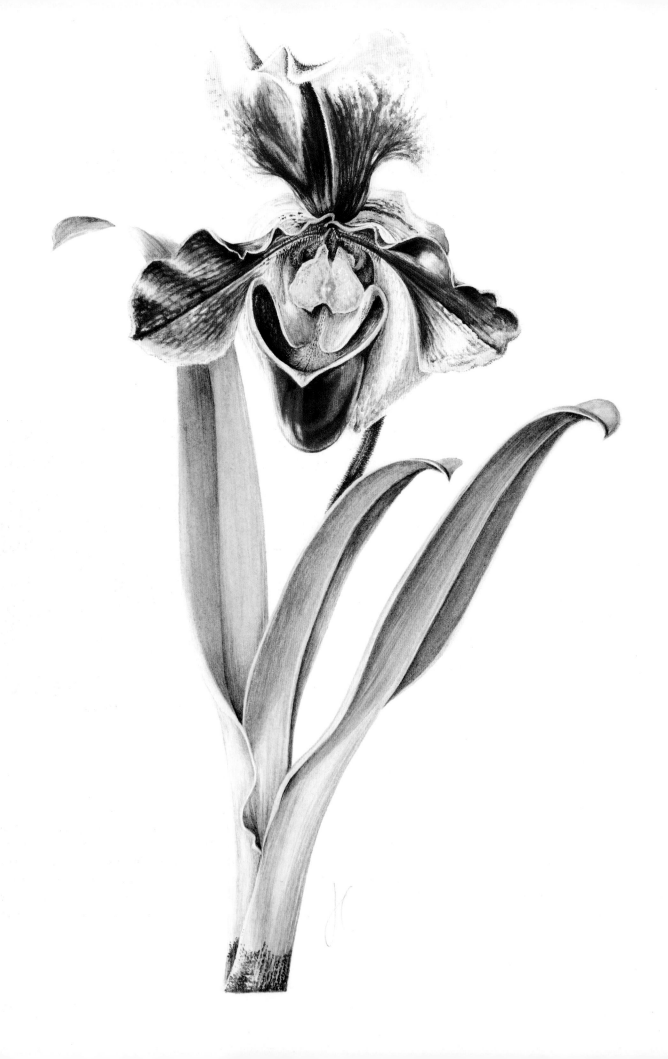

SOME SPECIALIZED FLOWER STRUCTURES

There is no botanical justification for grouping these plants together in a chapter. However, they give an insight into some of the more obvious oddities that you may come across, and represent large groups of flowering plants which make very attractive subjects for painting.

Orchids

British orchids are all terrestrial, i.e. they grow in the earth. Many tropical orchids of the rainforests are *epiphytic*, as they grow on other plants, festooning the upper trunks and branches where they can get sufficient light for *photosynthesis* and are better able to attract pollinators. Other orchids, like the rare coral-root orchid, are parasitic on *saprophytic* soil fungi that live on dead and decaying plant material which they use as a source of food and minerals. In these cases the orchid forms a *mycorrhiza* with the fungus, and their leaves are usually reduced to scale leaves and the plants lack green pigment.

Orchids can only really be recognized by their flower structure which is typical, regardless of shape, colour and size. The three sepals and three petals constitute a perianth where the parts are more or less like petals. However, the central 'petal' of the inner whorl is modified so that it is generally larger and a different shape, often with a nectar-containing spur. This petal is called the lip or *labellum* and is usually on the lower part of the flower, as the inferior ovary or the flower-stalk twists the flower through 180° as the flower develops. The flowers can be cut in

Dendrobium orchid showing lip.

only one place to give two identical half-flowers, so they are all zygomorphic.

From the centre of the flower there arises an obvious, distinctive *column*, which bears the stamens and stigmas at its free end. This column is made up of the male and female parts of the plant and is typical of orchids. The male anthers are usually club-shaped waxy or granular yellow masses, the *pollinia*, which may have a stalk-like structure at the end where they are attached to the column. The female stigmas are also found on

LEFT: *Paphiopedilum* orchid. (Jackie Copeman)

Cymbidium orchid, Lijang, China.

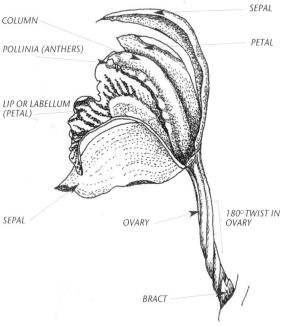

SEPAL

COLUMN

POLLINIA (ANTHERS)

PETAL

LIP OR LABELLUM
(PETAL)

SEPAL

OVARY

180° TWIST IN
OVARY

BRACT

Cymbidium orchid half flower.

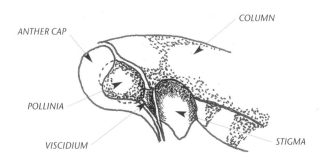

COLUMN

ANTHER CAP

POLLINIA

VISCIDIUM

STIGMA

Cymbidium orchid column detail.

the column and are usually seen as two to three shiny, moist surfaces close to the yellow pollen-bearing pollinia. In some orchids, one of the stigmas is sterile and forms a beak-like structure (*rostellum*) between the anthers and the fertile stigmas.

All the different shapes, designs, colours and patterns of various orchid flowers have evolved to attract their own pollinator, which has often even evolved in tandem with the flower. They are amongst the most highly developed groups of plants with highly sophisticated and complex means of pollination; these rely on colour, mimicry, scent and structures developed to aid or even capture the appropriate pollinator whilst discouraging inappropriate 'visitors'. Their extreme sophistication leaves them vulnerable should their chosen species of pollinator become scarce or extinct – hence the importance in saving sufficient tracts of the rainforests and other disappearing habitats.

The flowers are borne singly, or in groups forming inflorescences. The ovaries are inferior with one cavity (cell), which forms a capsule containing the very minute and dust-like seeds. (A common example of an orchid's capsule full of seeds is a vanilla pod.) The seeds are very difficult and slow to *propagate* as they need to form fungal mycorrhizas to provide nutrients for the seedling, so the majority of orchid plants for sale have been grown by *tissue culture* – where either the seeds are grown on nutrient jelly or small groups of cells are divided and grown into small plantlets in nutrient jelly, in a laboratory. Orchid plants can also be propagated from cuttings, splitting the plants, and from old *pseudobulbs* (*see* below).

Orchids are monocotyledonous plants with parallel-veined leaves that usually grow alternately up the stem. Very rarely the leaves may be in pairs growing opposite each other or in whorls. Leaves vary depending on the original habitat of the plant – they may also be leathery, *membranous*, fleshy, 'normal' and of widely ranging shapes, although the leaf-blade margins are usually smooth or 'entire'. Leaf-sheaths are tubular and the leaf-blades are often jointed at their bases.

In most British native, terrestrial orchids the leaves die down over winter and re-grow the following spring. These orchids have underground tubers to sustain them over the winter. In less temperate countries, many orchids survive the dry season in this fashion.

Other orchids have different ways of growing, depending on their type. Most cultivated orchids are *sympodial* and grow sideways and have rooting, underground storage stems called rhizomes. From the tip of the rhizome, upright leaves, and a flowering stalk with a characteristic swollen pseudobulb develop.

These pseudobulbs store water to help the plant survive in times of drought. Old pseudobulbs lose their crown of leaves but remain on the plant for a considerable time while their resources are used up. They are then replaced by a new shoot growing from the rhizome. In some instances, such as in the bamboo (*Dendrobium*) orchids, the pseudobulbs are cane-like

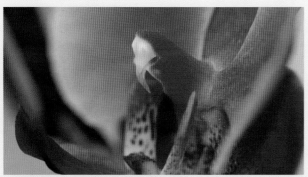

Phaelonopsis column with anther cap and viscidium.

Phaelonopsis showing anther cap and pollinia beneath.

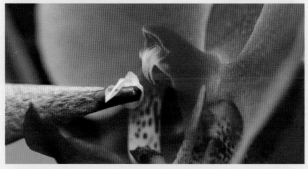

Phaelonopsis with viscidium and pollinia in cap stuck to 'pollinator' pencil.

Phaelonopsis showing pollinia in anther cap stuck to 'pollinator' pencil.

Phaelonopsis column showing notch over stigma that catches pollinia as pollinator enters flower.

Phaelonopsis with pollinia exposed and bending into position while stuck on 'pollinator'.

Phaelonopsis pollinia nearing stigma.

Phaelonopsis pollinia caught by hook over stigma and pollination of the hidden stigmatic surface occurs.

Stages leading to pollination of a typical orchid flower.

Pleione terrestrial orchid plants.

Dendrobium – bamboo-type stem and sheathing leaves.

Orchid plant with pseudobulb and new shoot.

Phaelonopsis orchid showing monopodial growth form and aerial roots.

and upright and very distinctive.

Some orchids, such as the moth orchid (*Phaelonopsis*) and the vanilla orchid, have an upright, *monopodial* growth habit and the stem grows for several years. Thick, pale, aerial roots with green tips and flowering stems arise from between the leaves.

The aerial roots can pick up water from the humid atmosphere around the plant, and store it in the pale outer layer of large, loosely packed cells. This is an adaptation to their epiphytic growth on the surface of the bark on forest trees.

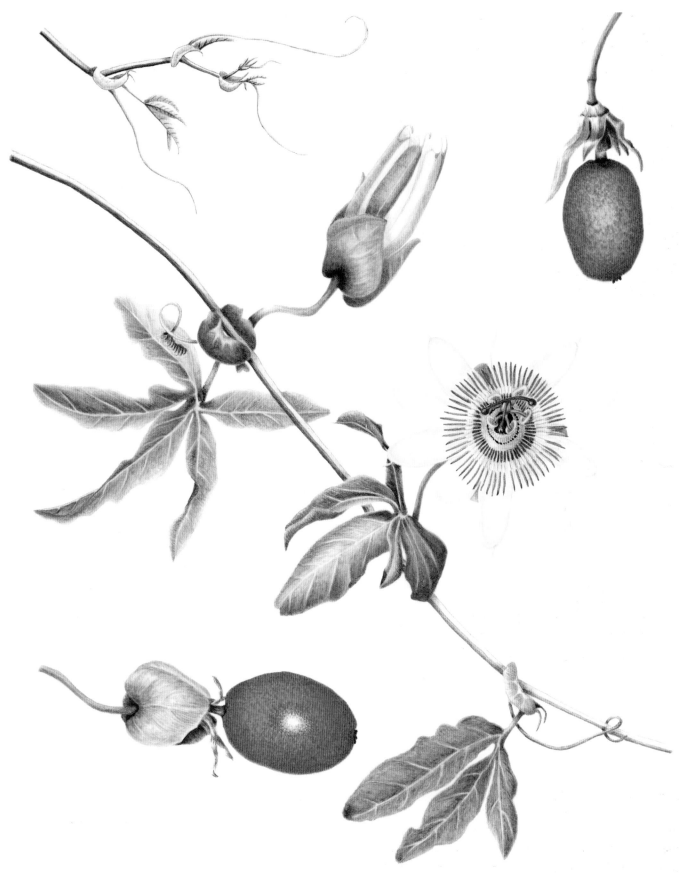

Passiflora caerulea – Passion flower. (Liz Leech)

Passionflowers

These flowers, belonging to the genus *Passiflora*, were original-ly found in Australasia and in the Americas but were absent from Africa and Europe. However, they have now been introduced, cultivated and naturalized in other parts of the world – the blue passionflower is now often found burgeoning in many gardens in southern Britain although it is not entirely hardy.

The passionflower gained its popular name from its charac-teristic structure, which has been likened to aspects of Jesus' crucifixion – the crown of thorns, three nails, and the five wounds. In other parts of the world the flowers have been linked to other images such as a clock-face or other types of reli-gious symbolism.

The flowers are usually large and colourful and may occur singly or in cyme-, or raceme-like inflorescences arising from the axils of leaves, where the leaf-stalk meets the stem. Just below the flower there may be three green bracts that form a ring (*involucre*) which you may be tempted to confuse with sepals, as they appear to protect the flower parts when they are in the bud. In other species these bracts may be absent or minute, or leaf-like or glandular. The sepals and petals are borne on a ring-like, cup-shaped structure (similar to those in roses and cher-ries). The five sepals are often petaloid and may have projecting 'prongs' arising from the outer surface, just below the tip. The petals are usually five in number and are generally more colour-ful than the sepals. From the surface of the ring-like perianth structure, there arises a ring (or rings) of extension tubes or fil-aments that make up the *corona* – similar to the trumpet of a daffodil. The innermost ring of the corona is membranous and hides the nectaries at the base of the central flower structure. These flowers attract a wide range of animal pollinators ranging from hummingbirds and bats, to various insects.

In the centre of the flower is the structure called the *androg-ynophore*, which is unique to passionflowers. It is made up of the stamens (male) and carpels (female) and usually stands proud from the rest of the flower. The five, or rarely four to eight, stamens form a ring around the extended base of the ovary and branch out in a ring below the ovary. The free anthers are dorsifixed and usually very large. The ovary usually has three (or up to five) styles that radiate outwards like the spokes of a wheel and end in knob-like stigmas. The ripe ovary usually forms a large berry (or a capsule) with many seeds surrounded by fleshy *arils*. These berries or passion fruits are edible and some are of commercial importance.

To return to the Christian symbolism of the flower, the coro-na filaments are likened to the crown of thorns; the five stamens represent the five wounds; and the three stigmas represent the three nails. This symbolism was used by missionaries when teaching about Calvary, in much the same way as the early American settlers used the flowers of the dogwood tree.

The passionflower's climbing plants are usually vines or *lianes* with variously shaped leaves which have leaf-stalks or *petioles*, and may have *stipules* where the leaf-stalk attaches to the main stem. Tendrils are usually found growing out of the axil of a leaf and assist the plant in its scramble upwards towards the light. Other features to look out for are nectaries on the leaf-stalk or leaf-blade – the purpose of these is to attract ants to protect the plant from unwelcome animals wanting to make a meal of its leaves.

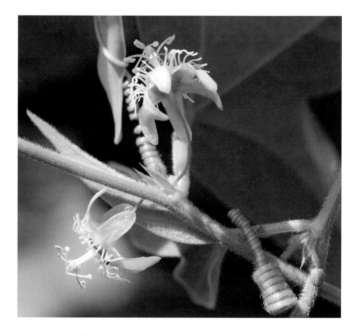

Passiflora suberosa flowers showing detail.

Passiflora suberosa showing flowers, tendrils and stipules at node.

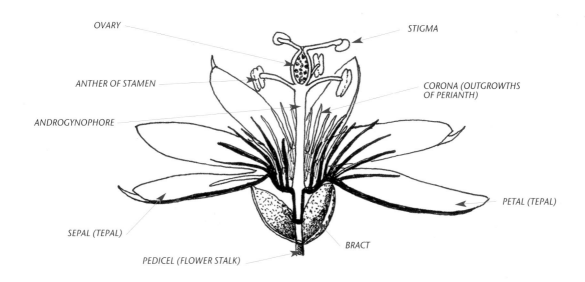

OVARY

STIGMA

ANTHER OF STAMEN

CORONA (OUTGROWTHS OF PERIANTH)

ANDROGYNOPHORE

PETAL (TEPAL)

SEPAL (TEPAL)

BRACT

PEDICEL (FLOWER STALK)

Passion flower half flower.

Spurges

These plants belong to one of the largest plant families, the Euphorbiaceae. However, this description will be confined only to the members of the *Euphorbia* genus. These plants all produce a milky white *latex*, which is poisonous and to which many people are allergic, so handle these plants with care.

These plants are a good example of why you should use the flowers for classification purposes as they vary from cactus-like plants that are spiny and lose all their leaves in dry periods (such as *E. splendens*, the crown of thorns plant) to those big tropical plants that have large leaves and are very showy, such as the poinsettia, *E. pulcherrima*, which is so popular at Christmas.

The European species are less exotic in colouration but still manage to attract attention with a vivid range of greens and yellows. In all these cases the attractive part of the plant is due to leafy or modified bracts that surround the typical, very reduced, smaller flowers.

The single-sex flowers are hardly recognizable as such, as they have been drastically reduced to a single upright stamen on a stalk, in the case of the male flowers, to a single unit made up of a stalked ovary of three united carpels with three styles, in the case of the female flowers. These are grouped together, one central female flower surrounded by several male flowers (stamens) in a cup-like structure called a *cyathium*, which is typical

of this genus of plants. The cup-like cyathium often has petal-like appendages and nectary glands which also help to attract pollinators towards the tiny flowers.

Once the stigmas are pollinated the developing ovary extends out of the cyathium, as its stalk elongates, and can be found hanging to one side. The fruit develops into a dry, three-valved capsule or *schizocarp*.

Poinsettia.

The three types of specialized flowers have been treated separately in this chapter as they are seemingly very different in arrangement from the more easily understood and more straightforward arrangements of parts in many other flowers.

Knowledge of a range of 'oddities' should prepare you for any unexpected structures that you may well meet whilst painting a wide range of flowers.

Euphorbia flowers (cyathia) and bracts.

Euphorbia cyathia with displaced ovary.

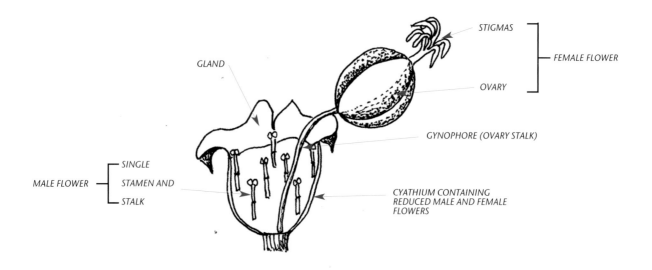

Section through a cyathium to show attachment of flowers.

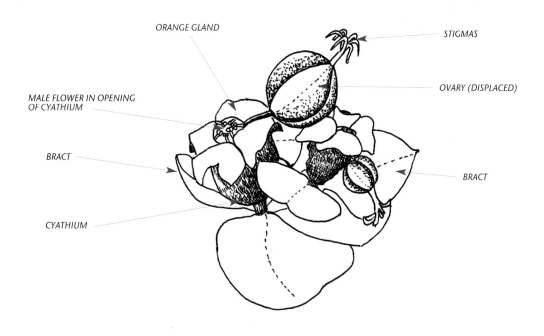

ORANGE GLAND

STIGMAS

OVARY (DISPLACED)

MALE FLOWER IN OPENING
OF CYATHIUM

BRACT

BRACT

CYATHIUM

Euphorbia cyathia with displaced ovary.

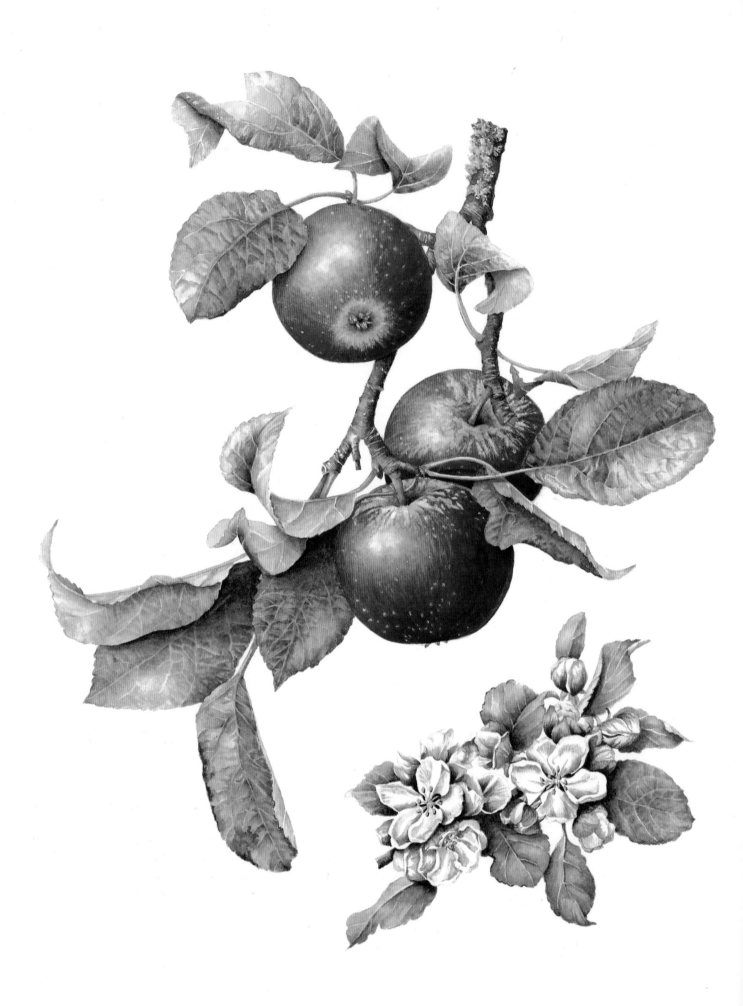

FRUITS AND SEEDS

We must not forget that fruits, and the fertile seeds associated with them, are the reason for a flower's existence and the end result of the successful pollination and fertilization strategies of each flower – the plant's equivalent to sexual intercourse.

What are seeds?

Seeds develop from the fertilized egg cell and the ovule, in the ovary, which surrounds them. The fertilized egg cell forms a 'baby' shoot system called a *plumule*, a 'baby' root called the *radicle*, and one or two seed leaves or *cotyledons*.

The embryo plant also stores food, either in a specialized area, called an *endosperm*, or in the cotyledons. This stored food will sustain the embryo plant until it grows into a self-sufficient plant. All this is then surrounded by a tough seed coat, or testa, which protects the embryo plant from the ravages of disease and from being digested if it is eaten, and the ripe seed then dehydrates and becomes dormant. At this point the 'mother' plant has to scatter or disperse 'her' seeds – just like ensuring that one's children leave the nest.

Sycamore – germinating seedling. (Margaret Hatherley-Champ)

The importance of seed dispersal

Seed dispersal is defined as the scattering or distribution of seeds away from the parent plant. Dispersal is important for two main reasons: firstly, it ensures that overcrowding of the devel-

oping seedlings doesn't occur. Overcrowding would mean that between the sibling seedlings, and also between the seedlings and their parent plant, there would be intense competition for necessities such as water, minerals and light and few, if any,

LEFT: *Malus domestica* 'Discovery' apple. (Beth Phillip)

would survive to flower and seed themselves. Secondly, dispersal is also important to ensure that some seeds may reach other environments, with different soils or growing conditions, as these may prove to be more favourable for the growth of the developing plants and their subsequent survival and future seed production.

Fruits and their shape, related to seed dispersal methods

Some other parts of the withered flower, mainly the ovary or the receptacle, also play their part in the dispersal process by forming 'fruits' that surround the seeds and help to disperse the seeds away from the 'mother' plant. There are several different strategies for efficient seed dispersal, depending on whether they are reliant on wind, water, animal or self-sowing (mechanical) strategies. Each of these strategies depends on the development of different adaptations in the shape and type of the fruit surrounding the ripe seed.

Wind dispersal

Wind dispersal may rely on outgrowths of various kinds, from the fruits or seeds, which greatly increase the surface area and so catch the wind more efficiently, without adding much in weight. This strategy allows the seeds to be flown or floated

away at the whim of dry air currents and breezes. The outgrowths are of two main types: wings and hairs.

WINGS
These fruits are extended into long, thin, wing-like structures called *samaras*. Examples of these fruits are found in ash, which are known as 'keys', and the fruits of elm, birch, maple and

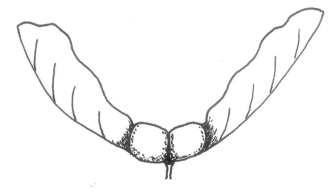

Sycamore 'helicopter' wings.

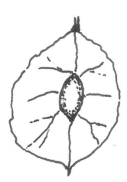

Elm wings.

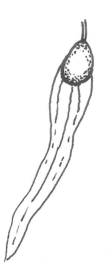

Ash key wings.

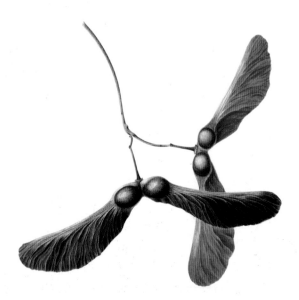

Acer winged seeds. (Annie Patterson)

sycamore, which children commonly call helicopters. Hornbeam, dock and sorrel provide other examples. The winged 'naked seeds' of larch, fir and pines are typical of the non-flowering, cone-bearing plants that use the same strategy (*see* Chapter 9, Conifers).

HAIRS

The fruits of the clematis are plumed with hairy outgrowths, which are persistent styles. Dandelion, thistle, and groundsel fruits have a stalked ring, or pappus, of hairs that derive from

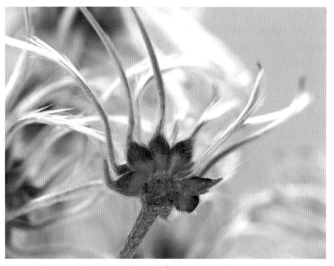

Clematis showing detail of achenes with hairy styles and stigmas.

Clematis, hairy style.

Dandelion, pappus of hairs 'parachute'.

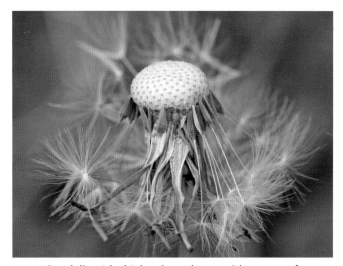

Dandelion 'clock' showing achenes with pappus of hairs on receptacle.

Willowherb fruit capsule releasing hairy seeds.

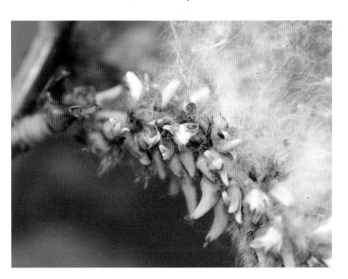

Black poplar fruits opening to show hairy seeds.

the modified sepals or calyx. These hairy appendages act like parachutes. In other plants the dry, mature fruits open to release hairy seeds that 'fly' away on the breeze. Examples of plants using hairy dispersal adaptations include willow, poplar, kapok, cotton and willow-herb.

Other wind-dispersal mechanisms, relying on the wind but not on an increase in surface area, are known as *censer*, or 'pepper pot' mechanisms. In these plants, the fruit develops as a

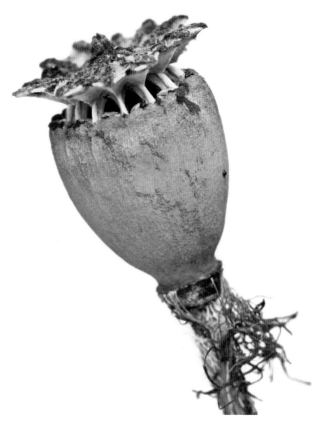

Poppy capsule with pores beneath stigmas.

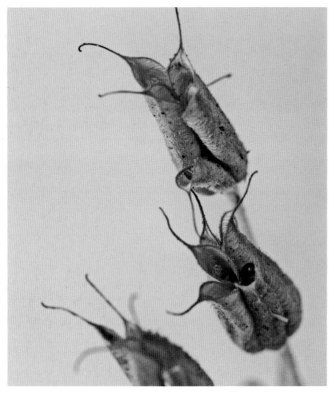

Aquilegia – ripe follicles with seeds.

Scarlet pimpernel capsule.

capsule which is held, above the plant's leaves, on a long stalk that sways about easily and helps to shake or flick the seeds out. When ripe the capsule opens and the seeds are dispersed. Examples of plants using this mechanism are the poppy, harebell (*Campanula*), campion, primrose, pimpernel, monkshood, larkspur, columbine (*Aquilegia*), and marsh marigolds, to name but a few.

In the case of yellow rattle (*Rhinanthus*), the scattered seeds are also winged, by extensions of the seed coat, for further dispersal by wind when they leave the capsule.

Water dispersal

This is the least common method of seed dispersal in which the seed or fruit acts like a nautical life-jacket. This strategy relies on seeds or fruits being adapted to contain trapped air so that they float for long enough to be moved by water currents.

Coconut palms produce a large coconut fruit (which is not really a nut), which is waterproof on the outside. It then has a thick, fibrous, air-containing layer (coir, commonly used in doormats), which gives it buoyancy so that the 'nut' is transported by ocean currents to another island beach.

Closer to home, the seeds of alder float, as do the fruits of the

yellow water-lily. In these cases the berry splits up into floating seeds which have air-trapping, slimy, seed coats. The white water-lily berry splits to release seeds that float because of a spongy air-containing mass of tissue called an aril.

Animal dispersal

There are two main types of fruit dispersal mechanisms that plants have developed as adaptations in order to use animals as the disseminators of their seeds. One mechanism relies on producing conspicuous, fleshy, often succulent, fruits which are eaten by the animal. The other mechanism relies on producing hooked fruits that attach to a passing animal and get carried away.

SUCCULENT FRUITS

These attract birds or other animals when they ripen. The pulpy, juicy part of the fruit is usually protected on the outside from microbe- or insect-damage by having a waxy, hairy, unpleasant-tasting, oily, corky, or tough skin, so that the fruit is 'saved' for the larger animal that is destined to disperse its seeds.

The seeds that are in or on these fruits are protected by woody or very tough seed coats. These seeds may remain uneaten and be dropped; or, if they are eaten, the very tough seed coat can resist the animal's digestive juices and protect the 'baby' plant they contain until they re-appear, unharmed, in a 'dollop' of fresh organic fertilizer. Once the seeds have started to *germinate* and grow, this manure then helps the developing plant grow strong and healthy. In some instances plants rely on the seed coat being softened and weakened (*scarified*) by digestive juices, such as those found inside an ostrich, so that the seed

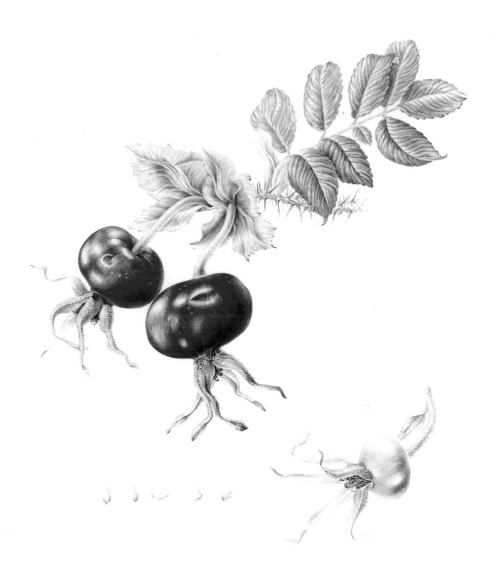

Rosa rugosa hips.
(Annie Patterson)

can germinate more successfully.

Some dry fruits, like those found inside a juicy rosehip, are covered in tough hairs which irritate a bird's mouth and are therefore spat out as it eats the succulent 'hip'. As children we used these hairy fruits very effectively, as a form of itching powder!

Some seeds are very slippery and 'shoot away' when grasped. Examples are apple and orange pips. Other seeds, such as those of mistletoe, are covered in gluey *mucilage*, which sticks the seed to the bird's beak as it consumes the rest of the white berry. The bird then, helpfully, scrapes the sticky seed off onto a branch where the seeds can then develop and grow.

HOOKED FRUITS

These are often dry and uninteresting looking fruits, called *burs*, which have an irritating but very successful strategy of clinging to one's clothes or an animal's fur – from which they have to be removed.

These fruits have developed hooked walls or spikes and attach themselves to the unsuspecting passing animal so they can steal a ride to another place. Examples include many grasses, goosegrass or cleavers, agrimony, avens (*Geum*), houndstongue, and bur marigold. Burdock has a similar strategy but it is each bract of the involucre, surrounding the head of flowers, that becomes hooked so that the whole 'seed head' is carried away.

Hooked fruits

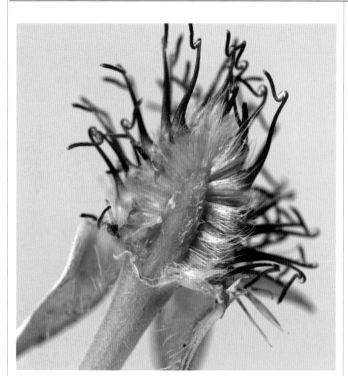

Wood avens – half fruiting head showing achenes with hooked styles.

Goosegrass showing detail of developing fruits with hooks.

Agrimony fruit with hooks.

Goosegrass ripe fruits with hooks.

Mechanical dispersal or self-sowing mechanisms

In this type of dispersal, the fruit, which has developed in-built lines of weakness, becomes dry at unequal rates and therefore under increasing tension until it eventually explodes and shoots the seeds out with some force (i.e. it dehisces). Gorse pods can fling their seeds several metres!

All the pea and bean family have fruits that are pods made up of two halves, and when ripe and dry these separate and twist in an instant. In addition, the seeds of gorse and broom also have fleshy arils full of oils that attract ants which carry the seeds away – even farther still.

The geranium and cranesbill family characteristically has five ovaries at the base of a central column made up of the styles. When dry the styles and ovaries 'flick' outwards from the column and the seeds are shot out – like a stone from a catapult.

Capsules of pansy, violet and the balsams, including Busy Lizzie, split along predetermined lines and 'shoot' the seeds out violently. Just inadvertently touching a ripe capsule 'pod' may give you quite a shock as it explodes.

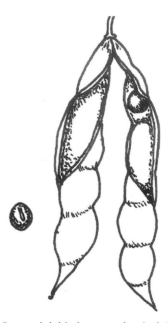

Pea pod dehiscing – mechanical dispersal.

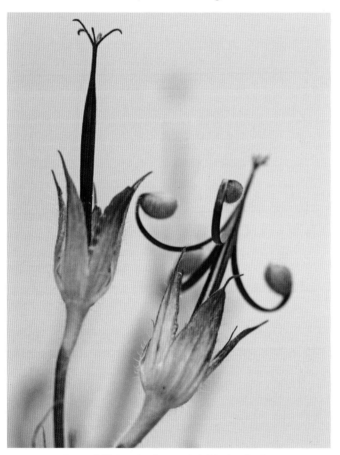

Cranesbill developing and dehiscing fruits.

Geranium.

Vetch pods twist to open – self-dispersal.

Buttercup achenes.

TYPES OF FRUITS

Botanically speaking the term 'fruit' refers to the ripe ovary wall with its enclosed seeds. However, some 'false fruits', such as the strawberry, rosehip, apple, pear and mistletoe, have developed their seed dispersal strategy by the development of the receptacle, the swollen top of the flower stalk which bears the flower parts. In the strawberry the 'pips' on a red, swollen, fleshy receptacle are actually the true, dry fruits made up of the ovary and seed. In the apple and similar fruits with 'cores', the juicy, fleshy outside is the swollen receptacle whilst the core is really the ovary containing the seeds – the true fruit. In rosehips, the swollen hollow red receptacle encloses the dry, hairy true fruits.

Fruits therefore may not look anything like one expects a 'fruit' to look. In the greengrocers, rhubarb is not a fruit as it contains no seeds and is not from a flower – it is red leaf-stalks called petioles. Vegetables such as cucumbers, marrows, tomatoes and nuts all contain seeds and are true fruits. Some 'fruits' such as pineapples, figs and mulberries, are really *infructescences* as they have developed from inflorescences, whole collections of flowers, and the separate fruits are not obvious.

but differ from achenes in that the wall of the carpel is extended out into a wing; e.g. ash 'keys', and maple and sycamore 'helicopters'.

TRUE NUTS

True nuts, such as the acorn and the hazelnut, are achenes that are covered by a woody shell called a *pericarp*, which developed from the ovary wall. This is surrounded by cups or *cupules*, made of bracts.

Beware the term 'nut', which is a non-botanical term when it includes almonds, brazils, and walnuts. These have a fleshy outer layer surrounding the hard pericarp and are more like the 'stone' of a peach in structure as the outer layers have usually been peeled off before they are sold as nuts.

True fruits

These often seem bewildering in their variety but actually fall into a few easily recognizable groups – dry dehiscent, dry indehiscent, and succulent – depending on how they have developed from the flower.

Dry, indehiscent, one-seeded fruits

Achenes are the simplest types of fruit and are formed from separate carpels, each containing a single seed. The carpel wall hardens as it ripens and forms a dry one-seeded fruit called an achene. Examples occur in the buttercup, clematis, dandelion, sunflower, wheat, other grasses and maize. The fruits inside a rosehip are also achenes, as are the encrusting 'pips' on a strawberry. The presence of the remains of the flower stigma shows that the achene is a fruit and not just a seed.

Samaras are one-seeded fruits formed from separate carpels,

Acorn. (Margaret Hatherley-Champ)

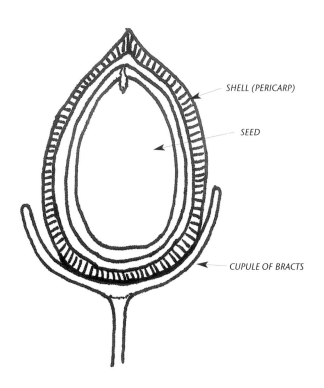

SHELL (PERICARP)

SEED

CUPULE OF BRACTS

Half hazelnut – true nut.

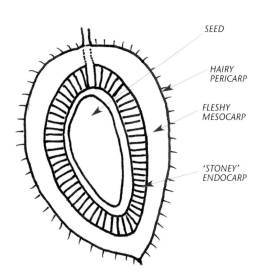

SEED

HAIRY PERICARP

FLESHY MESOCARP

'STONEY' ENDOCARP

Half almond – not a true nut due to fleshy mesocarp.

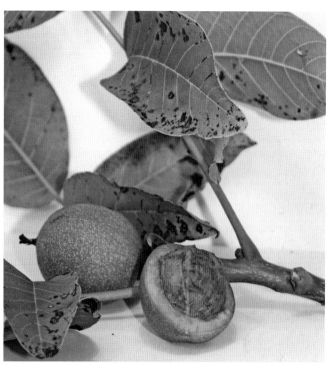

Walnut twig with fruit. Outer soft layer removed from a fruit to show stony endocarp.

SCHIZOCARPS

These are 'splitting fruits' found where the ripe ovaries split into dry one-seeded parts. Examples are found in mallow and hollyhock; also in deadnettles where the ovaries divide into *nutlets*. In the geranium the ovaries divide into five, whilst in cleavers, sycamore and all the cow parsley family (the Umbelliferae), the ovary divides into two. These do not count as dehiscent fruits as they do not expose the seeds. They are also not counted as achenes as they are still surrounded by part of the ovary wall.

Alexanders, splitting fruits. Typical of Umbelliferae.

Dry, dehiscent, many-seeded fruits

PODS OR LEGUMES

These are formed from one carpel which, when dry and ripe, splits along both margins. The two halves then move and twist apart to expose the seeds. The force of the two halves splitting often 'shoots' the seeds away, for example in peas, beans, laburnum, and gorse.

FOLLICLES

Follicles are compound fruits formed from more than one carpel. Each carpel splits along the whole length of only one margin to expose the seeds in, for example, the marsh marigold, monkshood, and delphinium.

SILICULAS AND SILIQUAS

Short and wide siliculas or long and narrow siliquas are a form of capsule consisting of two joined carpels, each separated by a membranous divider (false septum) to which the seeds are attached. When ripe, the carpel walls separate to expose the shiny, silvery membrane and the seeds. Examples of siliculas are honesty and shepherd's purse, whilst examples of siliquas are wallflower and that dire little weed of gardens, bittercress.

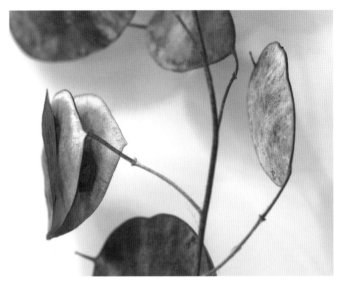

Honesty siliculas with sides splitting from central membrane.

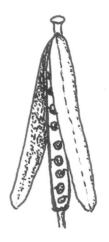

Wallflower siliquas.

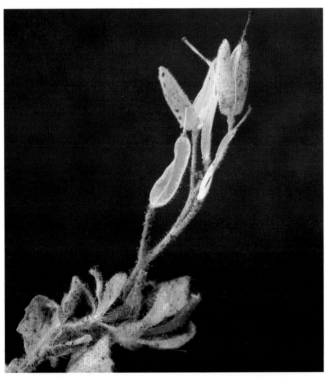

Aubretia dried siliquas showing central membrane.

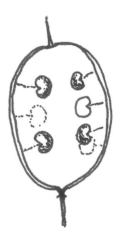

Wallflower siliquas with seeds attached to both sides.

CAPSULES

Capsules are usually formed from ovaries which are made up of more than two carpels. They are dehiscent and are very varied. Pansies and violets form three valved capsules. Poppies have capsules with a 'roof' consisting of a large, flattened, ridged stigma beneath which, when the plant is ripe and dry, the capsule develops perforations to shed the seeds using the censer mechanism.

Scarlet pimpernel capsules, *pyxidia*, split in half along a horizontal, transverse line so that the 'lid' then falls off and seeds are scattered.

Honeysuckle berries.

Mixed fruit, pen and ink. (Jenny Malcolm)

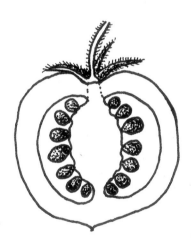

Half tomato – a berry.

Succulent fruits

BERRIES

Berries are the simplest type of succulent, often many-seeded, fruit. Here the ovary wall, pericarp, becomes thick and fleshy because it consists of masses of thin-walled cells that contain watery sugars. This fleshy mass is contained within an outer skin which protects the fruit. Examples are the tomato, gooseberry, currants, grapes, bananas, cucumbers, blueberries, citrus fruits, honeysuckle, and dates.

The ovary wall may be formed of different layers such as in the citrus fruits – the skin (*epicarp*), with oil glands, the pith (*mesocarp*) and the membranous segments (*endocarp*) with their juicy pulp. All the layers are soft and fleshy.

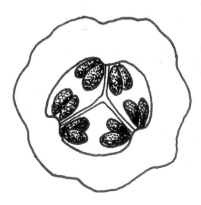

Cross-section cucumber – a berry.

DRUPES

These are fleshy fruits where the ovary wall (pericarp) is divided into three distinct layers that may not all be fleshy. The layers are the outer epicarp, the middle mesocarp, and the inner endocarp. Plums, apricots, cherries and peaches have a tough, thin, skin or epicarp, a fleshy mesocarp and a woody stone or endocarp. Inside the 'stone' is the seed surrounded by a thin, papery seed coat, the testa. Walnuts and almonds grow with a thin epicarp covering a thick, green, fleshy mesocarp and a woody, nut-like endocarp.

Coconuts are also *drupes* with a tough waterproof epicarp, a fibrous mesocarp and a tough woody endocarp containing the food stores (coconut 'meat' and milk) and the 'baby' plant. We normally only see the endocarp, containing the seed, when we buy walnuts, almonds and coconuts.

Collections of *drupelets* make up fruits such as the raspberry, blackberry, loganberry, and mulberry. Each little, fleshy, pip-containing part, is a little drupe. Each 'fruit' is therefore a collection of fruits.

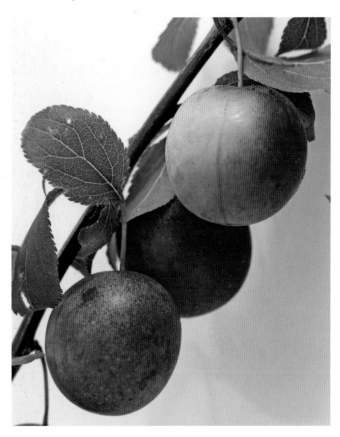

Plums.

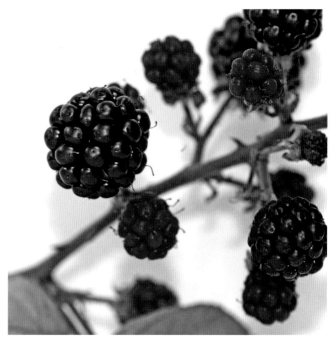

Blackberry fruits, collections of drupelets.

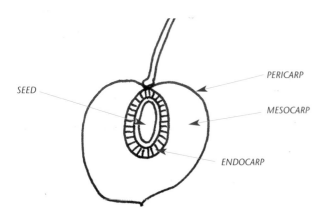

Half cherry – a drupe.

SEED

PERICARP

MESOCARP

ENDOCARP

False fruits

These occur where the fleshy part of the fruit is formed by the development of a part of the flower which is not the ovary wall. Most commonly it is the receptacle that develops. There are several different types of false fruit.

POMES

In *pomes*, such as apples and pears, the top of the flower stalk, receptacle, becomes fleshy and surrounds the tough core, made up of the ovary wall, containing the seeds.

HIPS AND HAWS

Hips and haws, such as rose and hawthorn fruits, are formed when the receptacle swells and becomes brightly coloured and surrounds the true fruits which contain the seeds.

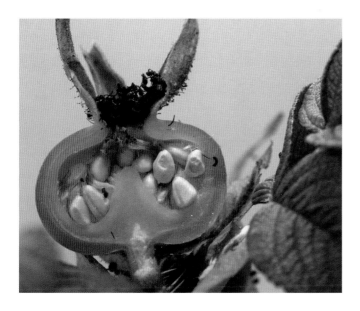

Half rose hip showing achenes and fleshy receptacle.

INFRUCTESCENCES

These occur where the whole inflorescence (group of flowers) develops and becomes succulent, for example in pineapples and figs.

Two figs, on vellum. (Maggie Cartmell)

STRAWBERRIES

In strawberries the receptacle becomes fleshy, swollen and coloured and is covered by the true fruits, the 'pips'.

Understanding the various differences between the types of fruits, and their role in the life of the plant, should help you, the artist, to depict them with greater appreciation and accuracy.

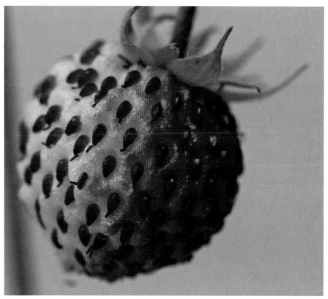

Wild strawberry showing achenes on the outside of the receptacle.

Half strawberry – a false fruit, showing achenes on the surface.

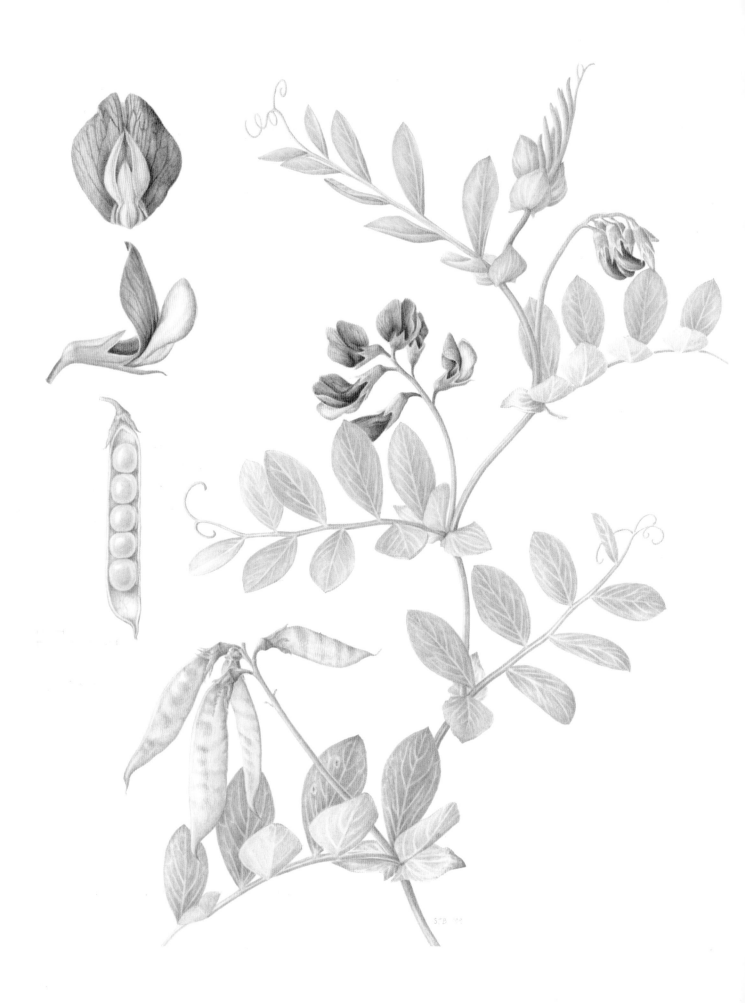

LEAVES, FRUITS, STEMS AND CARNIVOROUS PLANTS

Leaves

Leaves of different plants vary enormously in size, shape and arrangement on the stem. The shape of a leaf is characteristic for a particular species of plant but may vary markedly between members of the same genus and family, depending on the habitat and the coping strategy the species has evolved. Only the flower is similar and links plants within a family, genus and species.

In some cases there may be a wide variation of leaf shape in a species depending on where on the plant the leaf is growing, such as at the base or higher up, as in the groundsel and holly. In the holly the leaf edges have defensive prickles that deter animals from grazing on the leaf, but higher up there are fewer prickles. In other instances the amount of light may affect the shape of the leaves, such as is found in ivy, where the leaves in full light on a wall are deeply divided whilst those growing on a shady tree are less divided and more heart-shaped. Consequently you need to look for variations and may need to include these in your picture.

A typical leaf

Leaves are made up of a leaf-stalk, or petiole, which grows out from a joint in the stem. The opposite end of the stalk constitutes the flattened leaf-blade or *lamina*. In dicotyledonous plants there is a continuous main vein in the leaf-stalk which continues as the mid-rib of the leaf-blade and further divides to form a network of branching veins that extend throughout the

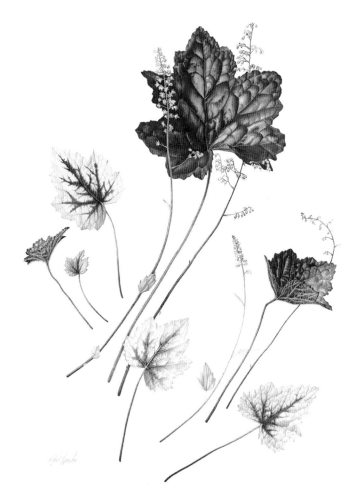

Heuchera/Heucherella. (Angeline de Meester)

LEFT: *Lathyrus japonicus.* (Sara Bedford)

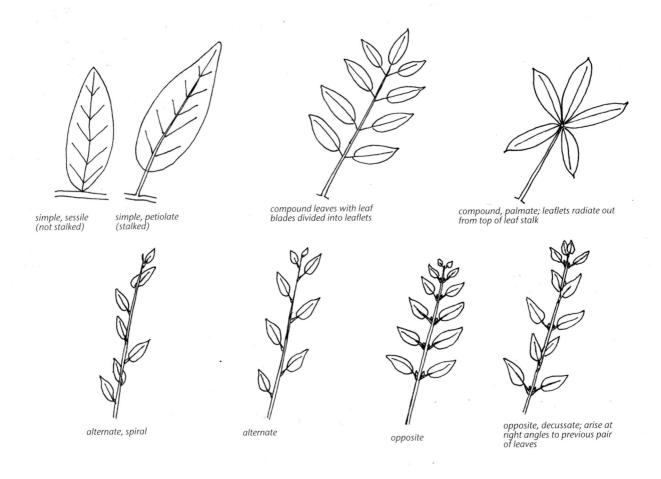

simple, sessile
(not stalked)

simple, petiolate
(stalked)

compound leaves with leaf
blades divided into leaflets

compound, palmate; leaflets radiate out
from top of leaf stalk

alternate, spiral

alternate

opposite

opposite, decussate; arise at
right angles to previous pair
of leaves

Types of leaf and their arrangement on the stem.

blade, but almost never to the very edge of it. These leaves are net-veined or described as having *reticulate* venation. Some leaves may have very short stalks or others may typically have no leaf-stalks and are *sessile*, with the blade attached directly to the stem. Other leaves, such as the nasturtium, have the leaf-stalk attached to the centre of a rounded leaf-blade; in this umbrella-like arrangement the leaf is called *peltate*. In all cases there is a small *axillary bud* (armpit bud) in the inner junction of the leaf-stalk and the stem. If there is no bud then it is probably a bract or a stipule and not a leaf.

In monocotyledonous leaves there is no mid-rib as the veins are all of the same size and run parallel to each other up the leaf. These are known as parallel-veined leaves and do not have leaf-stalks.

Types of leaf

Leaves are known as *simple* when the leaf-blade is undivided and complete. Other leaves have the leaf-blade divided into leaflets and form *compound* leaves, which can be distinguished from a twig with simple leaves, as there are no buds in the axils of the leaflets and there is a terminal leaflet. There are two types of compound leaves that can easily be recognized: the *compound pinnate* leaves have leaflets arranged along either side of the mid-rib, such as those of ash, rowan and roses. The *compound palmate* leaves have leaflets that all arise from the top of the leaf-stalk, like spread fingers from the palm of the hand; examples are the horse-chestnut and lupin. Some leaves have deeply indented leaf-blades but are not quite truly compound, such as oak leaves, which are simple and described as *pinnatifid*, and maple or sycamore leaves, which are simple and *palmatifid*. Further complications occur when the compound leaflets are further divided into smaller leaflets and are said to be *bipinnate*, as in some mimosas, or *tripinnate* if these small leaflets are even further divided, as in some fern and carrot leaves.

Eucalyptus – hanging leaves with both sides identical.

Goosegrass – detail of whorled leaves.

Leaf arrangement (phyllotaxy)

Leaves are arranged on stems and branches in such a way as to ensure they receive as much light as possible and do not shade each other. Maximum light ensures rapid photosynthesis, the process by which plants convert carbon dioxide gas from the air and water from the soil into sugars, which the plant uses as the starting point for making other food stuffs such as carbohydrates, proteins, fats and oils. The energy from the light is trapped by the green chlorophyll in the leaves and is used to drive this photosynthetic process. Without enough light the plant would be unable to photosynthesize sufficiently and would be weak and unhealthy – ultimately, it may even starve to death. It is therefore very important that the arrangement of the leaves on the stems and general mode of growth, or the habit, of a plant ensure maximum light reaches the green leaves.

In the eucalyptus, the juvenile leaves are often of a completely different shape to leaves found on the mature parts of the tree. The mature leaves are different to most other types of leaves in that they do not have a distinct upper and lower surface. The leaves hang to avoid being scorched by the strong sun.

The leaf arrangements, or phyllotaxy, follow characteristic patterns in each species of plant. Get the arrangement wrong in your pictures and the plant loses credibility. It is important that the artist is aware of the different arrangements and is not tempted to stick a leaf in at random, for the sake of a more 'artistic' feel to a picture.

OPPOSITE
Opposite leaf arrangements are those where two leaves are found opposite each other at a node. Usually the leaves at successive nodes are at right angles to each other (*decussate*), such as is found in the sycamore.

WHORLED
Whorled leaf arrangements occur when there are more than two leaves at each node. An example of this is goosegrass (cleavers), where there are six to eight leaves in each whorl or ring of leaves at the nodes.

ALTERNATE OR SPIRAL
Alternate or spiral leaf arrangements occur where there is only one leaf at each successive node. These leaves are attached to the stem in, for example, two, three, five or eight vertical rows. Where they occur in three, five, eight or thirteen vertical rows up the stem the successive leaves form a spiral, which is most

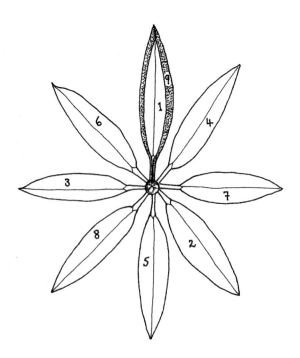

Phyllotaxy in the *Rhododendron* from above.
Radial leaf-mosaic showing 3/8 spiral phyllotaxy.

Bougainvillea – red bracts and small flowers.

Butcher's broom – close-up of scaly bracts and leaves round
flower bud on cladode.

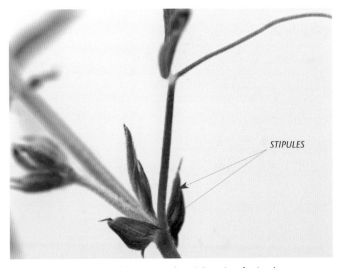

Meadow vetchling – node with pair of stipules.

easily seen by using a thread to join the base of successive leaves and in this way follow the spiral up the stem to the next leaf which is exactly over the leaf at the starting point. These spirals can be indicated by fractions, where the top number is the number of times round the stem and the bottom number is the number of nodes you pass through to get to the leaf directly over the starting point, not counting the starting node. The simplest spiral is ½, where there is one turn round the stem and the thread passes through two nodes or two rows of leaf bases. The fractions occur in a Fibonacci series where the top numbers of two successive fractions are added together to get the new top number and the two bottom numbers are added together to give the new bottom number of the next fraction. For example, ½ and $^1/_3$ gives $^2/_5$, $^1/_3$ and $^2/_5$ gives $^3/_8$, $^2/_5$ and $^3/_8$ gives $^5/_{13}$, $^3/_8$ and $^5/_{13}$ gives $^8/_{21}$, and so on.

Looking down the stem gives you the 'leaf-mosaic' for a plant which results from the spiral and number of rows of leaves. For example, lime trees (*Tilia*) have the simplest ½ phyllotaxy and this gives a flattened appearance to the leafy branches whilst oak and apple have $^2/_5$ phyllotaxy spirals. In these ways the plant ensures that maximum light reaches all the leaves.

80

Bauhinia variegata – spiny stipules.

White bryony – modified side-shoot tendril.

Bracts, stipules, tendrils and other modifications

BRACTS

These are outgrowths that occur at nodes, from the axils of which a flower-stalk or pedicel arises. They may be large, coloured and attractive (as in bougainvillea or poinsettia) or, more commonly, leaf-like to small and green, or papery and scale-like as found on butcher's broom.

Vetch leaflet tendrils.

STIPULES

Stipules occur as outgrowths at the base of the leaf stalk, where it attaches to the stem. If they are present, there is usually a pair of stipules and these vary greatly in size and shape, often surrounding the stem and the base of the leaf-stalk (petiole). They may be large and green and photosynthetic, as in peas and pansies, or like spines in the false acacia (*Robinia*), or may be modified to form tendrils, for example in *Smilax*.

TENDRILS

These are thread-like structures produced by climbing plants and are a means of tying the plant to a support. Tendrils start off as straight threads, which coil around any structure that they rub against. Darwin demonstrated this and you, too, can make a tendril curl by stroking it on the underside with a pencil, or matchstick, for ten minutes or so. Once the tendril is attached then the rest of the tendril coils to form a short 'spring' that pulls the stem towards the support whilst allowing movement and thus preventing wind damage.

The origins of tendrils are varied: they may be modified leaves, leaflets, or side branches. In peas the upper leaflets are replaced by tendrils, whilst in the yellow vetchling the whole leaf is represented by a tendril and the stipules become leaf-like and photosynthetic. Conversely, the stipules in *Smilax* form the tendrils. In the white bryony and the passionflower the tendrils are modified side-shoots and arise from the axil of a leaf.

In the vine and the Virginia creeper the tendrils are thought to be modified inflorescences as they arise in the same position and the stem ends in either an inflorescence or a tendril. In the case of these latter plants, the tips of the tendrils form adhesive discs where they meet a solid surface such as a wall.

Clematis armandii – twisting petioles for climbing.

In each case you can identify the type of tendril by its position in relation to leaves, stipules and axillary buds in the axils of leaves. This is worth doing so that you don't attach your tendrils in the wrong place when painting the plant.

TWINING LEAF-STALKS

Twining leaf- and leaflet-stalks play a similar role to tendrils in plants such as various clematis species and the canary creeper (*Tropaeolium*). Here the leaf-stalks are elongated and coil on contact with a support. The leaf-blades do not expand fully until the leaf-stalks are unlikely to find further support.

SPINES

Spines are produced by a plant as a means of defence from grazing animals. Holly leaf margins produce them, as mentioned previously. In some instances the whole leaf is reduced to a sharp spine, as in various cacti and gorse. However, the gorse has also reduced many side branches to spines; this is apparent as you can see spines (branches) growing from the axils of other spines (leaves).

PHYLLODES

These are found where the leaf-blade has been reduced or is absent and its photosynthetic role has been taken by an adapted leaf-stalk, the petiole. The petiole becomes flattened and leaf-like but does not have the veins of a typical dicotyledonous leaf-blade. This adapted leaf-stalk is called a *phyllode*. It is similar in drought-resistant function and resilience to a stem *cladode*, like butcher's broom, but different in origin. They are a feature of mature parts of the plant, in many acacia species.

FOOD STORAGE

Food-storage leaves are found to make up the majority of a bulb such as a tulip or an onion. In the case of a tulip, the bulb has complete leaves which are colourless and thick and store food for the plant to survive on until it grows new aerial leaves from a bud at the centre, the following spring. In other bulbs such as the onion, the storage leaves are the swollen bases of the green aerial, foliage leaves – which is why you should always allow the leaves of bulbs to die down and not be tempted to cut them off as soon as the plant has flowered, if you want them to set a new bulb for the next year. The outer leaves of a bulb are dry, membranous, and brownish in colour, and protect the rest of the bulb. The stem is modified and is the solid, basal part of a bulb, like an onion, from which the storage leaves and aerial parts grow upwards and adventitious roots grow downwards.

Other extreme modifications of leaves may be found amongst the carnivorous plants, which have evolved various techniques for catching and digesting their insect prey.

Stems

Stems are the part of the plant that connect the roots to the aerial parts of the plant such as the photosynthetic green leaves, the flowers and the fruits. They are normally upright and branched to bear the leaves and flowers in optimal positions to receive the maximum light for photosynthesis and to facilitate pollination and fruit dispersal, respectively. Their veins (vascular system) transport water and minerals up the plant, to the leaves and flowers and fruits, and dissolved food stuffs such as sugars from the leaves up and down the plant, to the roots and flowers and fruits. Stems also bear the growing points of a plant – within the apical bud (at the tip of the stem) and the axillary buds in the axils of leaves where they join the stem at a node. Generally stems contain enough woody tissues to make them stiff and upright, the ultimate being heart wood in tree trunks which allows the stem to reach enormous heights. However, climbing plants generally have weak stems whilst they climb in some manner, thus saving energy and resources, and these stems only become stronger and stiffer and fully leafed once they have reached the 'heights'.

Stem modifications

Stems have been modified in various ways to allow them to perform several functions, such as food storage and perennating organs that are inactive during poor weather conditions (such as in a drought or winter), and may also be involved in vegetative reproduction or cloning – with no sex or flowers involved.

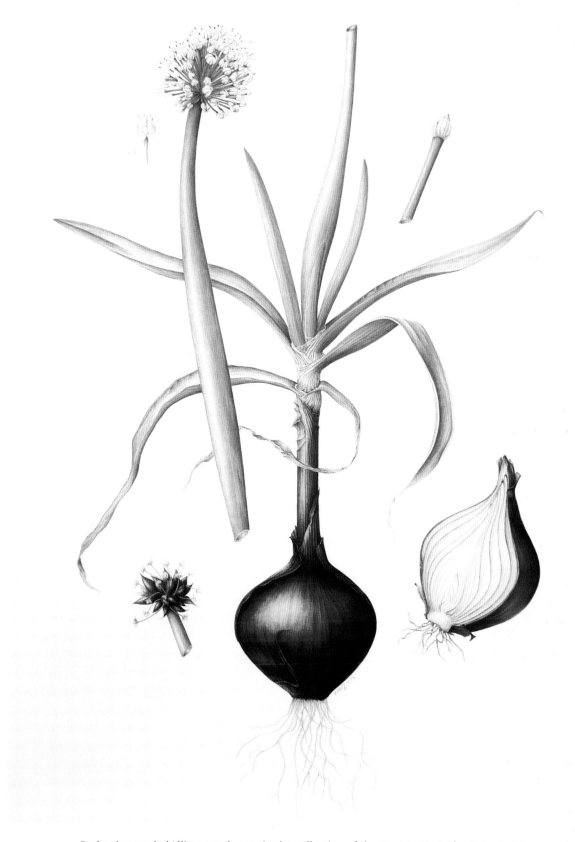

Red onion study (*Allium cepa*), now in the collection of the Hunt Institute for Botanical Documentation, Carnegie Mellon University, Pittsburgh, USA. (Leigh Ann Gale)

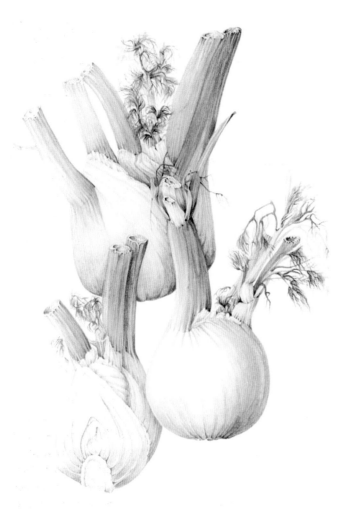

Some are modified as water storage organs, for example in cacti and many succulents. Others are modified as additional photo-synthetic structures such as the cladodes of butcher's broom or the wing-like extensions on a sweet pea stem. Spines or thorns are modifications to protect the plant from grazing animals, and also as a help to the plant, in some way, with its chosen strategy for climbing. Remember that stems are always recognizable as they bear leaves, or tiny scale leaves, in the axils of which are buds, or they arise as side-branches in the axil of a leaf. These features should be clear in your picture.

Foeniculum vulgare, fennel. (Shirley Slocock)

Potato stem tuber detail of 'eye' – leaf scar on right and buds in centre.

Potato stem tuber – buds of 'eye' growing into leaves and roots.

Food storage and perennating organs

These usually occur underground and include the corms, stem tubers, rhizomes and bulbs. In bulbs the stem is concertinaed into a small bun-shaped structure bearing the food storage leaves and buds (see above).

CORMS

Corms are very short stems but are very thick due to stored food; examples are the crocus, cyclamen, wild arum, bulbous buttercup and gladiolus. They have a large bud on top, which grows into the leaves and flower in the spring or summer, and are surrounded by fibrous, protective, scale leaves which have hidden axillary buds. The corm has a ring of adventitious roots round its base when it is growing, and may have thicker, knobbly *contractile* roots between the new corm, which develops on top, and last year's corm, which persists beneath it. These contractile roots pull the new corm down into the soil. You can often see a stack of corms of various ages in plants like montbretia (or *Crocosmia*).

STEM TUBERS

Stem tubers are also underground stems and are formed when side-branches grow down into the soil, which is usually banked up over the growing plant to facilitate this when they are grown commercially. The tip of the underground stem swells as it stores more and more starch, forming the stem tuber such as a potato or Jerusalem artichoke. Small, crescent-shaped *leaf-scars*, each with a tiny axillary bud (the 'eyes' of a potato) are where it can sprout (*chit*) to form a new plant in the spring. Root tubers never have these 'eyes'.

RHIZOMES

These are underground stems with nodes and internodes and scale leaves with their axillary buds. They are usually pale and lack the green pigment chlorophyll and may (or may not) store food which is made by the aerial leaves that grow up from a bud, as in irises or couch grass. Adventitious roots are found at the nodes. Each piece of a rhizome, with a node and bud, can grow into a new plant.

CREEPING STEMS

Creeping stems are like rhizomes but occur on the surface of the soil and have proper, photosynthetic leaves (for example, creeping Jenny). They grow from terminal and axillary buds. The nodes, of rhizomes, produce adventitious roots where they touch the soil and each end will grow into a new plant if the

Spider plant runner with plantlet.

stem is cut.

Similar to these creeping stems are *runners*: long creeping stems that grow from an axillary bud, as found in the strawberry, spider plant and creeping buttercup. The tips of these runners produce adventitious roots and develop into a new plant. The new plantlet can then produce runners and the plant 'leapfrogs' along at great speed – spreading rapidly. Commercially and in the garden, growers collect runner plantlets to produce plants that are genetically identical to the parent plant; they are naturally formed clones. Stolons are like enormous runners but are not on the ground. They tend to be long stems of a plant that grow upwards and eventually arch over to touch the ground, because of gravity. Where the stolon touches the ground a node produces adventitious roots and a bud grows into a new plant. Stolons are most obvious in brambles and account for the rampant spread of any un-pruned bramble patch.

SPINES AND THORNS

Defensive spines and thorns, such as those found in gorse and hawthorn, are modified structures which end in a sharp point. These have their origins as side-branch stems. In gorse they differ from leaf spines in that they arise in the axils of the leaf spine. In the hawthorn and blackthorn, the side branches, which arise in the axil of a leaf, are short and end in a sharp prong-like thorn. They also have nodes with a leaf or leaf-scar and a bud – another indicator that they are really stems.

These spines and thorns are not to be confused with rose or

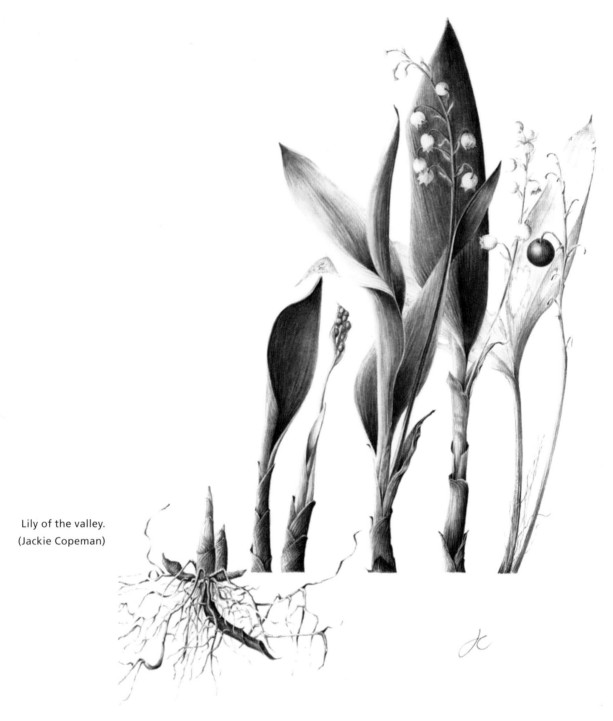

Lily of the valley.
(Jackie Copeman)

blackberry thorns, which are botanically not thorns but are real-ly prickles, or hooks, that grow out from the surface of the stem and are an adaptation to climbing, although they serve a sec-ondary defensive function.

Climbing adaptations

There are four main types, but all help the plant to reach and maintain heights that allow the leaves to photosynthesize rapid-

ly, the flowers to be pollinated and to set seed, and to produce fruits to disperse the seeds. If the plants remained close to the ground they would be overshadowed by larger plants, photo-synthesis would be too slow and they would gradually starve to death. The immature stems of climbing plants grow quickly as they are usually soft and not strengthened and have small un-expanded leaves as they climb. As these stems get older they become tougher and the leaves expand fully. Many climbing plants also develop means of attachment to hold them onto some form of support – another plant or a tree trunk or a wall.

STEM TENDRILS

Stem tendrils have already been mentioned together with leaf tendrils (see above), but examples of these modified side-stems or branches can be found in white bryony and passionflowers, and arise from the axils of leaves. They coil and tighten to hold the climbing plant to its support.

ADVENTITIOUS ROOTS

In ivy, these roots grow out of the shaded side of the stem, against the support plant or wall, and glue themselves on by exuding a sticky fluid. These small roots are the reason why it is so difficult to remove ivy from the walls of a house, even when the stems and leaves are removed. The remains of the roots look like a centipede's footsteps.

TWINING STEMS

These have thin growing tips, with unexpanded leaves, which grow in a circular fashion searching for a support. Once part of the stem touches a support it stops moving and the upper part continues to circle and therefore twines round the support. The direction of the circular movement of a twining plant is specific – the majority twine in an anticlockwise direction, for example runner beans and bindweeds; some twine in a clockwise direction, such as honeysuckle and black bryony. It is important that you get the 'direction of twine' right when painting a climbing plant.

SCRAMBLING PLANTS WITH PRICKLES OR HOOKS

Scrambling plants do not reach the heights of many other climbing plants but are able to survive in hedgerows and open spaces by producing long stems with backward-facing prickles

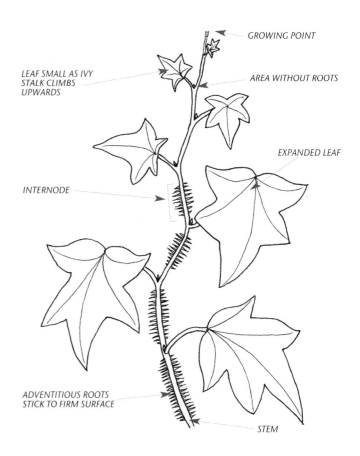

GROWING POINT

LEAF SMALL AS IVY STALK CLIMBS UPWARDS

AREA WITHOUT ROOTS

EXPANDED LEAF

INTERNODE

ADVENTITIOUS ROOTS STICK TO FIRM SURFACE

STEM

Ivy, showing how it climbs using adventitious roots.

or hooks, which grow out of the surface of the stem. These snag onto other plants and allow the plant to scramble upwards towards the light. Examples of scrambling plants with prickles are the blackberry and its allies, and the dog rose. These surface stem prickles are easily removed, which is a disadvantage when you are picking blackberries and get them embedded in your flesh, but an advantage to health and safety conscious florists who remove the 'thorns' from roses before you put them in a vase. Plants like goosegrass scramble using lots of tiny hooks on the stems and leaves.

Roots

The roots of a plant have two main functions: they anchor the plant in the soil or wherever it is growing; they also take up water and dissolved minerals (salts) and pass them up the plant to the stems and leaves, in the transporting *xylem* tubes. The water keeps the plant cells turgid (stiff) and this keeps the plant from wilting. Water also allows all the chemical reactions in a cell to happen in solution. The minerals form the basis of many

Blackthorn – spiked side-branch.

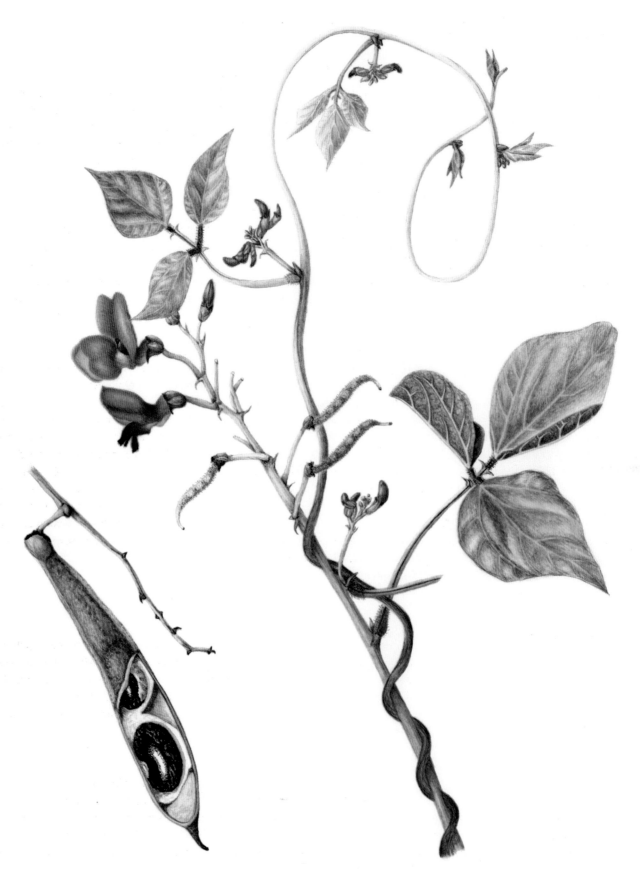

Phaseolus coccineus, runner bean. (Liz Leech)

Rose prickles or 'thorns'.

types of roots.

substances that the plant makes and needs for survival. It is therefore important that the root system is well developed to carry out its functions.

A normal dicotyledonous root system consists of a long main or tap root, which grows downwards from the germinating seed. This tap root then develops side or lateral roots which also branch. In other plants, such as grasses, the seedling tap root is replaced by many fibrous roots which grow out of the base of the stem and are all equal in size. An adventitious root is defined as being a root that grows out of any other part of the plant, such as stems or leaves, but not from the original root system. A gardener's cuttings produce adventitious roots before growing into a new plant.

Root modifications

Roots are modified to undertake various roles in different plants. Some roots store food; others help to further support the aerial parts of larger plants. Some, like the adventitious roots of the ivy, are climbing in function (see above), whilst some roots are aerial and others are developed to help the plant root system to breathe where the soil is water-logged and swampy.

FOOD STORAGE ROOTS

These roots collect food passed down from the leaves and allow the plant to withstand adverse conditions, such as winter, in a dormant state before it re-grows the following year. Storage roots are therefore perennating organs, in the same way as corms and stem tubers are, but may develop from different

SWOLLEN TAP ROOTS

Tap roots that store food constitute many of our crop plants and therefore are of commercial importance to us as well as to the plant; examples are the sugar beet, parsnip, carrot, turnip, swede, and so on. When the plants re-grow the following year they use the stored food to develop new stems and leaves.

ROOT TUBERS

Root tubers are formed when food is stored in adventitious roots which grow from the base of the stem and swell. These tubers differ from stem tubers in not having scale-leaves or buds and have typical root internal structures. These are commonly found in dahlias, the lesser celandine, and many orchids.

AERIAL ROOTS

These are clearly seen in some orchid plants. The plants originally grew on the trunks of rainforest or jungle trees and obtained their moisture from the damp, humid air around them – the roots being unable to reach the ground a long way below, over 40 metres in some instances. The roots are typical in internal structure but are surrounded by a thick layer of dead, empty, water-absorbing cells that act like a sponge. This layer is usually shiny and grey/white and called the *velamen*. The tip of the root protrudes and is uncovered by the velamen and appears greeny in colour. In the cheese plant the adventitious roots are also aerial and covered in a brown layer: they serve the same purpose.

BREATHING ROOTS

These are roots that grow upwards from the main rooting system of a plant and are covered in pores which allow air to enter the root system in habitats where there is little available air surrounding the roots, such as swamps and muddy river or island margins. The best examples of these are the mangroves of more tropical climes.

PROP ROOTS AND BUTTRESS ROOTS

Roots that support the aerial parts of the plant are called *prop roots* or *buttress roots* and are not a feature of our British native plants. However, they are usually found in warmer regions and would need to be included if you were painting these larger plants or trees.

Prop roots are adventitious roots that grow from successively

Phaelonopsis orchid aerial root and tip.

Phoenix canariensis, palm – prop roots.

Great banyan tree with 'stilt' prop roots that became secondary trunks, Yangshuo, China.

higher up the stem and anchor in the soil. They act like guy ropes in large grasses like maize (sweetcorn) and some palms, and prevent them from toppling over. Similar to prop roots are those *stilt roots* that grow down from large branches and help to support their weight, as in the Banyan tree.

Buttress roots are found in some large tropical rainforest trees and help to support the huge trunks in the same way as buttresses do on old fortifications and cathedrals. They are vertical and radiate out from the trunk, and usually become narrower and thinner as they grow outwards.

With so many adaptations of stems, roots and leaves, which have evolved to serve various purposes, artists have to keep their wits about them to understand and then depict, and show the links between structures and their functions, in their work.

Leaf adaptations in carnivorous plants

Carnivorous plants live in habitats such as peat bogs, which are lacking in the minerals, or lacking minerals in sufficient quantities, that a plant requires to grow and maintain its health. These plants have evolved sophisticated methods for entrapping small animals and then digesting and absorbing nutrients from them. Most of the adaptations involve structural modifications to their leaves, such as traps or pitchers, rolling leaf-edges and sticky tentacles.

They are a fascinating 'group' of plants whose families are often botanically unrelated. Most people either love them or hate them – seldom do they elicit a neutral response. Darwin was spell-bound by them and wrote a book devoted entirely to 'insectivorous plants'. These plants are also the inspiration for some classic science fiction of the 'man-eating plant' variety. Many of the plants are undoubtedly bizarre and exciting in shape, form and colour, and are therefore likely to be of interest to plant artists.

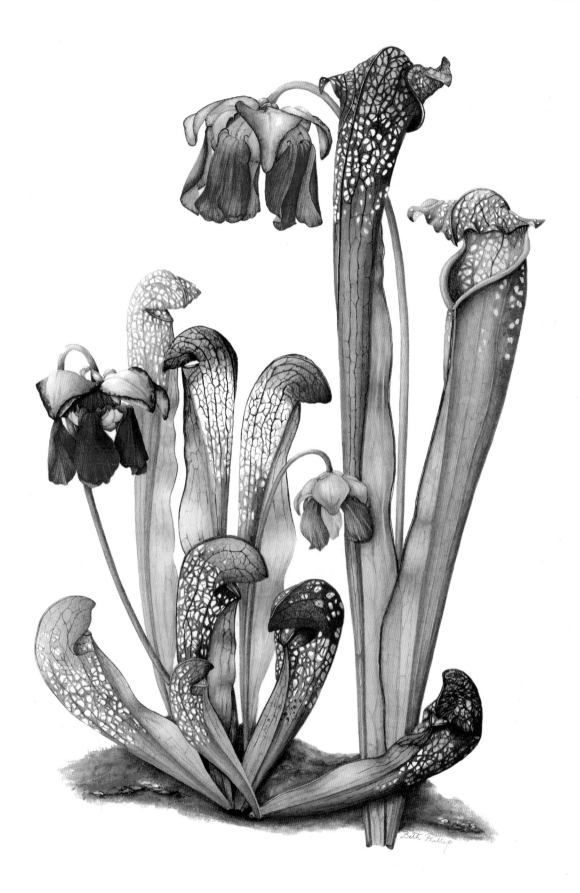

Sarracenia hybrid w-f-e. (Beth Phillip)

These plants are now known as carnivorous plants as their diet is known to include a wide variety of other small animals as well as insects. A brief description of the main types of carnivorous plants is included here, grouped under their type of adaptation for trapping their animal prey.

The pitcher plants

These produce pitfall traps, which are often called pitchers, as they consist of jug-like traps that are filled with watery liquid into which the animals fall, can find no way out and subsequently drown. The dead animals are then broken down by the trap's digestive *enzymes* (acting like biological washing powders which digest and remove stains on clothes) into soluble chemicals that can be absorbed and used by the plant. Finally, little is left of the trapped animal except for a few undigested remains.

The pitchers have evolved independently, at several different times, from rolled leaves which have ultimately joined along the free edges of their leaf blades. Over time, these 'leaf tubes' may have developed different types of sophistication to help them succeed in their blatantly 'non-vegetarian' life-style.

The main genera of plants that produce pitchers are *Sarracenia* (pitcher plants) and *Darlingtonia* (cobra lilies) from North America, *Heliamphora* (sun pitchers) from South America, *Cephalotus* (Albany pitcher plants) from Western Australia, and *Nepenthes* (tropical pitcher plants) from tropical regions of Asia. There are no native European pitcher plants.

SUN PITCHERS *(Heliamphora)*
These are very simple tubular pitchers with open tops that collect rainwater. In order to prevent overflowing, the pitchers have a hole in the sealed edge to allow excess water to drain away. The pitchers do not secrete enzymes but absorb some of the nutrients which are released as the drowned prey rots due to bacterial digestion.

The top of the pitcher has a small erect spoon-like structure. This is reddish in colour to attract insects and produces nectar from the lower surface – presumably to further attract insects, which have to hang upside down over the pitcher and so are more likely to fall in. Below the spoon-like structure, the red colouration leads enticingly down into the pitcher. Inside the funnel the walls are lined with downward facing hairs that pose a problem for any insect wanting to move upwards.

PITCHER PLANTS *(SARRACENIA)*
These pitchers have a distinct flap of tissue that overhangs the entrance to the pitcher and prevents excess water entering the

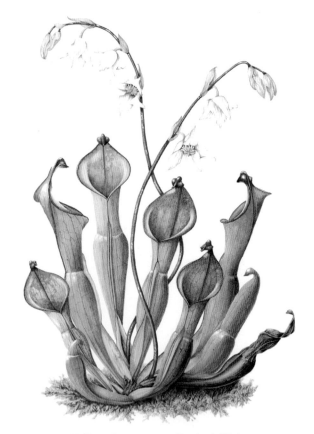

Heliamphora nutans (Beth Phillip).

OTHER PLANTS WITH SIMPLE RAINWATER TRAPS

Many bromeliads – and our native teasel (*Dipsacus*) – have similar strategies, where leaf bases form a collecting 'cup' for water in which insects die and rot. In many of the bromeliads, these tiny pools of water provide a micro-habitat for animals, like tiny rainforest frogs and mosquitoes, to breed in.

Nidularia fulgens, Blushing bromeliad.

pitcher whilst at the same time attracting insects with colour and nectar, like the sun pitcher. As the *Sarracenia* matures it may also become brightly coloured and produce nectar round its lip, whilst the incidental smell of rotting insects may act as further inducement for flies to visit. Invariably flies drop into the liquid in the pitcher where another Machiavellian twist awaits – to help the prey to drown more quickly, some pitchers may secrete a narcotic, to slow its reactions, or a wetting compound, to help it sink quickly. Once dead in the liquid, it is digested. Any fly that does try to escape by climbing the walls is hindered by the steep sides, a smooth slippery waxy zone and a further zone of downward pointing hairs. Death is inevitable!

COBRA LILY *(Darlingtonia)*

These pitchers are formed from tubular leaf structures, the opening of which is over-arched by a curved hood-like outgrowth from which the plants get their common name of cobra lily. These hood-like structures stop rainwater flooding the pitcher and constrict the pitcher aperture to a round opening. Opposite the entrance the hood has translucent, pigment-free

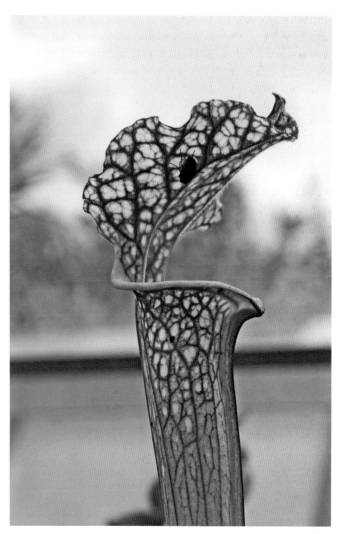

Sarracenia – pitcher with bluebottle on lid feeding on nectar.

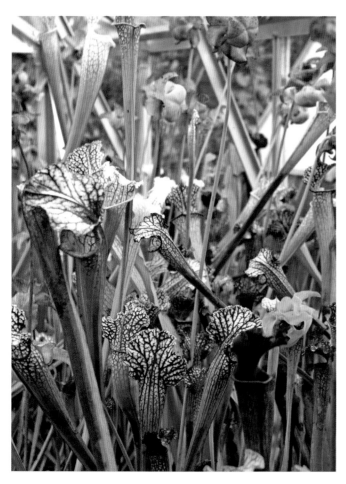

Sarracenia – massed plants and pitchers.

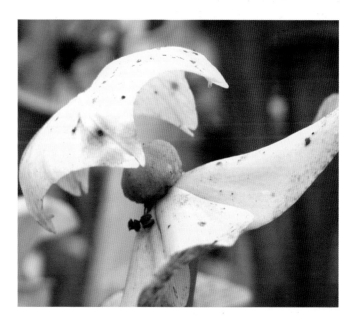

Sarracenia – remains of flower with developing ovary.

patches of tissue which let light in and give a 'stained-glass window' effect that lures insects into the pitcher and then confuses them so that they can't get out. Hanging down from the opening are two long and drooping moustache-like flaps of tissue which may be brightly coloured to attract insects, and are covered in nectar-secreting glands to offer further inducement. Once again, areas of smooth, waxy surfaces and downward pointing hairs cause the prey to land in the liquid and drown, to be digested.

ALBANY PITCHER PLANTS (*Cephalotus*)

These are comparatively small pitcher plants and have two types of leaves: the flat photosynthetic leaves and those that form pitchers later in the growing season. These pitchers are less elegant and more hairy and grotesque than other pitchers, but share many of the same adaptations. There is a lid over the mouth of the pitcher and this has pigment-free window-like patches, nectar glands to attract insects, and the inside of the pitcher is waxy and slippery with a pool of liquid waiting in the depths. Running up the outside of the pitcher are three flaps of tissue leading to the mouth. Around the mouth is a brightly coloured rim with smooth ridges leading to the inside. These ridges overhang the inner edge and form downward-facing spikes that prevent an insect from climbing back out.

TROPICAL PITCHER PLANTS (*Nepenthes*)

These are large vine-like climbing plants that produce hanging pitchers. The leaves are long, strap-shaped, green and photo-

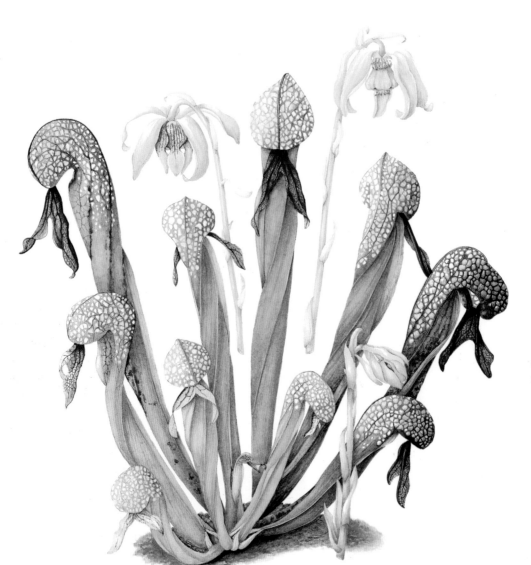

Darlingtonia californica.
(Beth Phillip)

synthetic in function. The mid-rib at the tip of the leaf grows out into a tendril which can coil round a support and grows a pitcher at its tip. The pitcher has a lid and is fluid-filled, with smooth waxy walls within. Round the mouth of the pitcher is a ridged rim similar in structure and function to that in *Cephalotus*. The pitchers may be brightly coloured. Unlike the other types of pitcher plant, the various species of *Nepenthes* have separate male and female plants. This is evident from their flowers.

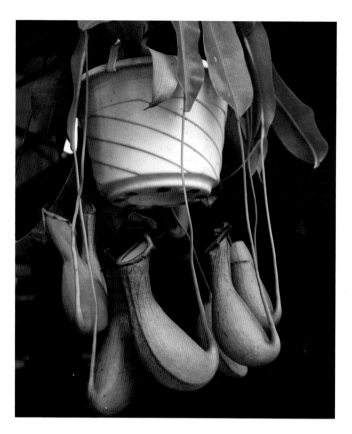

Nepenthes pitcher plant, China.

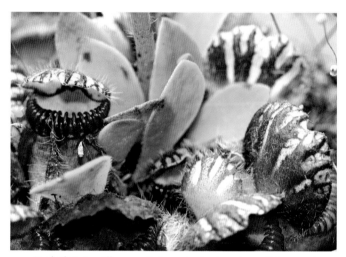

Cephalotus – Albany pitcher plants showing pitcher and photosynthetic leaves.

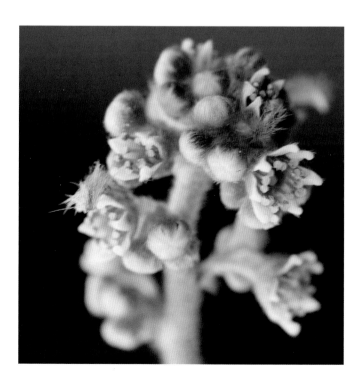

Albany pitcher plant – flower detail (magnified).

Plants with sticky 'fly-paper' traps

These plants vary enormously in the adaptations that they have evolved, but can be grouped together because, in all cases, their leaves secrete a substance that traps by sticking the insect prey to the leaf. The genera of plants that produce fly-paper traps include *Pinguicula*, *Drosera*, *Drosophyllum* and *Byblis*.

There are European members of both *Pinguicula* and *Drosera*, which occur in bogs and on wet acid heathlands and are relatively easy to find, although they are small compared to their 'cousins' on other continents. Members of both these genera respond to a trapped animal by rapid growth, which results in movements of part of the leaf to further entrap the prey. In this they differ from *Drosophyllum* and *Byblis*, where the leaves remain static with no growth movements around their prey.

THE BUTTERWORTS (*Pinguicula*)

These plants have got their common name from their pale yellow-green leaves, which look 'greasy'. They form rosettes of leaves which are held close to the ground. The surface of a leaf is moist and sticky, due to mucilage produced by stalked glands. Stalkless leaf glands produce liquid containing digestive enzymes in response to trapped prey. At the same time the leaf-

margins may roll inwards and the surface of the leaf under the prey moves downwards, to form a shallow pool for the digestive enzymes round the prey. Once digested the nutrients are absorbed through the surface of the leaf.

Butterwort leaf, from Irish bog, with rolled margin, glands and insect remains.

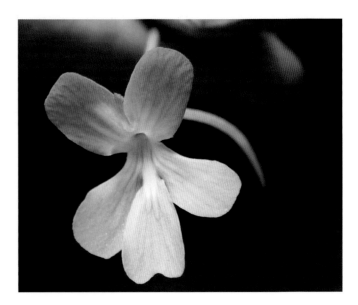

Butterwort – exotic species, flower with spur.

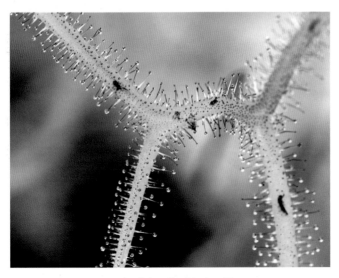

Drosera sp. – leaf detail with dead insect prey.

THE SUNDEWS *(Drosera)*

The upper surfaces of the leaves of these plants are covered in tentacles at the end of which are coloured knobs that secrete drops of mucilage and digestive enzymes. These drops of sticky mucilage glisten in the sunshine and gave the plants their common name. European species are generally small rosette plants but many of the Australian species are tall with elongated leaves covered in tentacles. These larger plants make very effective flypapers. (I can vouch for this, having collected and hung some from the ridge-pole of my tent awning, whilst camping out in the bush on botanical expeditions.)

The hapless fly becomes stuck to the mucilage on the tentacles and its struggles cause the tentacles and surrounding tentacles to bend and close over the insect. It is then digested. Once digestion and absorption of the nutrients is complete, the tentacles open up again – ready and waiting!

PORTUGUESE DEWY PINE *(Drosophyllum)*

Similar to sundews, these plants have tentacles with red glands at their tip, which secrete mucilage. They differ from sundews in that the tentacles and leaves do not move. The prey is mechanically trapped by the amount of mucilage. As the prey struggles, glands secrete enzymes that digest it. These plants are also different in that they are quite tall, resembling seedling pines, and they live in drier habitats.

RAINBOW PLANTS *(Byblis)*

These plants are native to Australia and have hairs on their leaves which produce drops of mucilage that trap the insects. They have derived their common name from light refracting through the mucilage drops. Trapping insects is also a purely passive process on the plant's part, as it is in *Drosophyllum*. These plants also live in dry habitats.

Plants with traps that snap shut ('snap-traps')

These traps are typified by the Venus fly trap, which resembles the emotive 'jawed' animal and man-traps, although on a very

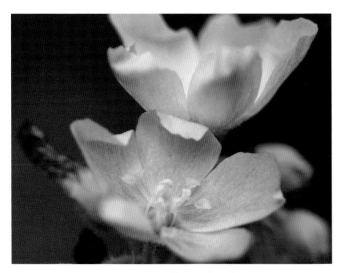

Drosera sp. – flower detail.

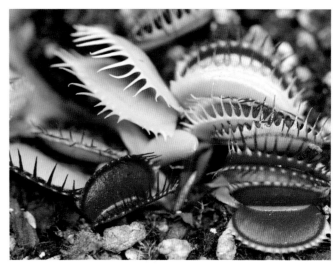

Dionaea sp. Various traps, three trigger hairs in bottom left trap.

diminutive scale. Once sprung, the trap snaps shut with great speed, far faster than one would normally associate with plants.

THE VENUS FLY TRAP *(Dionaea)*

These are small plants that grow with the leaves arranged in a circular or a rosette shape, in boggy habitats in more southerly states of North America. The majority of each leaf is green and carries out photosynthesis. However, the free end of the leaf forms a hinged trap. The trap consists of two lobes hinged by the mid-rib, with longish 'teeth' along the outer edge of each lobe. On the upper surface of each lobe are three colourless trigger hairs which control the 'snap' response.

Insects landing on the lobes must stimulate a minimum of two of these trigger hairs in a very short time to cause the trap to shut. This fail-safe mechanism prevents the trap shutting for nothing when something like a rain-drop lands on a lobe or an animal doesn't linger in the trap. Traps can only shut and re-open a limited number of times before becoming inoperative.

Once stimulated, the trap snaps almost instantaneously as the two lobes come together. Their teeth, at the edge, criss-cross over the free edge to prevent escape. If there is no prey the trap reopens. However, if there is trapped prey, the lobes squeeze against it and secrete enzymes to digest it. Only after the prey has been absorbed does the trap re-open and the whole process starts again. (The actual mechanism that shuts the trap is still open to debate and is not really of relevance here, so reference to it has been omitted.)

Those aquatic carnivorous plants with traps, such as bladderwort (*Utricularia*) and the waterwheel plant (*Aldrovanda*), have been omitted from this section for no other reason than that they are less likely to be of interest to most botanical artists.

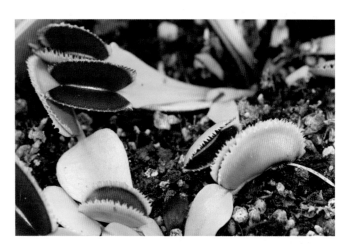

Dionaea sp. 'Shark tooth' trap detail.

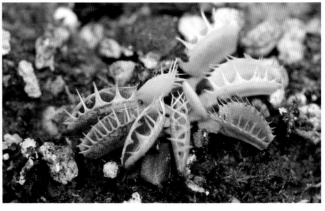

Dionaea sp. with widely spaced teeth.

Leech 2006

CACTI AND SUCCULENTS

These plants have been grouped together in this chapter as they are frequently thought to be one and the same thing – which they are not. Cacti are usually succulents but not all succulents are cacti. There is a very broad range of plant families represented by the term 'succulent' but only one family represented by the term 'cactus'. To be deemed a 'succulent' the plant must have the ability to store water in some way and this implies 'fleshiness' of the storage tissue – regardless of any other adaptations that may be present.

What is a succulent?

The term 'succulent' simply denotes a water-retaining, usually thick, and fleshy plant in botanical terms but does not mean that the plants it describes are necessarily related or belong to the same plant family. The only thing linking what are commonly called 'succulents' together, is that they have developed some physical adaptations to enable them to survive long periods of water shortages, or environmental conditions that cause the plants to lose more water than they can replace and so become dehydrated, stressed and unable to survive. These conditions are known as *xerophytic* and include those found in deserts and sand-dunes, on exposed and drying, windy mountain tops, and in saltmarshes and salt-pans, where the salty environment constantly tries to remove water from the plant's tissues. They are also found in plants that are droughted during winter, when the water is frozen in the soil, and in geographic regions liable to serious drought.

Xerophytic adaptations

Xerophytic adaptations vary depending on the strategy used, although plants may have adopted more than one strategy. Storing water to be used in times of drought causes parts of a plant to become swollen and fleshy (succulent). The parts of the plant may be the stem, leaves, or tubers.

Another method relies on reducing the amount of leaf surface area, as the plant loses huge amounts of water by evaporation from pores called *stomata* on the leaf surfaces. Leaf fall in autumn in deciduous trees is an example of this method, as is the temporary shedding of leaves by other plants. Some plants, like cacti, have reduced their leaves to spines and compensate by relying on the green stem to carry out photosynthesis; others have flattened their green stems, called cladodes, for maximum light trapping for photosynthesis and reduced their leaves to scale leaves, for example in butcher's broom and Christmas cactus.

Reducing the evaporation effect of a dry atmosphere on the pores (stomata) is also an effective strategy and may be achieved in a variety of ways, such as having the stomata at the bottom of damp pits in the leaf surface or in deep folds of the stem, or having the plant surfaces covered in hairs that trap damp air close to the leaves – like the Edelweiss – or perhaps

LEFT: *Cactus Schlumbergera* 'Wintermärchen'. (Liz Leech)

having waxy ornamentations, arching over the stomatal pores, which also trap damp air close to the leaf and prevent excess evaporation. Other plants such as the sand-dune marram grass roll their leaves, with the stomata and damp air inside the roll.

Waterproofing the leaves to prevent water-loss is a method used by many tough and shiny-leaved plants and many evergreen trees – the leaves are coated in a thick outer layer of wax that prevents evaporation. Other methods involve changes in habit or growth forms, such as being prostrate and growing very low to the ground or forming a compact cushion, such as many of the alpine plants do. Other plants have altered their life cycles so that the plant seeds germinate rapidly after rain and the whole, very short, life cycle of flowering and new seed production is completed before the next drought starts – these are the plants that make the deserts bloom so spectacularly.

Many plants have developed underground perennating organs, such as bulbs, corms, rhizomes and tubers which store food and water and allow the plant to die down and become dormant until good conditions return. In the case of saltmarsh and salt-pan plants, they may have developed strategies to rid themselves of salt, for example by exuding salt from salt glands – like the marine iguanas do, although not as forcefully. Glasswort (samphire) has water with a high salt content stored in succulent stems with reduced, scale leaves; thus they are salt tolerant. Its common name, glasswort, derives from the fact that when burnt it produces ash that was used in glass making.

Plants may use only one, or many, of these methods to counteract lack of water or its loss. Thus, there are numerous plant types that fit into such broad groupings as 'succulents' or 'xerophytes'. Many families of plants have developed similar strategies in one or more of their species, by *convergent evolution*, and this in turn has allowed them to extend their ecological range or to survive in 'less than-ideal' circumstances.

To be deemed a 'succulent', the plant must have the ability to store water in some way and this implies 'fleshiness' of the storage tissue – regardless of any other adaptations that may be present.

Recognizing a cactus

Cacti all belong to the same plant family – the Cactaceae. This family is almost exclusively endemic to the American continent, North and South, but has now been distributed worldwide. There are some leafy members of the family, which appear as

Glasswort showing three flowers, swollen stems and reduced leaves.

FLOWER

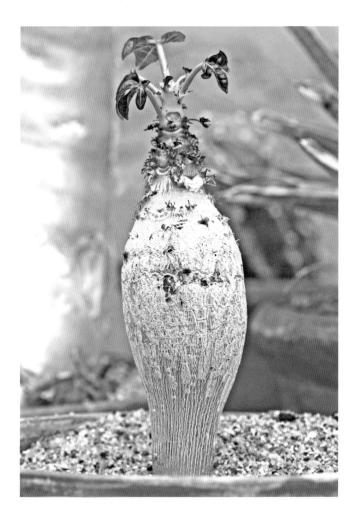

Jatropha podagrica – swollen stem.

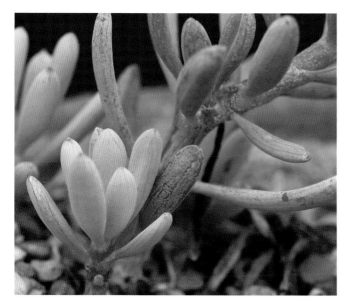

Senecio serpens – succulent leaves.

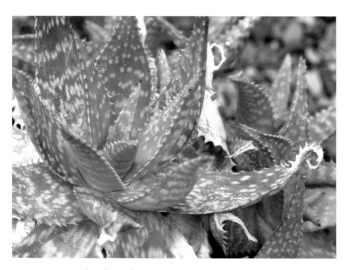

Aloe karasbergensis – succulent leaves.

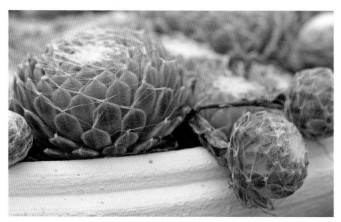

Sempervivum arachnoideum – hairy, succulent leaves with runners.

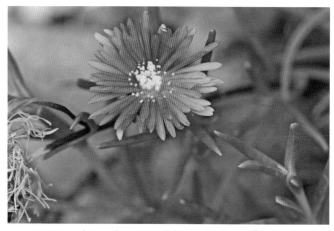

Mesembryanthemum – fleshy leaves and flowers.

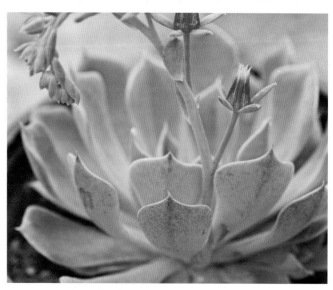

Echeveria elegans – succulent with flowers.

'normal' plants, such as the genus *Pereskia*. However, this chapter will concentrate on those members of the family which are more typically *cactoid* in form and are generally easy to recognize as such. All these plants share unmistakeable features, which are found on all cacti.

Cacti have spines. These spines may be many or few and of varying shapes and sizes, depending on the species. All the spines arise from specialized buds that form areoles, which are distinct due to the cluster of hairs and spines that they form. The areoles are spirally arranged up the stem, along stem ridges or may occur at the tips of the stem – depending on the way the cactus grows. The spines are reduced leaves and help prevent water loss by evaporation but, more importantly, protect the plant from animals intent on a moist meal to slake their thirsts.

Within the areoles are other dormant buds which may develop into side stems or flowers. The stems may be rounded (cactoid) or flattened (cladodes) and are photosynthetic in function

Cactus spines and areoles.

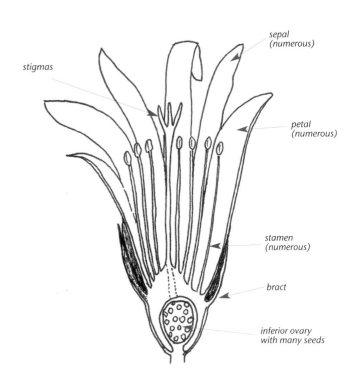

Cactus half flower.

due to the reduction or total absence of leaves. They are also succulent and fleshy, as they store water. Other xerophytic features may also be present.

The flowers grow out of an areole and are usually solitary or in inflorescences such as cymes. The flowers are usually large and showy and often circular (*cyclic*) and regular in shape. Some flowers have lop-sided perianth parts or groups of stamens and are *acyclic* and irregular (zygomorphic).

The perianth parts are not clearly distinguishable as sepals and petals, as the sepals usually merge into the petals in a graded and seamless fashion. They, and the numerous stamens, all arise from a ring of tissue that occurs above the ovary, the epigynous region. The stamens mature from the outside inwards and are all fertile; they are usually attached singly or, in some cases, are attached in groups.

The ovary is generally inferior, below the other flower parts, and consists of three to many carpels, although there is only one space in the ovary, so this is not obvious. However, there is a single style and the number of stigmas it bears indicates the number of carpels present. This number varies from species to species. After pollination, the fruit usually develops into a fleshy berry with spines. In some atypical members of the family, the fruit may be a capsule that splits open, rather than a berry.

In summary, if there are no areoles, and no spines, then the succulent is not a cactus. If, in doubt, check the floral features carefully – numerous perianth parts, numerous stamens and an inferior ovary with a single style and three to numerous stigmas. However, many succulents and cacti may not necessarily oblige by flowering. To induce flowers, treat the plant unkindly and drought it over a period, such as the winter and spring, and then water. A near-death experience makes most plants flower, so that they can set seeds, which remain dormant until the unsuitable conditions improve – or that is the theory.

Cactus bud arising from areole between two cladodes.

102

Cactus flower showing parts and inferior ovary.

Cactus flower showing stamens and stigmas.

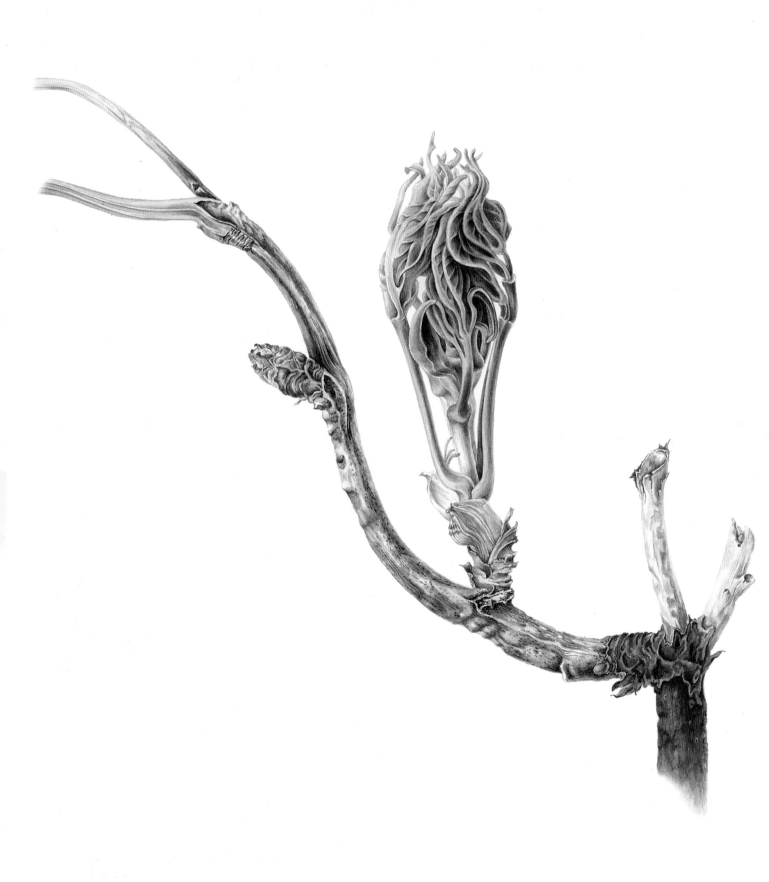

TREES THAT FLOWER

Trees are defined as woody plants that are over 4 metres tall. Shrubs are woody plants that reach a maximum of 4 metres in height. However, this may be a somewhat blurred distinction depending on habitat and growing conditions. Trees may be stunted and shrubs over-large!

Flowering trees are dicotyledons. The flowers are obvious on some trees, such as the cherry tree, but less obvious on others, like an oak, where the flowers take the form of groups of reduced flowers or catkins.

They are called hardwood trees as the main conducting tissue (xylem tubes) is toughened with a supportive, waterproof substance called *lignin*. Wood that is bought in planks is xylem tissue and distinguishes the hardwood trees from the non-flowering softwood trees such as the pines and conifers, which do not have this type of conducting tissue.

Evergreen and deciduous trees

Hardwood trees may also be called broadleaves, as their leaves are broad with a central mid-rib and smaller net-like veins. They may be evergreen or deciduous.

Evergreen broadleaf trees

There are not many types of British tree in this category, but the holly, holme oak, and box are included. They have toughened,

LEFT: Tree paeony bud. (Annie Patterson).

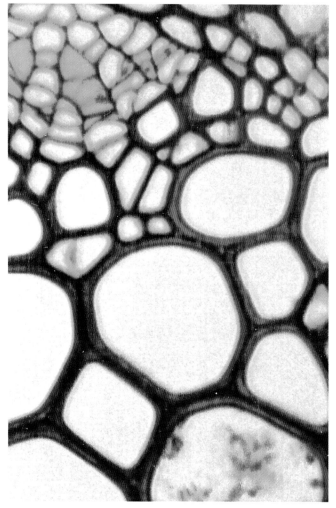

Microscope section through cells at root centre, showing stained conducting tissues. Xylem showing as thick, lignified red cell walls, and phloem as small green cells (top left).

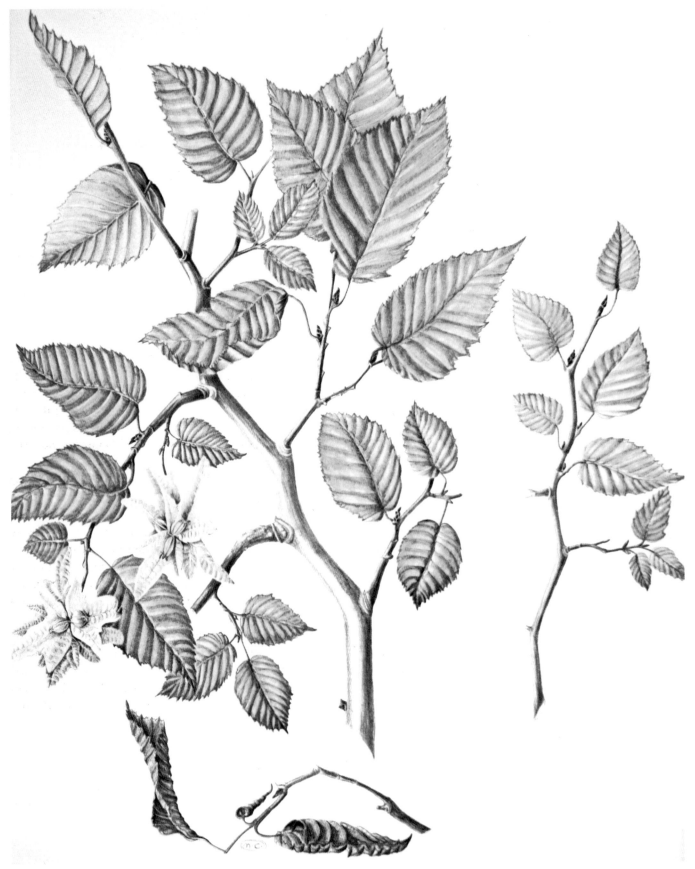

Hornbeam. (Maggie Cartmell)

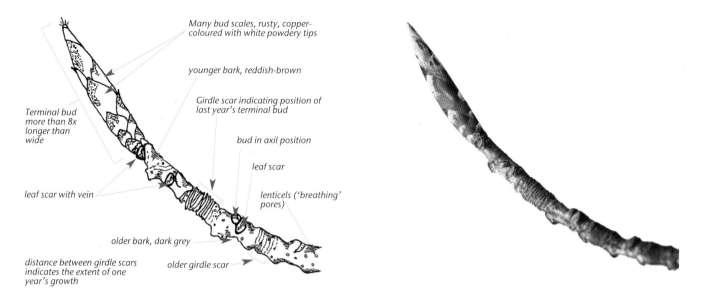

Many bud scales, rusty, copper-coloured with white powdery tips

younger bark, reddish-brown

Girdle scar indicating position of last year's terminal bud

Terminal bud more than 8x longer than wide

bud in axil position

leaf scar

leaf scar with vein

lenticels ('breathing' pores)

older bark, dark grey

older girdle scar

distance between girdle scars indicates the extent of one year's growth

Beech twig in winter.

waxy leaves that are resistant to drying out and to freezing conditions. The leaves last for several years and are never all lost at once, so the tree is never leafless. Some dead leaves are dropped in the summer months and often last a long time, undecayed on the ground, as they are so tough. Eucalyptus trees behave in the same way, although not being broadleaves in the strictest sense.

Deciduous broadleaf trees

The majority of our British trees belong to this category and go through alternate leaved and leafless phases in a year. In the autumn, a deciduous tree takes any goodness out of its leaves and transfers any waste matter into them for disposal when they drop off. It is this transfer of waste which gives the autumn colouring. Leaf stalks become separated from the twig by the development of a waterproof, corky, *abscission* layer which causes leaf fall and leaves a leaf (stalk) scar on the twig. At the same time, the tree forms distinctive buds above each leaf scar. Inside each bud is a growing point and next year's leaves and flowers, all surrounded by tough, waterproof scale leaves, which protect the dormant bud.

Leaf fall (abscission) is important to ensure that the tree does not lose water through its leaves at a time when water is difficult to get – when it may be frozen in the ground, for example. It also reduces any possible frost and wind damage to the delicate leaves. The remaining leafless twigs and buds are resistant to winter. In hotter climes leaf fall and bud formation also happen in times of severe drought.

In the spring, when the sap starts to rise, the *bud* scales drop off as the buds swell and growth begins. The bud scales leave circles of scars on the twig – the *girdle scars*. The new leaves unfurl and expand rapidly, often doubling in size each day, so that they can photosynthesize and provide the tree with food. Flowers appear and the annual cycle begins anew. The distance between girdle scars is a year's growth. When painting tree and shrub branches, look out for the old leaf and girdle scars on the bark.

Winter twigs are an easy way to identify trees. The buds are characteristic in shape, size range, colour and arrangement and have a set number of bud scales. At the same time the twig bark may be distinctive in colour and texture and have distinctively shaped leaf scars, where the leaf stalk was attached, and girdle scars from last year's bud scales.

Observations of alder twigs

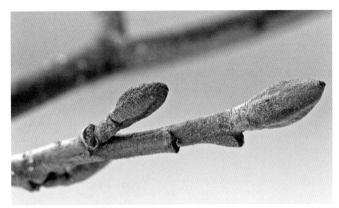

1. Alder twig – detail.

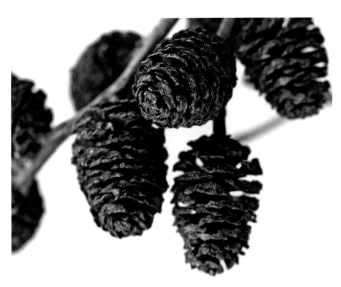

2. Alder. Cone-like fruits.

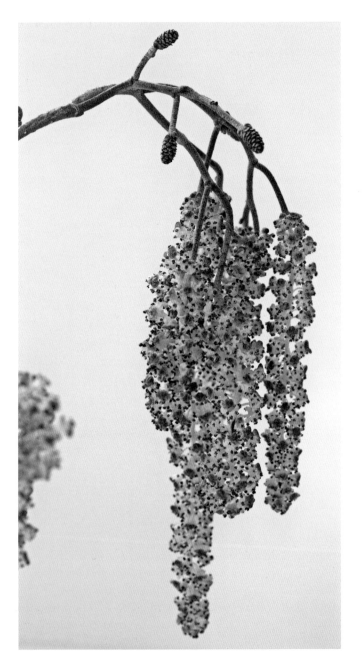

4. Alder – male and female catkins.

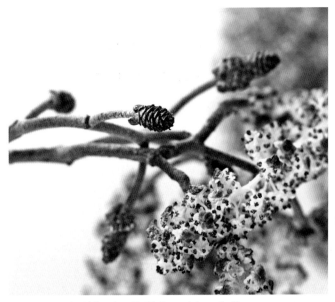

3. Alder detail. Male and female flowers.

HELPSHEET 3: A Winter Twig (Alder)

The Bark:

Bark scaly and black on older trunks.

What colour is the bark on the twig? ...*Dark grey - brown on older twigs, grey - red brown on younger twigs.*

Is it smooth, ridged, shiny, powdery or warty? ...*dull, uneven coloured, fissured.*

Is it hairy? ...*No hairs*........... If yes, where, and what

colour are the hairs?

The Twig:

Slender or thick? ...*Neither obviously thin or thick.*

Angular, oval or round? ...*round - oval (just below leaf scars) where twig widens.*

Are there spines or sharp points present? ...*No.*

If spines are present, what length are they ?...............cm

spines
Do <u>they</u> have buds on them?

Are catkins present in winter? ...*Yes. Male catkins develop from the tips of branches.*

Ⓧ Are cone-like structures present? ...*Yes. 1.5-3 cm, rounded, false cones persist - thick woody scales, with 5 lobes*

Is the pith in the centre of the twig chambered (with spaces) or not? ...*No spaces in centre of twig.*

The Arrangement of The Leaf Scars:

What shape are the leaf scars? ...*Semi-circular, heart-shaped.*

Are they flush with the bark or on projecting "brackets"? ...*On projecting "brackets"*

How many leaf scar veins can you see and how are they distributed? *3 large veins in a triangle.*

Buds:

Are they single and arranged alternately or in a spiral? ...*Spirally arranged, single* or,

Are they single, spirally arranged with <u>clusters of buds</u> near the tip of the twig or <u>clustered</u> near the centre

of the twig with single terminal buds? ...*No*

Are they in opposite pairs? ...*No*

Are the terminal buds (at tip of twig) single or double or ? ...*Single buds terminal*

Are the terminal buds larger than the others? ...*Yes*

Are the buds large or small in relation to the size of the twig? ...*large - bit larger than diameter of the twig.*

Are the buds pressed tightly to the twig or at an angle to it? ...*At an angle to twig, has distinct stalk beneath bud.*

Completed Helpsheet 3. Alder twig.

Are the buds directly over the leaf scar or distinctly to one side? *Stalk arises above a leaf scar, bud at slight angle to scar.*

Do the leaf scars almost encircle the bud, or, spread almost half way round the bud? ... *No.*

Are the buds on short columns or stalks? *Yes, on a stalk.*

The Colour, Shape and Size of the Buds:

Are the buds ragged and half open or lacking bud scales? *Not ragged or open* or,

are they closed with compact bud scales ? *Closed buds with large outer bud scale, that hides those beneath.*

Are they sticky? *Not sticky.*

What colour are the buds? *purplish - grey*

Are all the buds egg-shaped, pointed, rounded, flattened, or are some pointed and some rounded?

..... *Buds blunt and flattened on one side.*

What size are the side and terminal buds?

Side buds. Height *0.5* cm; Width *about* *0.3* cm. } *See below.*

Terminal buds. Height *0.8* cm; Width *0.5* cm. }

Are the buds 4x as long as broad or less than 4x as long as broad? *less than 4x as long as broad.*

The Bud Scales:

Are some bud scales present or none? *Yes.*

If bud scales present, how many bud scales are apparent? *1*

Do they make the bud look lop-sided? *slightly uneven shaped — not really lop-sided.*

Are the bud scales covered in hairs? *No.* or,

Are the tips of the bud scales a different colour or hairy? *No.*

Drawing of twig and its features. Name of Tree *Alder (Alnus glutinosa)*

stalk

leaf scar

bud

terminal bud

lenticels (paler 'breathing' pores).

small side bud

Catkins

Catkins are groups of single-sex flowers, with reduced or absent petals and sepals of inconspicuous colour. They are often arranged as dangling (pendulous), cylindrical 'tails' like those found in hazel's male lamb-tail catkins, or as drooping tufts of flowers like the catkins of ash or beech. The male and female catkins are often very different in number and scale.

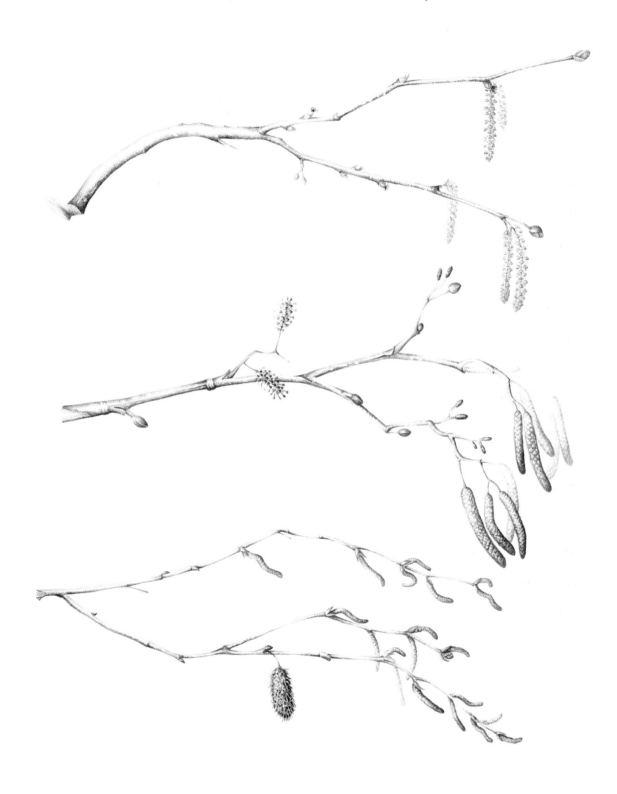

Catkins. (Lesley Ann Sandbach)

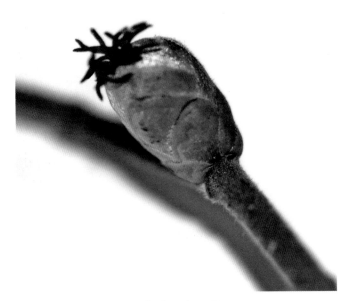

Hazel – female catkin.

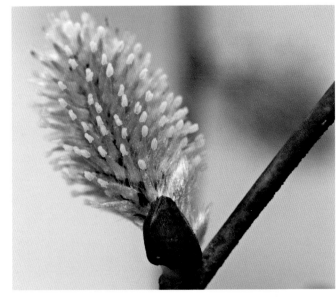

Goat willow – female catkin and bud scale.

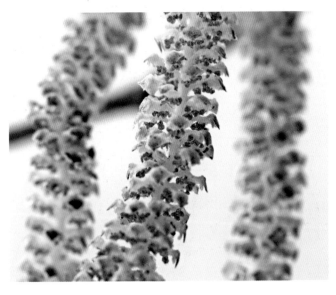

Hazel – male catkins, detail of dichasia.

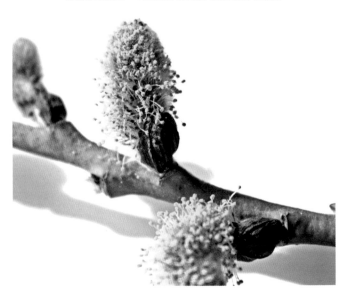

Goat willow – male catkins, detail.

A catkin may have a central stalk with lots of reduced flowers coming off it. A *dichasium* is the name for each flower unit of a 'catkin' and consists generally of a large bract (modified leaf) overarching smaller mini-bracts (*bracteoles*) and a set number of reduced flowers. Catkins are therefore made up of groups of flower units or dichasia.

Plants with both male and female catkins on the same plant are called monoecious and are more frequently found. Dioecious plants, where the sexes are separated on different plants,

are less common and occur in *Garrya elliptica*, poplar trees, or the goat willow (*Salix caprea*), which is often called 'pussy willow' due to the hairy catkins that emerge from the buds in spring.

Most catkins are found on tree species such as alder, oak, hazel, birch, willow, walnut, poplar, beech, and hornbeam. However, some occur on non-woody (herbaceous) plants such as nettles, hops and cannabis.

OTHER DIOECIOUS PLANTS

Other flowering plants that have more conventional flowers (not catkins) may also be either male or female, with the female flowers lacking stamens and the male flowers lacking carpels. In these cases, only the female plant will bear fruit and then only when there is a male plant nearby to provide the necessary pollen for pollination.

Examples of plants belonging to this group are the holly, butcher's broom (*Ruscus aculeatus*), and the kiwi fruit. Many a frustrated novice gardener has discovered the sexual orientation of their particular plant when they have no holly berries to cut for Christmas!

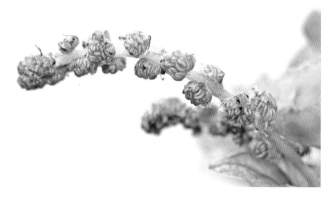

Oak – male catkins.

Pollination of catkin flowers

Catkins can be divided into those that are wind-pollinated (using air currents to transfer pollen) and those that are insect-pollinated (using insects or other animals to carry their pollen from the male catkin to the female catkin flowers).

WIND-POLLINATED CATKINS

The number of flower parts is greatly reduced as they don't have to attract insects and would only get in the way. In general the male flowered catkins are long and pendulous, so that they dangle freely in the air, to shed their pollen grains. The female flowered catkins are usually smaller and more upright,

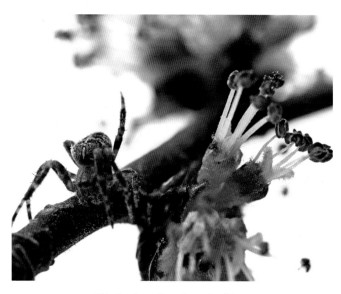

Wych elm – flower and spider.

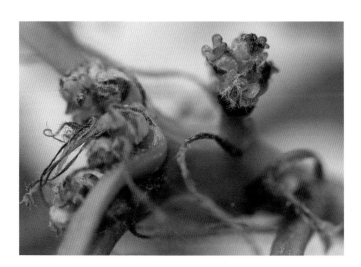

Oak – upright female flower.

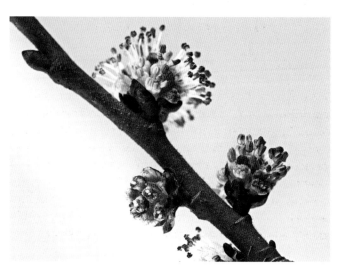

Wych elm twig with winter buds and opening flower buds.

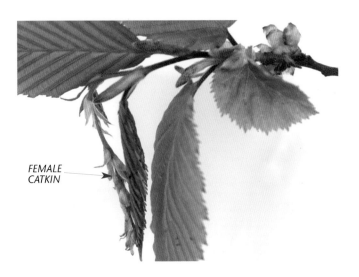

FEMALE
CATKIN

Hornbeam twig with female catkins (at tip of branch).

with long stiff styles and stigmas, so that they can easily catch passing pollen grains. In oaks, the male catkins are long and dangle beyond the expanding leaves.

Catkins usually flower before the leaves unfurl or before the leaves have fully expanded. This stops pollen grains being trapped by the leaves and thus wasted. Examples of wind-pollinated trees are alder, birch, hornbeam, hazel, beech, ash, walnut, poplar, oak and elm.

INSECT-POLLINATED CATKINS

As these catkins rely on insects or other animals to transfer their pollen, they have to be more attractive and showy and/or offer nectar as an inducement. Examples of insect-pollinated trees are sweet chestnut and goat willow (pussy willow). Some other willows may be both insect-pollinated and wind-pollinated.

Once they have shed their pollen the male catkins shrivel and drop off. After pollination, the female catkins persist and form fruits. The stigmas and styles wither after pollination, as their job is completed.

Ripe hazel nut – close up.

Hornbeam male flowered catkin – detail.

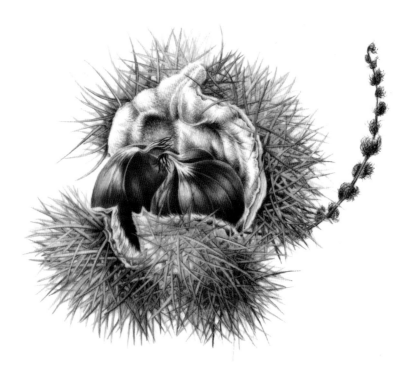

Sweet chestnut (with remains of catkin). (Annie Patterson)

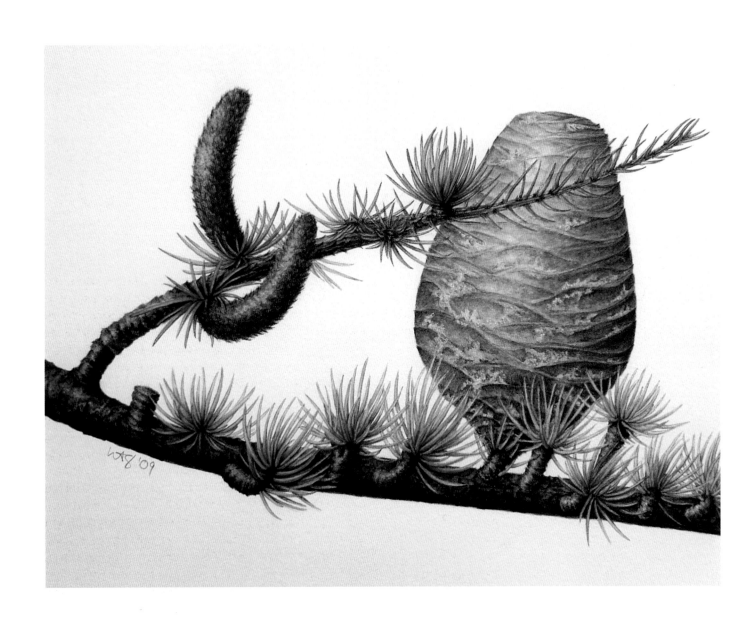

CONE BEARING TREES AND SHRUBS

The gymnosperms: non-flowering plants

This group of softwood plants and trees, the conifers or *gymnosperms*, includes all the higher plants that do not have flowers. The plants consist of very well developed stems, roots and leaves and have well developed conducting (vascular) tissues. However, these conducting tissues do not include tough xylem tubes so the wood is soft (c.f. hardwood trees, Chapter 8). The bark is often scaly and the wood resinous.

The leaves are usually reduced to needle-like structures like those in *Pinus*, or scale-like structures like those in *Cupressus*. These smaller leaves reduce the amount of water loss by evaporation from the leaves: this is important as they often occupy exposed, drying habitats where there is a shortage of available water.

Like the flowering plants they are too well evolved to show any obvious alternation of generations (*see* pages 136 and 145) compared with the evolutionarily lower ferns and mosses.

These trees and shrubs do not have flowers, but instead have cones that surround their sex-organs. The resulting seeds are naked ('gymnosperm' means naked seeds), and may be winged for dispersal. There are no fruits formed as there are no ovary walls!

Cones

Cones are spirally arranged, reduced, scale-like leaves surrounding and protecting the male and female sex organs. Male and female cones are separate and may look very different from each other. They generally occur on the same plant but some genera have separate male and female plants.

The male pollen-cone's scale leaves (*sporophylls*) surround and protect pollen-containing sacs which burst when ripe and scatter prodigious amounts of dry, light, sometimes winged, pollen grains into the air for distribution by the wind. The exhausted male cones then wither and drop off – job done!

The female cone's scale leaves surround and protect 'egg-containing' ovules and are designed to help to catch passing pollen grains for fertilization of the egg cells. The fertilized ovules develop into the 'naked' seeds as the scale leaves develop and grow into larger cones, which will protect the seeds and eventually help to disperse them when they are ripe. Unlike male cones, the female cones persist and there may be several years' worth of cones at different stages of development on a plant. In the juniper, the female cone scale leaves become fleshy and look like a berry but it is not a true berry as found in flowering plants. In the yew, the ripe seed is surrounded by a pink, fleshy aril, which develops from part of the ovule, and is not a true berry either.

LEFT: *Cedrus atlantica* 'Manetti'. (Leigh Ann Gale)

How to distinguish the different groups of the phylum Coniferophyta or 'conifers'

Softwood trees or conifers are not really botanically valid groupings but on the whole mean something to most people. Broadly they include the yew, pine and cypress families in the phylum Coniferophyta, but there are still more gymnosperms whose characteristics are also included in Appendix 3.

Included here are easily recognizable features that distinguish the main types (genera) of the three families of 'conifers'. These should help you to know what to look out for when painting this group.

Pinus twig showing fascicles and needles.

Pinaceae – the pine family

PINUS

These trees have terminal branches, which are radially symmetrical. The lateral branches are reduced to dwarf shoots with bundles (*fascicles*) of two, three, five or, rarely, one needle-like leaves which are surrounded at their bases by a membranous structure. There are also brown scale leaves on the twig at the base of each needle bundle.

The male cones are catkin-like and lateral and develop at the base of last year's growth. They go brown and fall off after shedding their pollen, each grain of which has two air sacs that look like Mickey Mouse's ears under the microscope! The female cones may take two to three years to mature and are woody. Their scales have a broad base and a very distinctive knob-like protrusion, an *umbo*, rising from the surface of the free scale tip. The seeds have wings that hold onto the seed by a pair of claw-like structures.

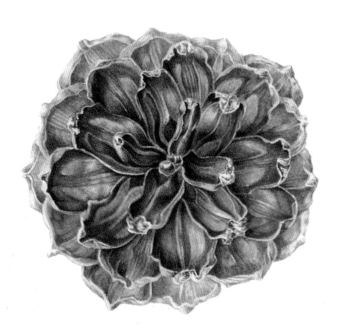

Pine cone. (Annie Patterson)

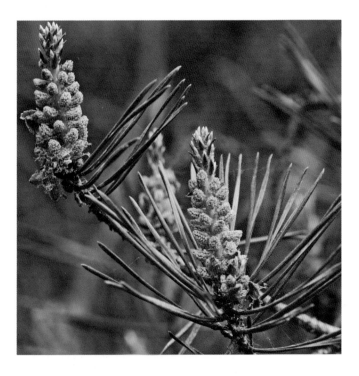

Scots pine – male cones.

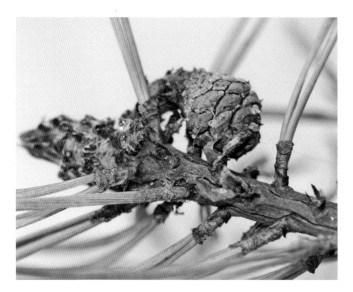

Pinus twig with one-year-old cone.

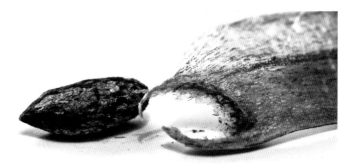

Pinus seed, showing claws on wing.

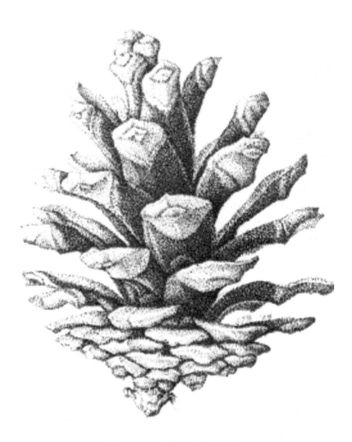

Pine cone. (Sara Bedford)

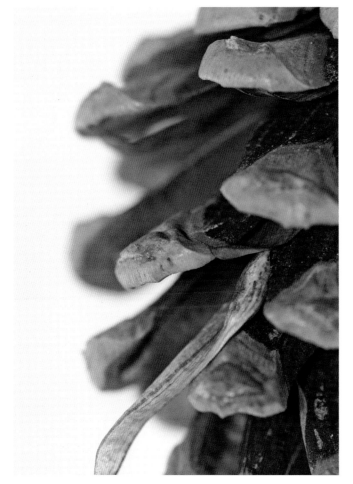

Pine cone with winged seed falling out.

PICEA

These trees have branches in whorls e.g. the Norway spruce or Christmas tree. The twigs are covered in small cushion-like pegs or projections, *pulvini*, which are separated by grooves. The stalkless leaves are four angled or flat and not in two rows. The leaves are inserted on the projections. After the leaves fall, the peg-like projections remain. The ripe female cones are large and can be terminal. The scales have broad bases but no protrusion (umbo). The seeds are blackish and held on a cup on the seed wing.

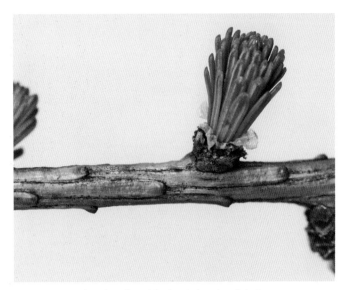

Larch twig with short shoot – detail.

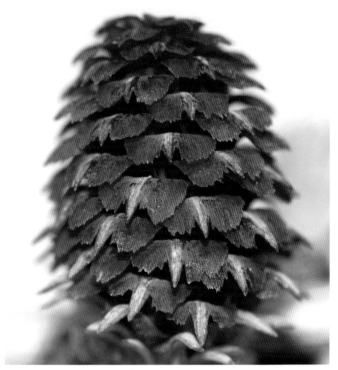

Larch female cone – detail.

LARIX

Unusually for conifers, larch trees are deciduous. The long shoots have spirally arranged flat leaves whilst the short knob-like lateral shoots produce clusters of numerous leaves at their tips. After the leaves are shed these knob-like short shoots remain and make larch easily recognizable.

The cones are erect and coloured and arise from the side shoots. The young female cones are pink or pale green. The small, oval, mature cones, which are brown, remain for several years. The scales are broad-based with no umbo. The seeds are white-ish and firmly fixed to the seed wing.

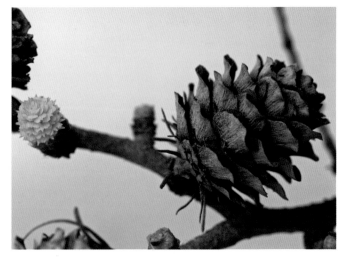

Larch – old and new female cones.

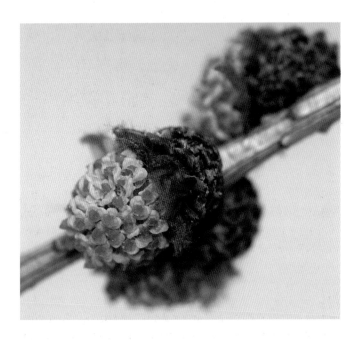

Larch – male cone showing pollen sacs.

PSEUDOTSUGA

These trees include the Douglas fir and have flat leaves with tiny leaf stalks with round bases. They leave only a small, rounded scar when they fall off; no projections remain. It has distinctive sharply pointed, papery, brown buds.

The young female cones are pinkish in colour and the more

Douglas fir – detail of twig. Leaves are flat with round bases.

Douglas fir – new female cones.

mature cone scales have a wide base and distinctive long bracts on the outside. The scales are broad based with no umbo. The seeds are whitish and firmly fixed to the seed wing.

Douglas fir – old cone from front.

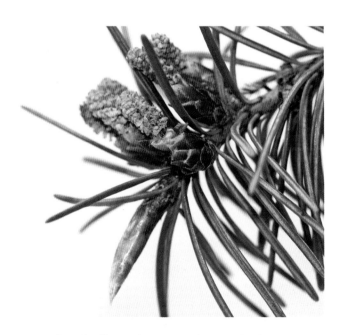

Douglas fir – male cones and papery buds.

ABIES

Trees such as the silver fir have flat, rigid leaves with a flat, rounded base. When the leaves fall they leave a round, slightly concave, non-projecting scar. The buds are ovoid and blunt. The cones are erect. The scales fall with the seeds.

TSUGA

Known as hemlock trees, these have flattened, slightly angular needles which appear two-rowed on the upper side of the shoots. The needles are distinct because they are all of variable

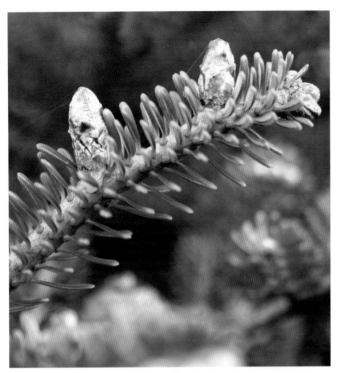

Abies koreana, Korean fir – buds and needles.

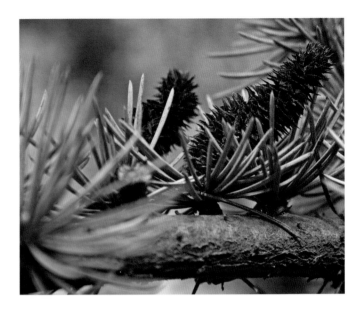

Cedar – old male cones and twig.

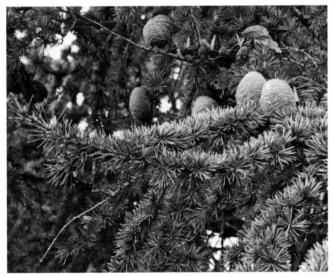

Cedar cones and foliage.

CEDRUS

The true cedars do not have branches in whorls. The long terminal shoots have solitary needles which are spirally arranged. The short side branches have tufts of numerous needles which are three-sided and pointed at the tips. The buds are small and oval.

The cones are terminal on the short side shoots. The male catkin-like cone is erect and about 5cm long. It persists for several months before dropping off. The female cones are oval, erect, reddish in colour and surrounded by needles at their base. When mature, after two to three years, the female cones are like large, brown hand-grenades! They fall off the trees with

Cedar – remains of cone and winged seeds.

lengths with leaf-bases twisted to be parallel with the stem. The leaf stalks are on forward-angled projections or pegs that persist. The tips of the branches droop.

The female cones can be small, pendulous and terminal or larger and lateral. The cone scales have a narrow base and no umbo. The seeds are brown and reasonably firmly fixed to the seed wing.

122

enough force to dent your car, and shatter into separate cone scales releasing their large, winged seeds.

The Taxaceae – the yew family

TAXUS

The dark green, flattened needles are not sharp. The leaves are alternate and spirally arranged but are twisted to appear two-rowed. The leaf bases are twisted and prolonged down the twigs (*decurrent*) leaving distinct ridges down the stem. The younger twigs are green.

The ripe female cones are very distinctive, being single seeded surrounded by a pink, fleshy aril. The young female cones are green, tiny and inconspicuous – consisting of a couple of ovules and bracts. The male cones are solitary or clustered. Axillary, on young branches, they are rounded and the scales have two to sixteen pollen sacs.

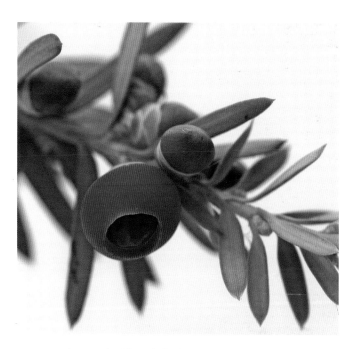

Yew – ripe seed with pink fleshy aril and developing seeds.

Yew twig.

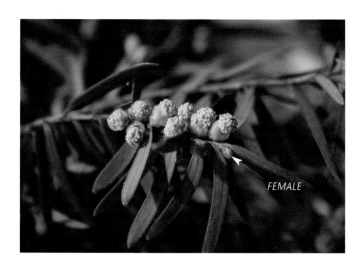

FEMALE

Yew – male and female cones.

The Cupressaceae – the cypress family

JUNIPERUS

These trees and shrubs have a resinous smell. Junipers have two leaf forms. The leaves of young and immature parts are needle-like, sharply pointed and without stalks. They occur in groups of three in rings (whorls) round the stem. On mature parts of the plant there are scale-like leaves that closely surround the stem.

The male cones are cylindrical, solitary and axillary. The female cones are axillary and solitary with three to eight scales that become dark blue and fleshy when ripe, forming a berry-like fruit – the joy of gin drinkers! The sexes are usually on separate trees or shrubs.

THUJA

The western red cedars, for example, belong to this genus, and are not to be confused with the true cedars belonging to the genus *Cedrus*.

The twigs and leaves all give a smooth, scaly, flattened frond-like appearance. The pairs of leaves are scale-like and held tightly on the twig – hiding it and any buds. The scale leaves are distinctly ridged.

The woody, female cones persist at the tips of the branchlets and are upright but with lax cone scales that release small winged seeds when ripe. The male cones are terminal and solitary and are shed after releasing their pollen.

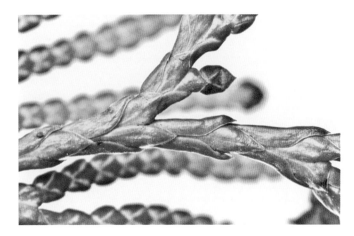

Thuja – ridged scale leaves.

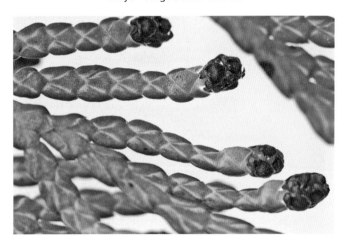

Thuja – male cones.

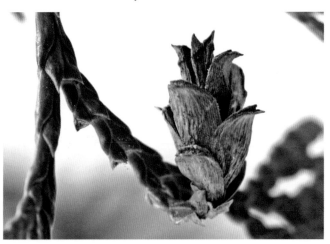

Thuja – upright old cone.

CHAMAECYPARIS

These are known as cypress trees. They are similar in growth form to *Thuja* in that they, too, have a flattened, scaly, frond-like appearance with hidden twigs and buds. The leaves are also scale-like and grow in opposite pairs. They are not obviously ridged.

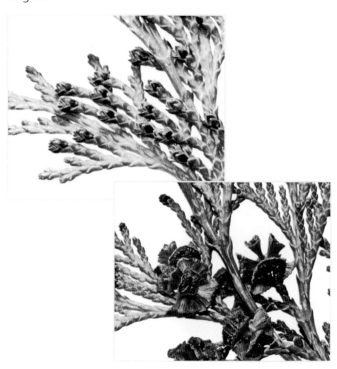

Chamaecyparis with young and old cones.

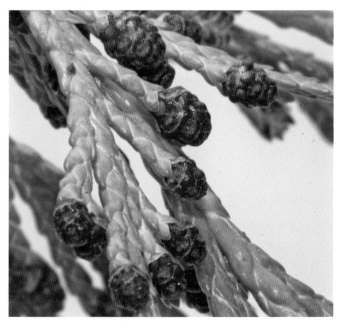

Chamaecyparis – male cones and un-ridged leaf scales.

Chamaecyparis – young female cones.

The young female cones are borne on the tips of shoots and mature to become roundish and woody. They open to release small winged seeds. The male cones are terminal and pink to reddish in colour. They fall off after shedding their pollen.

Cupressus and *Sequoia* are some of the other genera.

Observations of yew

1. Yew showing leaves twisted into two rows.

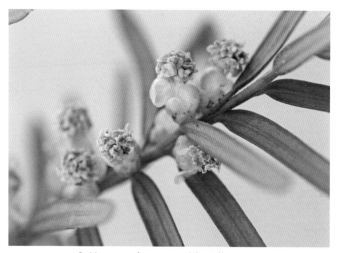

2. Yew – male cones with pollen sacs.

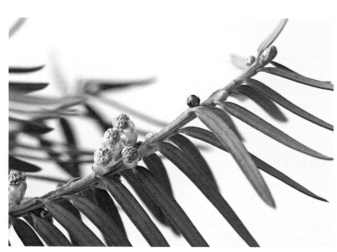

3. Yew – male and female cones.

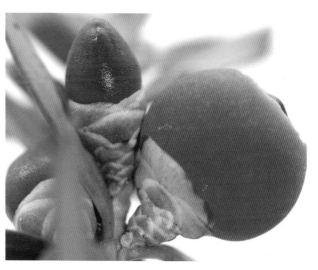

4. Yew seed with pink aril and remains of cone scales beneath.

HELPSHEET 4. Looking at a Conifer (Gymnosperm).

Always select a mature side branch to look at, so that you are sure to have a representative part of the tree. New and upright growth near the tips of branches should also be ignored as they are probably atypical.

Beware of trees that have different leaves when young and when mature e.g. Juniper. Try to pick a bit of each foliage type to look at so you can decide which is mature and which is juvenile.

Also, try to find an older mature female cone and keep it warm and dry so that it opens and releases some seeds for you to look at. True Cedars have their pollen-bearing male cones and new female cones in the autumn, whilst other conifers may have their male and new female cones in the spring or early summer. You may have to visit the tree more than once to find all the necessary, characteristic features.

All these things help with identification and may need to be included in your picture.

Don't forget to sketch parts as well as describing them on this sheet.

Branching.

Are the branches in rings (whorls) or are they differently arranged in spirals or frond-like?

....... Branches in spirals. Bark red-brown, thin and scaly.

Are the lateral branches like the main ones or are they obviously very short or knob-like?

Side branches like main ones but younger twigs green.

If they are knob-like, are the leaves in tufts or clusters at its tip?No.

Leaves.

Are they **scale-like** and flattened?No. If yes, do they completely hide the stem

of a frond-like twig?

Using a hand-lens, do they have obvious stomata or ridges or neither?Neither.

Does the plant have both scale-like and needle-like leaves, like Juniper does?No.

Completed Helpsheet 4. Yew.

If yes, which type of leaf is linked to juvenile growth and which to mature growth?

..

Are the leaves **needle-like**?*No.*......... If yes, are they single or in fixed numbers in

groups or in tufts ? *Leaves long and narrow c. 10x as long as broad.*

Are the leaves flat or angular? ...*flat*............ ; pointed or blunt?. *pointed at tip.*

Are the leaves rounded or tapering at the base?...*tapering at base.*..........

Are the leaves held together in bundles, *fascicles*, by a thin membrane and with a

scale-leaf at their base, like the Pines?*No.*..................

If yes, how many leaves occur in each bundle?*N/A.*....................

Are the leaves **spirally arranged**? *Spiral and alternate* If yes, are they single, in 3s or twisted to

appear in 2 rows? .*Base of leaf twisted so they appear to grow in 2 rows.*

Are there **leaf stalks** present or not? ...*Present*.......If present, short or long?..*short*.....

Leaf Attachments to Stem.

Are there **projections or pegs** on the twig?*None*..............If yes, are they short,

small, or forward angled?Do they persist?..................

Are the **leaf-stalks extended** (decurrent) down the twig, leaving ridges as found in Yew?

Yes. Ridges extend down twig to axil of next leaf stalk in same position on the twig.

Are there **cushion-like pegs** separated by grooves, as in Spruce?*No.*..................

Are there **no projections**? ...*None*..... If none, are there **scars** left on the twig where old

leaves have been shed?*None*.............. Are the scars small and round or round and

concave or ? ...

Bud shapes.

Sharply pointed or oval and blunt or?*Buds oval to slightly pointed.*

Male Pollen-Cones and their position on tree.

These may not be obvious for much of the year as many trees produce them and then drop

them once the pollen is shed. Remember, depending on the species they may occur at different

times of year. Cone scale leaves with pollen sacs — bracts (yellow green) male cone — stem

Cones long and catkin-like or large and cylindrical or rounded or ovoid? Rounded - like knobs.

Number of pollen-sacs on each cone-scale leaf or sporophyll? 2-16. Difficult to count.

Are the male cones solitary or clustered? Solitary or usually clustered.

Male cones lateral, axillary or terminal on the branches or on spur-like side shoots?

Male cones axillary on branches. Deciduous after pollen shed.

Colour of male cones? Off white / cream coloured.
Stalked with scales surrounding the base.

Female Cones.

Remember that you may find several, differently aged female cones on some trees. Some

persist for many years as they mature slowly. Others mature and are shed in a year. young female cone twig { ovule — leaf

Young, immature female cones.

1.* Not woody and lacking scale leaves; inconspicuous and consisting of ovules

surrounded by bracts? Inconspicuous and green. Ovules surrounded by bracts.

2.** More conspicuous with woody scale leaves arranged spirally in the cone?

Not woody scale leaves.

Positioned on terminal, lateral or side-shoots (spurs) on the branches? In leaf axils near the tips of the branches.

Are the cones solitary or in groups? Solitary

Colour of young cones? Green. fleshy pink aril Seed twig bracts

Mature female cones.

1.* Seeds erect and surrounded by a pink, fleshy aril e.g. Yew Yes.
with green bracts at base - round the stalk leaf

2.** Woody scales become dark and fleshy and cone looks berry-like as in Juniper?

........No............ Or, Scales remain obviously woody?No.............................

If yes,

 Cone scales with umbo (raised knob) at free end or no umbo?

 Cone scales with distinctive long bracts on the outside of the scales, as in Douglas Fir?

 ...

Describe **Shape of Cones** - erect, rounded, cone-shaped, cylindrical, large, small, hanging etc.

...

...

Number of seeds per cone scale?N/A...

Colour of seeds ?........Green and naked except for pink aril surrounding it.

Seed wings firmly fixed to seed, or seeds in a cup on the wing, or wing held onto seed by

claws?N/A..

Common Name of Tree.Yew...........................

Latin Name of TreeTaxus baccata...........................

Annotated sketch of various, diagnostic features. Part of Young Green Twig

twisted leaf stalk.

ridges extending back to next leaf.

twig

Leaves in 2 rows.

leaf blade

pointed tip

Underside of leaf yellowy-green with outer edges slightly in-rolled. Upper surface leaf shiny and dark black-green.

Phyla of naked-seeded, cone-bearing trees (gymnosperms)

PHYLUM AND FAMILY	GENERA	LEAVES AND BRANCHES	MALE CONES	FEMALE CONES
Phylum Ginkgophyta, Ginkgoaceae	*Ginkgo biloba* Maidenhair tree (dioecious)	Long shoots with short, thick, knob-like side (spur) shoots, covered in scale leaf scars. Buds brown and rounded. Leaves fan-shaped, with an apical cleft, and smooth with a tuft of hairs where they meet the stem (axils). Leaves are deciduous and go yellow in autumn before leaf-fall. Venation looks parallel but branches by forking into twos (dichotomous). Leaf scars are semi-circular. *Ginkgo* leaves and short shoots.	Pollen-bearing cones are long and catkin-like and arise in a whorl on the spurs of male trees. *Ginkgo* – male cones.	These are not cone-like but are found in pairs at the end of long stems. They arise from the spurs of female trees. Seeds mature in one year and are large and rounded, orange-yellow, and with a really revolting smell! *Ginkgo* – developing seeds, China.
Phylum Cycadophyta, Cycadaceae	*Cycas revoluta* Sago palm (dioecious)	Very primitive. They look like a fern or a palm – which they are not! Leaves are pinnate and form a distinct crown. Stems are succulent and may be underground. Although woody, they are more like monocotyledon stems and do not have annual rings. The plants are very long-lived. *Cycas*, Sago palm.	The male cones, on the male 'palms' are very large and produce pollen which 'swims' (becomes motile) in water. *Cycas pectinata* – male cone with flat palm-like microsporophyll structures.	Female cones are in the centre of a plant and grow into a large 'pineapple-like' cone as the seeds develop. These disintegrate to release the seeds when they are ripe.

PHYLUM AND FAMILY	GENERA	LEAVES AND BRANCHES	MALE CONES	FEMALE CONES
Phylum Coniferophyta, Araucariaceae	*Araucaria sp.* *A. araucaria* monkey puzzle; *A. heterophylla* Norfolk Island pine, etc. (dioecious, mono-ecious)	Evergreen trees. Broad or narrow, spirally arranged leaves with parallel veins. *Araucaria*, Monkey puzzle tree.	Male cones large, cylindrical, and catkin-like. Take two years to mature before pollen shed. Each of the sporophylls has about twelve inverted pollen sacs. *Araucaria* – Male cones. (Photo: Phillip Edwards)	Female cones are large, round and terminal on branches. The scales are single-seeded with no distinct bracts. *Araucaria* – Female cones at the top of the tree.
Phylum Coniferophyta, Cupressaceae	Includes (monoecious) *Thuja Sequoia* giant redwood; *Chamaecyparis* Lawson cypress; and *Juniperus* juniper (dioecious)	Resinous and aromatic trees and shrubs. Leaves are opposite or in whorls of 3–4. Young plants have needle-like leaves. In mature plants leaves are small, scale-like and held tightly to the twig (appressed) so it may be difficult to see the buds or stalks. Leaves shed with lateral shoots (cladoptiscic).	Male cones solitary and terminal (axillary in *Juniperus*), with opposite or whorled scales bearing 2–10 pollen sacs. They are shed after releasing pollen. Pollen not winged.	Female cones usually with woody scales (may be fleshy when ripe in *Juniperus*). 1–20 winged seeds per scale. Cones mature in 1–2 years and are shed with short shoots.
Phylum Coniferophyta, Taxaceae	*Taxus* yew (monoecious and dioecious)	Not resinous. Twigs are more or less ridged because of prolonged leaf bases (decurrent). Leaves are alternate and spirally arranged but are twisted so that they appear to be in two rows.	Male cones solitary or clustered. Axillary on one-year-old branches. They are rounded and the cone scale leaves (sporophylls) each have 2–16 pollen sacs. Pollen grains are not winged. The cones drop off after shedding pollen.	Female cones are inconspicuous and axillary. They consist of 1–2 ovules surrounded by pairs of opposite bracts which are arranged at right angles to each other. One seed ripens per cone. The seeds are erect (not winged) but are surrounded by a pink, juicy, fleshy aril that attracts birds for seed dispersal.

PHYLUM AND FAMILY	GENERA	LEAVES AND BRANCHES	MALE CONES	FEMALE CONES
Phylum Coniferophyta, Pinaceae	*Pinus, Picea, Larix, Pseudotsuga, Abies, Cedrus, Tsuga*, etc. (mainly monoecious)	Evergreen and resinous trees and shrubs. Branches are in rings (whorled) and are radially symmetrical. Lateral branches may be long shoots, or reduced to short, spur shoots or reduced even more to dwarf shoots (*Pinus*). Leaves are needle-like and may occur singly or in bundles (fascicles) of 2–5 needles.	Male cones are catkin-like and generally lateral. These cones are shed annually, after releasing their pollen. Each pollen-bearing scale leaf (sporophyll) has two pollen sacs.	Female cones are woody and may be solitary or in groups. They are generally lateral but may be terminal in some genera – *Picea* and *Tsuga*. Cones may take years to mature – so all ages may be seen on a tree. Cone scales are spirally arranged and hold two inverted ovules on the upper side. The wings attached to the ripe seeds develop from the surface of the cone scale.

Mature Spruce trees, Austria.

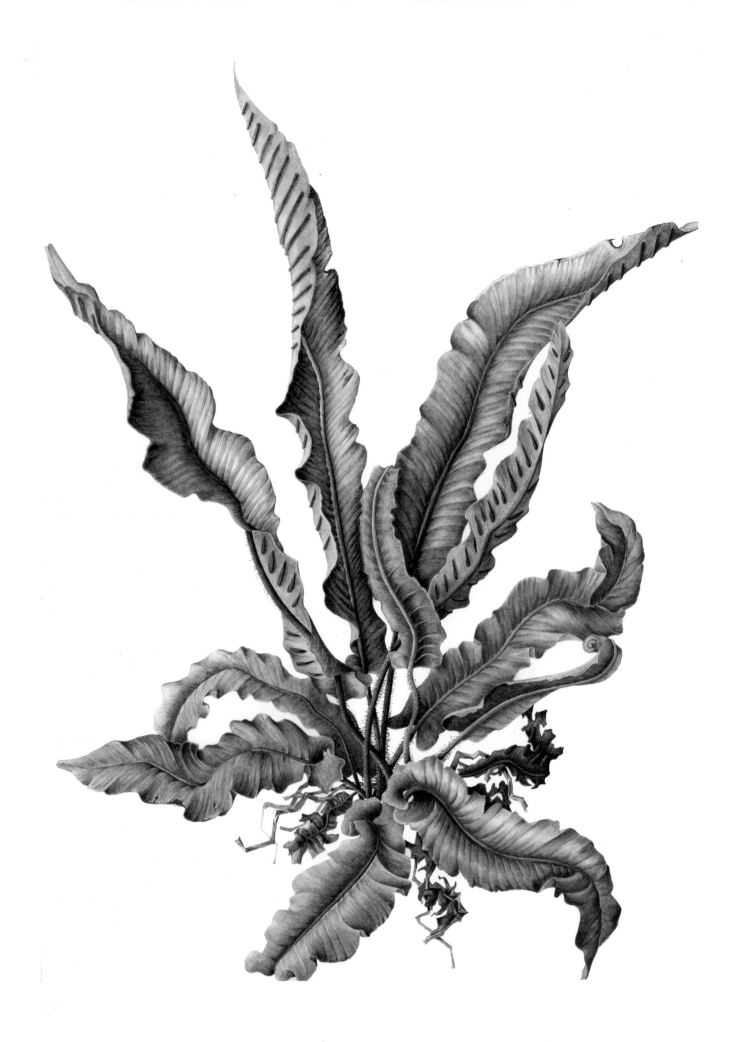

FERNS, CLUBMOSSES AND HORSETAILS

All these plants, the Pteridophyta, have veins made up of distinct conducting (vascular) tissues, the *xylem* and *phloem*, and are therefore, evolutionarily speaking, the first group of vascular plants. The plants have distinguishable stems, roots and leaves – unlike the more primitive mosses.

These plants are still evolutionarily primitive enough to have two distinct, different, alternating generations (see below) but, in comparison with the mosses, there has been a change in which generation is known as the 'plant'.

In the Pteridophyta, what we recognize as the fern plant is the *spore*-bearing, asexual, *sporophyte* generation. The sex organ-bearing *gametophyte* generation is a small, flat, green structure (a *thallus*) bearing the microscopic male and female sex organs (similar to those of a liverwort plant). The male sex cells swim and are reliant on a film of water to allow them to reach and fertilize the egg cell, so the ferns must inhabit damp habitats. The fertilized egg cell then grows out of the tiny, flattened thallus and into a new fern plant which soon becomes independent, whilst the thallus dies.

During the geological period known as the Palaeozoic, the ferns were at their zenith. All groups of ferns, and many more that have since become extinct, had a prodigious number of giant examples which covered the face of the earth. The tree ferns, where they occur en masse, still give one an idea of what the vegetation must have looked like. It is to these giant ferns, and their prolific growth, that we owe the energy-rich coal, oil, and gas deposits which were formed from their dead remains.

EVOLUTION AND THE ALTERNATION OF GENERATIONS

In higher plants and animals, such as the conifers (gymnosperms), flowering plants (angiosperms), and all the vertebrate animals from fish to humans, the main generation is the sporophyte whilst the sexual gametophyte generation has been reduced to a very transient generation consisting only of an egg and a sperm or pollen grain. Once the egg has joined with a sperm or 'pollen grain' to form an embryo, after the moment of fertilization, the next sporophyte generation has begun.

The three main groups of modern pteridophyte phyla

The Lycopodophyta – the clubmosses

These include *Lycopodium* and *Selaginella*, and look superficially like mosses as their leaves are small and simple, usually spirally arranged, and cover the stems densely. The stems branch

LEFT: Hart's tongue fern. (Annie Patterson)

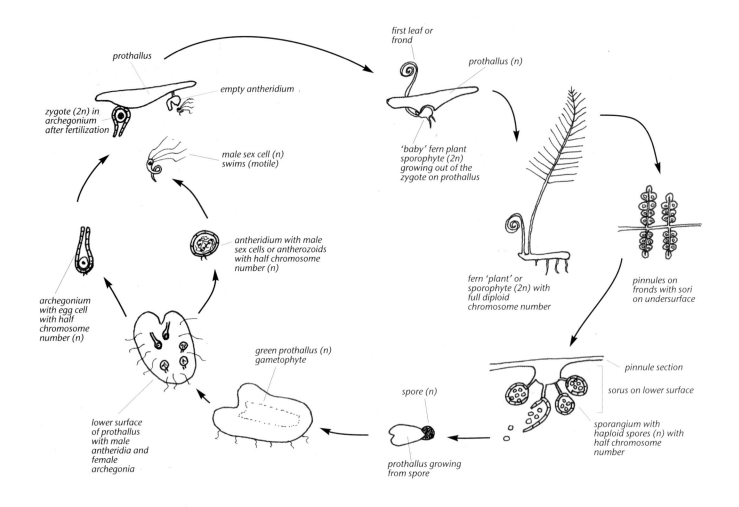

Typical life-cycle of a fern showing alternation of generations.

successively into two (*dichotomous* branching) and have a forked appearance.

The normal vegetative leaves are often different in shape and size to the fertile, spore-bearing leaves (*sporophylls*). These bear spore-producing capsules called *sporangia* in the axils of leaves of mature stems.

In *Lycopodium* species, sporangia are borne at the tips of mature stems, in club-shaped cones. In *Selaginella* species, sporangia are borne in fertile regions up the stem.

Note: the quillworts also belong in this group but are less common. They are aquatic.

The Phylum Sphenophyta – the horsetails

These have upright, hollow stems with rings (whorls) of small leaves that form a basal sheath around the stem, at a stem joint (node). The nodes are therefore quite distinct from the internodes (stem between the nodes) and give these plants (e.g. *Equisetum*) a distinctive look. Rings of branches arise at the nodes of some species so the tail-like plant looks 'hairy' and gives the group their common name of horsetails. These sterile, vegetative, non-reproductive stems are usually green.

The spore-bearing reproductive stems are pale and not green. These reproductive stems have a compact terminal cone in which the spore-bearing leaves are modified (*sporangiophores*) on the underside of which are the spore-producing sacs called sporangia.

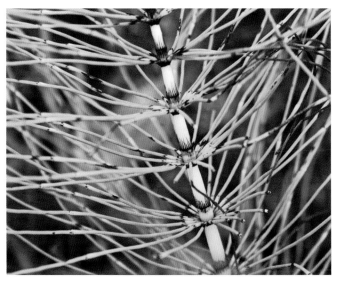

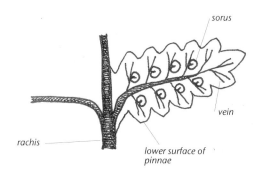

Position of sori.

Equisetum telmateia, Giant Horsetail stem showing detail and whorls.

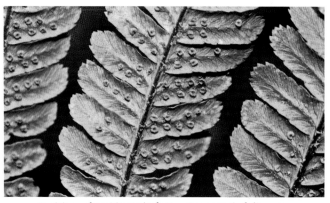

Position of sori in male fern – *Dryopteris felix-mas*.

The Phylum Filicinophyta – the true ferns

Today this group of ferns contains the most species, far outnumbering those in the other two groups. They are competing successfully with all the other groups of higher plants and still appear to be actively evolving.

True fern plants are generally distinguished from the other two groups by having leaves that are more strongly developed than their stems, although this is not the case in the prehistoric-looking tree ferns of the Antipodes, where the stems may reach 10 metres in height.

True ferns have large leaves called *fronds* which may be undivided (entire), or divided into leaflets (*pinnae*) that may be further subdivided into *pinnules*. Where the leaf is subdivided but

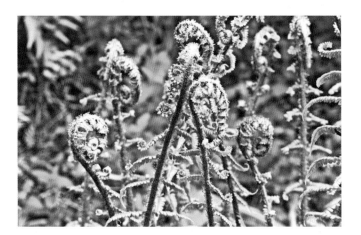

Fern crosiers unravelling.

doesn't form distinct leaflets, the division is known as a *segment* – which may be complete to the mid-rib or may not reach it.

In many ferns the young fronds are coiled like crosiers so that they are protected as they grow. The surface of the frond 'stem', particularly when it is young, may have distinct hairs or scales which may be lost as the frond ages.

The stems are usually short, forming underground food-storage organs called rhizomes, which have roots growing off them and produce the fronds at the stem's tip.

Fertile leaves are more mature and reproductive in function and have spore-producing sporangia in groups, forming a *sorus*, which may or may not be covered by a protective 'umbrella' of tissue called an *indusium*. Each sorus is located on a vein so that it gets sufficient nourishment.

Once the ripe spores are shed, from the sporangia, they travel in air currents until they reach a suitable moist habitat. Here they germinate and grow into a flat thallus, the gametophyte, which bears the male and female sex organs. After the egg cell has been fertilized, it grows into a baby fern plant, the sporophyte.

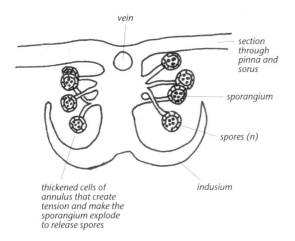

Section through a sorus.

Dryopteris felix-mas - male fern frond.

Features important in recognizing different ferns

In most genera fertile leaves are normally indistinguishable from vegetative leaves.

Shape of leaf-blade

The frond may be entire, e.g. hart's tongue fern, or in segments or pinnae. Pinnae may be further divided into pinnules. Be

Platycerium bifurcatum, Antler fern.

aware that the occurrence of segments, pinnae and pinnules may vary with the position on the frond. The frond, segments or pinnae may be ovate, *lanceolate*, triangular, linear, narrow, or oblong.

Shape of tip of leaf-blade or pinnae

They may be sharply pointed (acute), blunt or rounded (obtuse), recurved, incurved, drawn out into a point (*acuminate*), ending in a short straight point (*mucronate*) or some other shape.

Asplenium ruta-muraria, Wall rue fern.

Base of leaf or segment

These may be tapering, asymmetrical, at right angles to the mid-rib (truncate), running down the mid-rib or rachis on one side (decurrent), or attached by its whole width to the mid-rib (adnate).

Margins of pinnae

These may, for example, be toothed (serrate) with large or small teeth, scallop-edged (crenate), smooth (entire), waved (sinuate), reflexed, inflexed, or curled.

segments – leaflets not distinct

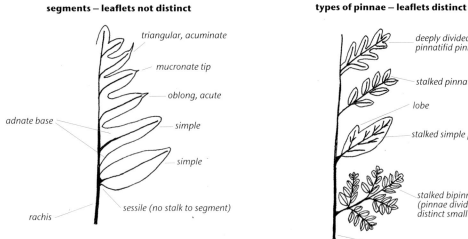

types of pinnae – leaflets distinct

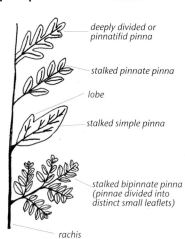

Types of segment and types of pinnae.

Veins of segments or pinnae

These may be simple, forked or doubly forked. Most veins are free at their tips, except for bracken (*Pteridium*) and hard ferns (*Blechnum*), where the vein tips are linked at the margins of the pinnae.

Arrangement of veins in fern frond.

Asplenium scolopendrium, Hart's tongue fern – part of frond showing veins.

Shape and position of sori

Sori are only found on mature fronds. They are found on the underside of the fronds and are always on veins or at the edges of the frond. Their shape varies depending on the type of fern. They may be variously shaped: round, kidney-shaped, long, oval and so on. The sori may be naked or protected by a flap of tissue called the indusium. If the indusium is present it may shrivel or be shed when the spores are ripe so that it doesn't get in the way of spore dispersal in dry air currents.

Wall rue fern with massed sporangia beneath.

Hart's tongue fern showing long sori and massed sporangia.

Polypodium, fern showing older sori with ripe and dehisced sporangia.

HELPSHEET 5: A Fern.

Take care to find a representative piece or plant when drawing or painting a fern. Young or sterile

plants are difficult to identify and there may be considerable variation in leaf size and shape. In

mature plants there is less variation.

Try to make sure that you have a fertile leaf with sori on the under-surface and that you have the

fronds' attachment to the stem (usually underground).

Hold leaves up to the light to observe veins.

Plant Name. Common Name ...Common Polypody Fern...........

Latin NamePolypodium vulgare.......

Habitat i.e. where it grows ...Shady woodland areas, on banks.......

Start by looking closely at the leaves (fronds).

Are the fertile leaves different to the vegetative leaves? ...No apparent distinction.....

1. **Describing A Typical Frond or Leaf.**

The Leaf Blade- entire, or divided into segments or into *pinnae?* Divided into segments.

If *pinnae* are present, are they further divided into *pinnules?* ...No pinnules or pinnae.

Does the arrangement of segments, pinnae and pinnules vary with the position on the frond?

Segments merge at tip of frond following the main vein. Where main vein branches/splits, the segments follow each vein.

Shape of whole leaf-blade, pinnae or segments.

Ovate, narrow, oblong, lanceolate, triangular, linear, or? Whole leaf blade linear, - longer then wide, to lanceolate - tapering towards tip from wider base.

Shape of the Tip of the leaf-blade, pinnae or segments.

Sharply pointed , blunt or rounded, recurved, incurved, drawn out to a point, ending in a

short straight point? Final tip of frond pointed and segments fused. Tips of segments rounded.

Shape of the Base of the Leaf, segment or pinna.

Tapering, asymmetrical, at right angles to the mid-rib, running down the mid-rib on one

side, attached by its whole width to the mid-rib or? Segments at about 45° to mid-rib. Most segments more or less equal in length (like feather) Segments attached by whole width to mid-rib and continuous with the segment next to it.

Completed Helpsheet 5. Fern.

Shape of Margins of the Leaf, segment ~~or pinna~~.

Toothed (~~large or~~ small teeth _1_..mm), scallop-edged, smooth, entire, waved, reflexed,

inflexed, curled, in-rolled ?...*Vary from toothed to more or less smooth. Teeth small, more obvious at tip of segment. Fronds uneven or curled in part.*

Detailed diagram of a couple of typical segments or ~~pinnae~~.

main Vein. *— segment*

Spacing of the segments ~~or pinnae~~.

Are they widely spaced or close together on the mid-rib? ...*Segments widely spaced from ½ cm above junction with mid-rib.*

Measure the distance between them*3 - 4*............mm gap.

Diagram. *see frond below.*

Are the pinnae stalked or not? ...

Are the pinnae opposite each other or alternate? ..

Segments alternate.

Drawing of a Whole Frond or Leaf.

Frond dull. Darker green above, paler below. Feels leathery.

from ⅓ to almost as long as frond 'blade'. Greenish and smooth with no scales.

2. **Arrangement of Veins in Leaf, Segments or Pinnae.** *Segment main veins black.*

Simple, forked or double forked? ...*Side veins indistinct — forked or double forked.*

Free at tips or linked at the margins?*free at tips.*.........................

3. **Scales or Hairs on the Stem of the main frond and/or on the Leaf.**

Pale, dark, thick, widely spaced, colour ?*None — stem and leaf smooth.*

Mainly on young parts of the plant or? *No scales or hairs.*

Do they persist as the part of the plant matures?

4. **Number, shape and Position of Sori** (On underside of fertile leaves)

Position: on veins or at edges? *On swollen tip of lower fork of a vein facing the tip of a frond. Forming a row on either side of mid-rib.*

Number ? *Numerous, especially at tip of frond.*

Shape ? *large and round.*

Diagram

Swollen tips of vein (appear lighter or browny blobs).

sorus

Naked or protected by a flap of tissue (*indusium*)? *Naked — sporangia obvious. (as dots)*

Is the indusium persistent or does it shrivel or fall off when sori are ripe (brown)?

..... *No indusium.*

Young sori pale green ⟶ yellow ⟶ brown in older sori.

Size of underground stems (*rhizomes*). *Horizontal, short (→ 1 cm) and thick (→ 4 cm)*

Is the fern growing on another plant (*epiphytic*) e.g. tree?
Not in this instance, but can be epiphytic.

Any other noteworthy features?

⊗ *Segments*
Pale oval patches near tips, of long side vein branch, at leaf edge. Swollen parts of vein.

Small brown patches in same position as sori occur (in fertile leaves). i.e. in a row along the side of the segment mid-rib. Probably placenta tissue where sori could have developed on fertile parts of the frond.

This helpsheet for observing ferns can be adapted for use with the other groups.

143

MOSSES AND LIVERWORTS

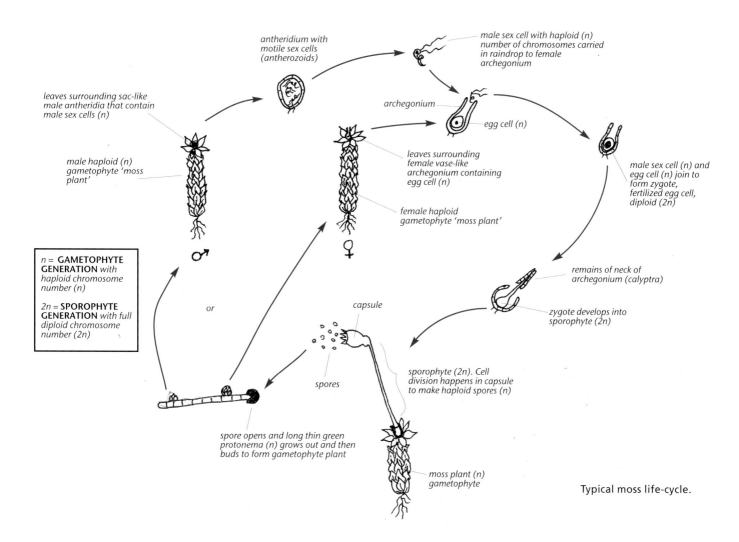

antheridium with motile sex cells (antherozoids)

male sex cell with haploid (n) number of chromosomes carried in raindrop to female archegonium

leaves surrounding sac-like male antheridia that contain male sex cells (n)

archegonium

egg cell (n)

male haploid (n) gametophyte 'moss plant'

leaves surrounding female vase-like archegonium containing egg cell (n)

male sex cell (n) and egg cell (n) join to form zygote, fertilized egg cell, diploid (2n)

female haploid gametophyte 'moss plant'

n = **GAMETOPHYTE GENERATION** with haploid chromosome number (n)

2n = **SPOROPHYTE GENERATION** with full diploid chromosome number (2n)

remains of neck of archegonium (calyptra)

zygote develops into sporophyte (2n)

or

capsule

sporophyte (2n). Cell division happens in capsule to make haploid spores (n)

spores

spore opens and long thin green protonema (n) grows out and then buds to form gametophyte plant

moss plant (n) gametophyte

Typical moss life-cycle.

These plants, the Bryophyta, are more advanced than the algae and are more primitive than ferns. Evolutionarily they are equiv-

alent to the amphibians, such as frogs, toads, and newts, of the animal kingdom. They live on land but require water to repro-

LEFT: Shuttlecock fern. (Annie Patterson)

duce sexually, as the male sex cells must swim to the waiting female 'egg' cell for successful reproduction. We have all seen frogs returning to ponds in the spring for exactly the same reasons.

The bryophytes include both the mosses (*Musci*) and the liverworts (*Hepaticae*). They are all too primitive to have proper veins as they lack xylem and phloem (conducting tissues). They also lack roots and most frequently live in moist conditions such as those found in woodlands, growing on wet soil, on damp tree bark, on damp river banks and in bogs. Their detail often requires a ×20 lens or a microscope to be distinguished clearly.

Being primitive plants they have two distinct generations in their life-cycle, which alternate, but can often be found at the same time, on the same 'plant'. These two generations consist of the gametophyte generation and the sporophyte generation. The green 'plant-like' gametophyte generation develops male sex organs (*antheridia*) and female sex organs (*archegonia*) and carries out sexual reproduction with the aid of raindrops that carry the swimming 'sperm' to fertilize the egg cell (in a vase-like archegonium). After this, the tall, thin, sexually produced sporophyte generation grows out of the fertilized 'egg', as a stalk and has a swollen spore-containing capsule on the top. The spores are wind-distributed and when they reach a suitable habitat they grow into new green gametophyte 'plants' and the cycle continues anew. Just think what damage you do to a moss's sex life when next you sit on or trample it!

Assorted *Sphagnum* bog mosses, Southern Ireland.

The mosses (*Musci*)

Mosses are amazingly resilient plants that are easily collected, dried and kept in paper packets for later use. They can survive for decades in this dormant state but 'come back to life' when moistened. This resilience has allowed them to colonize almost anywhere, e.g. roof tiles, walls, tree bark, sand-dunes, bare soil. This gives them great ecological importance as pioneering 'primary colonizers', which improve conditions so that higher

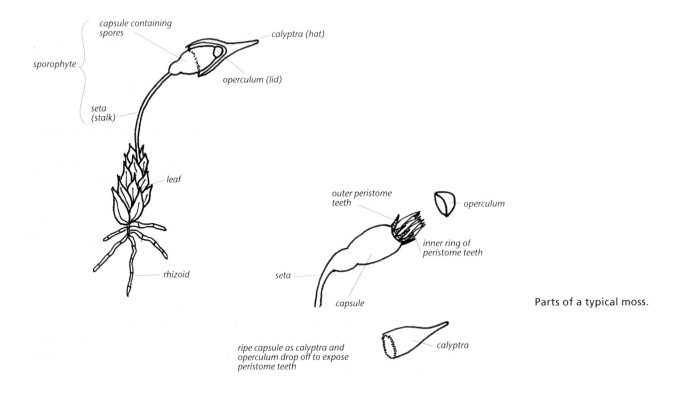

Parts of a typical moss.

plants and animals can then colonize and survive.

Peat or bog moss (*Sphagnum*) has pores on its leaves that soak up water like sponges. These mosses form peat bogs which are economically important as they provide the peat for domestic fuel when dried and cut into turves for burning. Also peat can be dried and crumbled to provide the garden peat that we add to soil to enrich it and keep it moist. The water absorbency of this moss makes it useful in bogs where it acts as a rainwater storage area and so prevents flooding. Florists also use this moss, although less so since the invention of 'oasis foam'.

Moss plants (gametophytes) can be recognized by having:

- a simple stem;
- simple leaves (never lobed), that are spirally arranged and may have obvious mid-ribs;
- thin, hair-like rhizoids, which are multicellular (c.f. liver worts).

Moss plants grow from a spore when it lands in a nice moist habitat. The stalked capsules (sporophytes) have:

- a cap or *calyptra* when developing. These 'hat-like' remains are the walls of the vase-like archegonium, which originally surrounded the egg cell. The cap protects the developing capsule and falls off when the spores are ripe.
- Beneath the hat-like calyptra there is a lid (*operculum*), which protects the developing spores in the capsule but breaks away at a ring of cells, called the *annulus*, when the spores are ripe. The operculum falls off to expose the entrance to the swollen spore-filled capsule.
- The capsule entrance (the stoma) is surrounded by up to two rows of tough *peristome teeth* that twist as they dry out unevenly. This twisting flicks spores out of the capsule and into the air currents for dispersal to a suitable place for the spore to grow into a new moss plant.

Important features for identifying and classifying mosses

LEAF SHAPE
Vegetative leaves on the moss plant may vary in size, colour and shape from the leaves surrounding the reproductive organs. Also the leaves associated with the reproductive organs may vary between those surrounding the male sex organs (*perigonial* leaves) and those surrounding the female sex organs (*perichaetial* leaves). These specialized leaves may also be brightly coloured and/or form a flower-like cup at the tip of the

Bryum capillare – details of leaves and capsules.

plants.

Vegetative, non-reproductive leaves are usually described by their shape e.g. rounded, lance-head shaped (*lanceolate*), tongue-like (*lingulate*), sickle-shaped (*falcate*), divided at the tip (*bifid*), folded or wrinkled (*plicate*).

Some leaves may have the mid-rib extending beyond the leaf-tip as a long, colourless (*hyaline*) hair. In other leaves the mid-rib is short and may not reach the tip or may be absent entirely.

LEAF MARGIN
These may be smooth, hairy, toothed, or be otherwise strengthened by specialized cells.

LEAF CELL SHAPE AND STRUCTURE
This level of microscopic detail may well be needed to identify mosses to a species level!
Some cells may be covered by small protuberances (*papillose*); others may have long, narrow cells, or hexagonal cells. The shapes are many and varied. *Sphagnum* has leaves with patterns of cells of alternating clear water-filled cells, with pores that allow the water in, and green living cells, which photosynthesize.

THE 'ROOT' OR RHIZOID SYSTEM
This may vary from a thick, felt-like system that covers the stem, to a well developed, obvious system anchoring the plant in the *substrate* that it grows on, or a weak system with only a few thread-like *rhizoids*.

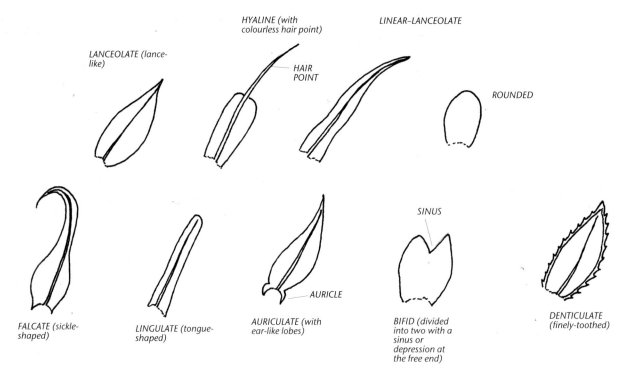

LANCEOLATE (lance-like)

HYALINE (with colourless hair point)

HAIR POINT

LINEAR–LANCEOLATE

ROUNDED

FALCATE (sickle-shaped)

LINGULATE (tongue-shaped)

AURICULATE (with ear-like lobes)

AURICLE

SINUS

BIFID (divided into two with a sinus or depression at the free end)

DENTICULATE (finely-toothed)

Leaf shapes in bryophytes.

FORKING or DICHOTOMOUS

PINNATE OR PLUMOSE, e.g. Ctenidium molluscum

PINNATE WITH PLEUROCARPUS CAPSULE ON A SIDE BRANCH, e.g. Hypnum

capsule

BRANCHES IN FASCICLES or bundles, e.g. Sphagnum (bog moss)

branches usually in fives

main stem stout

DENDROID OR TREE-LIKE, e.g. Climacium dendroides

ERECT WITH ACROCARPOUS CAPSULE, e.g. Funaria

capsule

Branching habits of mosses.

BRANCHING

Branching, or a lack of branches, gives most species of mosses their characteristic appearance. Branches tend to occur just below leaves, unlike branches that arise from buds in the axils of leaves in flowering plants. Moss branches arise from a surface stem cell that changes status to become 'apical' and divides to form a branch. Depending on the arrangement of the new apical cells, the moss plant will develop a distinctive look or habit.

COLOUR AND LENGTH OF CAPSULE STALK

In mosses the sporophyte stalks (*setae*) are generally strong, lengthen early and persist – unlike those of liverworts. The colour and length may be diagnostic for a species. Setae may develop at the tip of a main shoot, in an *acrocarpous* fashion, or from a side branch, in a *pleurocarpous* fashion.

Sphagnum is distinct in that it has no true setae. Their spore capsules are borne on short, weak and numerous 'setae' amongst the terminal cluster of moss shoots.

CAPSULES

These are characteristic for different groups of mosses, so note the shape, colour and how they are held at the tip of a seta.

Brachythecium rutabulum. Pleurocarpous moss showing branching growth.

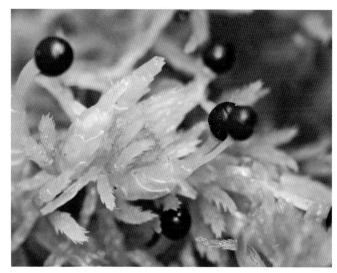

Sphagnum subnitens, Bog moss with capsules.

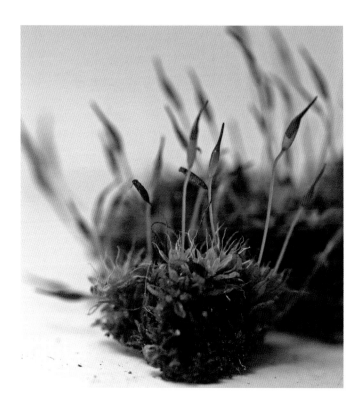

Tortula muralis, Wall moss with acrocarpous habit.

THE CALYPTRA

When the capsule is unripe, the calyptra ('hat' of tissue) may be distinctive in shape and colour.

THE PERISTOME

When the capsules are ripe, the calyptra and operculum lid fall off to expose the stoma, or opening to the capsule, and the surrounding peristome which consists of a single or double ring of teeth that surround the stoma.

The peristome usually consists of sixteen teeth that taper to points – there may be a double or a single ring of teeth. Where

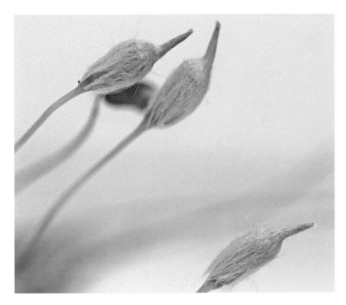

Polytrichum commune – moss capsules with hairy calyptra.

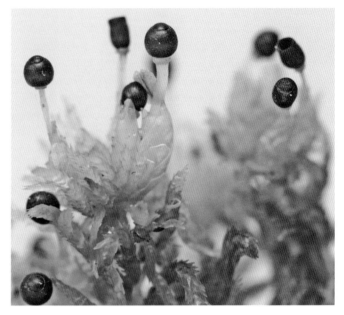

Sphagnum subnitens – closed and open capsules.

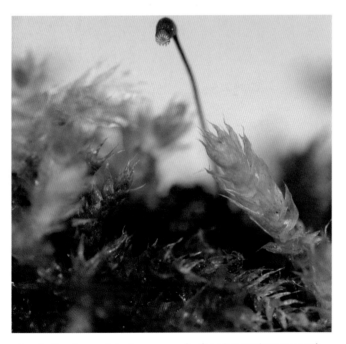

Brachythecium rutabulum – capsule showing peristome teeth.

there is a double ring, the outer ring is usually made up of tough, thickened teeth that may be upright, twisted or reflexed. Where there is an inner ring of teeth, these teeth arise from a basal membrane and there may be sixteen or fewer. Hairs (cilia) may also arise from the membrane between the inner and outer teeth. *Sphagnum* capsules have no peristome teeth and the spores are released by pressure, which 'blows' the lid off the capsule and releases them.

The liverworts

The liverworts (Hepaticae) look less like conventional plants than the mosses. Like the mosses, they are anchored by thin hair-like rhizoids but these are single-celled. However, the 'plants' (gametophytes) develop in two very different forms.

Thalloid plants

These consist of a dorso-ventrally flattened (like a pancake), green, liver-like (hence their name, lobed, leafless, thallus. The thallus may successively divide into two equal branches at its tip (dichotomous branching). It may have a well-defined mid-rib and often has obvious pores which lead into air-filled chambers in the surface of the thallus. Although only 16 per cent of all liverworts are thalloid, they are usually more obvious than the larger group of leafy liverworts. A common liverwort found on soil in pots in glasshouses is *Marchantia*.

Leafy liverwort plants

These have a simple stem and three rows of leaves: two rows of larger leaves on the top and one row of small leaves on the lower surface. These look more like mosses but the leaf arrangement is quite distinct. Also the leaves are often bi-lobed or cleft.

HELPSHEET 6: A Moss.

Try to collect the plants and also some bits with the stalks and capsules sticking out.

You will need a dissecting microscope or a very good hand lens to help you see and record details.

Moss Name: Common Name (if there is one)...

Latin Name*Funaria hygrometrica*...............................

Habitat and what it was growing on: ...*bare soil in garden near old bonfire;*
also in soil of 'pots'.

1. **Leaves.**

Leaf shape - Rounded, lance-head shaped, tongue-like, divided at the tip, folded or

wrinkled? *Uneven in size; 'large', broad and pointed at tip.*
(Very large hexagonal cells on leaves – under microscope.)

Leaf Margin- Smooth, toothed, or otherwise strengthened by specialised cells?

...........*Smooth margins*...

Leaf Mid-Ribs- present or absent?.....*present.*...................

- short (not reaching the tip of the leaf), or extending beyond the leaf-tip as

a long colourless hair? ...*not extending into leaf tip*...........

Leaf Cell Shape- covered in protuberances, or with long, narrow cells, or hexagonal cells

or clear cells with pores that may be water-filled (*Sphagnum*)?

.........*hexagonal cells — getting larger the nearer the leaf-base.*

2. **Branching Habit (Shape of Plant).**

Plant erect without branches or branched? ...*Erect, with few branches.* (*3-10mm*)

Type of Branching- forked into 2, opposite pairs of side branches, side branches alternate,

tree-like branches, rings of branches?*Few branches from close to base*
of erect shoot.

Drawing *(larger than life)*

seta
3-5 cm.

capsule
deformed calyptra 'hat'.

male
rosette of
perichaetal leaves

uneven sized leaves
of female "tuft"

stem

Completed Helpsheet 6. Moss.

3. **Rhizoid System**.

Thick and felt like covering on the stem, and / or, well developed anchoring system
embedded in substrate? *Embedded in substrate at base of plant stem.*

Not obvious, weak system with few rhizoids? *Not obvious.*

4. **Capsule Stalk (*Seta*)**.

At tip of main shoot or on side branches? *tip of main shoot.*

Measure Length *2 - 4 cm* ▬▬▬ (may be diagnostic) – *long.*

Strong or weak? *thin / fine* Persistent? *Only with old brown capsules;*

Colour? *green → orange → rusty brown.*

5. **Spore Capsules**, at tip of stalk.

Shape e.g. cylindrical, rounded, short, curved? *Pear-shaped and curved.*

Position (how they are held at tip of seta) e.g. erect, dangling, horizontal, inclined, swan-
necked, other? *Swan-necked, ± horizontal when older.*

Colour when developing ? *green*,and when ripe? *Orange → rust brown and ridged.*

6. **"Hat" of Tissue (*Calyptra*)**, on unopened capsule.

Shape? *narrow and pointed on young capsule. Deformed on swelling capsules and drops off early. ∴ Most capsules without.*

Colour ? *pale translucent green.*

7. **Teeth Surrounding the Mouth of the Capsule (*Peristome*)**.

No teeth (Sphagnum)? *Has teeth.*

Double or single ring of teeth? *Only one ring visible*

Are hairs present arising from the membrane between the rings of teeth ? *Can't see!*

Outer ring of thickened teeth, upright, twisted or reflexed (bent backwards)?
Curved and joined at tips to a central disc.

Drawing.

Capsule — *bent Seta of younger green capsule.* — *falling off 'hat'*

ridges on old capsule — *teeth* — *Seta*

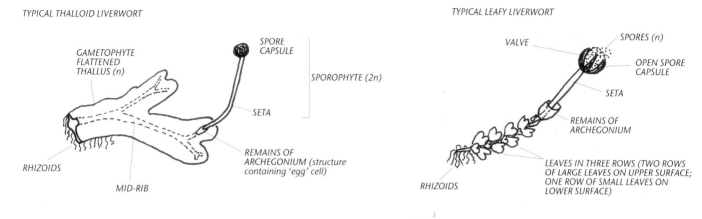

TYPICAL THALLOID LIVERWORT

GAMETOPHYTE FLATTENED THALLUS (n)

SPORE CAPSULE

SPOROPHYTE (2n)

SETA

REMAINS OF ARCHEGONIUM (structure containing 'egg' cell)

RHIZOIDS

MID-RIB

TYPICAL LEAFY LIVERWORT

VALVE

SPORES (n)

OPEN SPORE CAPSULE

SETA

REMAINS OF ARCHEGONIUM

RHIZOIDS

LEAVES IN THREE ROWS (TWO ROWS OF LARGE LEAVES ON UPPER SURFACE; ONE ROW OF SMALL LEAVES ON LOWER SURFACE)

Liverwort growth forms.

Asexual or vegetative reproduction by gemmae

This occurs in many thalloid liverworts. *Gemmae* are small plates of tissue that can grow into a new liverwort plant. They normally occur on the upper or dorsal surface of the thallus in obvious membrane-bound 'gemmae cups'. These gemmae cups look a bit like mini bird's nests.

The stalked capsules (sporophytes)

These consist of a stalk (seta) and capsule. The seta is usually delicate and colourless and does not persist unlike those found in mosses. The capsule is usually oval or spherical and dark with a glossy surface. There are no peristome teeth as the capsule wall normally splits into valves to expose the spores when they are ripe.

The spores

In most liverworts the spores are mixed with long, narrow, hair-like *elaters* which twist as they dry and flick out the spores. These elaters may arise in the centre of the base of the capsule or in tufts on the tips of the valves. Thickening bands in the elaters are also species characteristic.

Mosses and liverworts are difficult to identify without a microscope, or a very strong hand-lens, and a lot of patience. For most botanical artists the actual identification to species level will be unnecessary. However, an awareness of their structure and what to look out for and include, can only mean that pictures with a 'bit of moss', often included for artistic effect, will not grate on a botanist's eye. On the other hand, you may be inspired to draw these plants for their own sakes and will have sufficient knowledge to use more specific tomes.

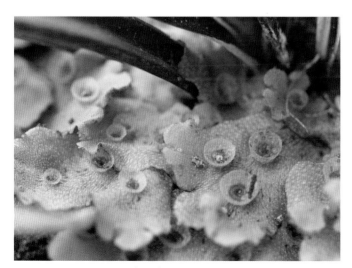

Marchantia, gemmae cups.

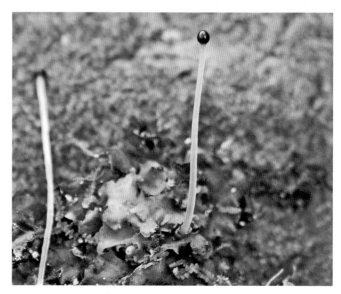

Pellia – liverwort with capsules.

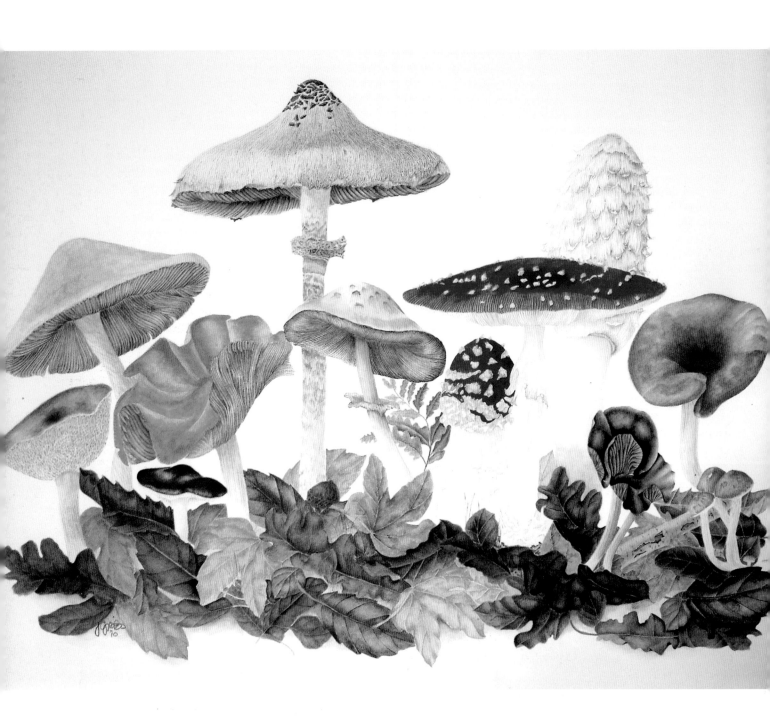

FUNGI AND LICHENS

Fungi

Fungi are typified by having no chlorophyll (green pigment) and therefore are unable to carry out photosynthesis. This means that they do not need light to grow but must obtain food by 'digesting' other things, i.e. they are parasites (living on other living organisms, e.g. athlete's foot fungus on humans) or saprophytes (living on dead organisms). By digesting dead organisms, they cause decay and are important in food-chains as 'recyclers' and for increasing soil fertility. They prevent the build-up of dead leaves and animals in the environment – acting as waste disposal operatives!

Economically they are expensive as their 'digesting' destroys crops and food stuffs, fabrics, leather, paint and most other materials (even glass) and causes diseases that debilitate plants and animals, weaken crops and herds and are expensive to treat. Some fungi are economically useful as they are involved in many industrial processes e.g. fermentation in bread, wine, cider, alcohol and brewing. They are also involved in the fermentation of the cacao (chocolate) bean for chocolate production, the colouring of blue cheeses, the commercial production of vitamins, organic acids and enzymes, and antibiotics.

Others form mycorrhizae by associating with higher plant roots – this benefits both the plant (which grows more successfully) and the fungus.

Added to these uses, some fungi are edible (mushrooms) and enhance various gastronomic dishes.

Fungal structure

Most fungi are made up of filamentous, thread-like structures called '*hyphae*'. Exceptions include yeasts, which are rounded single cell-like structures, and the slime-moulds, which are probably not fungi and are more like amoebae. Hyphae, en masse, make up a fungal 'plant' or *mycelium* which is generally unseen as it grows through its food source (*substrate*). One gen-

Milk drop mycena fungus showing base of stalk, felted and hairy. Hyphae apparent as fine silvery threads.

LEFT: Mixed fungi. (Jan Gibbs)

erally only sees fungi when they are reproducing and produce many microscopic 'spores' from fruiting bodies called *fructifications*. These fructifications are large aerial spore- producing structures, which are designed to help disperse spores. We see and recognize these as the mushrooms, toadstools, moulds, mildews, rusts, smuts, puffballs and brackets.

Fungi are no longer classified as plants. They have been given their own distinct kingdom, as they have no chlorophyll, can't photosynthesize and their cell walls are not made of cellulose. The division of the fungal kingdom is based on a Linnaean system with phyla (major divisions), orders, families, genera and species. The grouping of the fungi takes into account their reproductive structures. However, the system is constantly being updated and there are many slightly different systems, used in books, which can be confusing.

The majority of the 'true fungi' (*Eumycota*) have thread-like hyphal mycelia and spore-bearing fructifications which are readily visible with the 'naked eye' (without a microscope) and generally belong to three main sub-divisions that are distinguished by how the microscopic spores are produced.

These are the Zygomycetes, the Basidiomycetes and the Ascomycetes. However, I shall not include details of the Zygomycetes, as this group includes many moulds (often found growing on bread and fruit) which are smaller, much more difficult to distinguish and less decorative to paint.

The Basidiomycetes

Basidiomycetes produce spores that are called basidiospores as they are borne on specialized cells that are called *basidia*. They include the majority of the fungi that you notice and the mushrooms and toadstools. Mushrooms (edible) and toadstools (poisonous) are commonly used terms that are scientifically inexact but we all understand what they mean! Also included in this group are the brackets, puffballs, stinkhorns, earthstars, jelly fungi, bird's nest fungi, and parasitic rust and smut fungi.

The Basidiomycetes are divided into three main groups.

1. Holobasidiomycetes – the mushrooms, toadstools, and brackets. In this group the spore-producing basidia cells form in layers and shed the spores into the air currents. The layers of basidia cover or line:
 - gills, e.g. edible mushroom,
 - tubes, e.g. French cep or English penny bun (*Boletus*),
 - spines or teeth, e.g. the wood hedgehog (*Hydnum*), and
 - veins or folds, e.g. the chanterelle or French girolle.

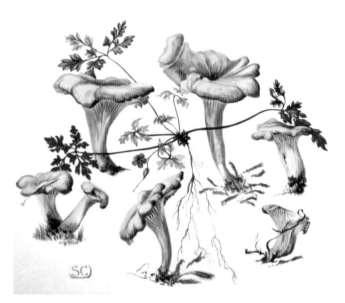

Chanterelles and Herb Robert on vellum. (Sheila Clarke)

2. Gasteromycetes – the stinkhorns, earthstars, puffballs, bird's nest fungi. In this group the spore-producing basidia are enclosed inside a fruiting body, which has a very distinctive form.
3. Heterobasidiomycetes – the jelly fungi (Tremellales). In this group the basidia form a layer on the outside of the fruiting body. These fungi are very hard when dry and gelatinous when moist, e.g. Jew's ear fungus.

The Ascomycetes

These fungi produce spores called *ascospores*, which are formed in specialized cells called asci. Included in this group are the yeasts, *Penicillium* (the mould that yields penicillin), truffles, morels, cup fungi (e.g. *Peziza*), coral spot fungi, dead man's fingers and cramp balls.

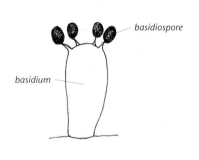

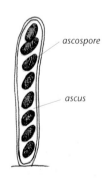

A basidium. An ascus.

Lycoperdon perlatum – Common puffball.

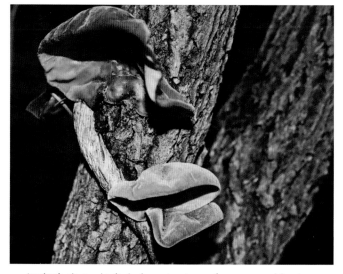

Auricularia auricula-judae – Jew's ear fungus on elder tree.

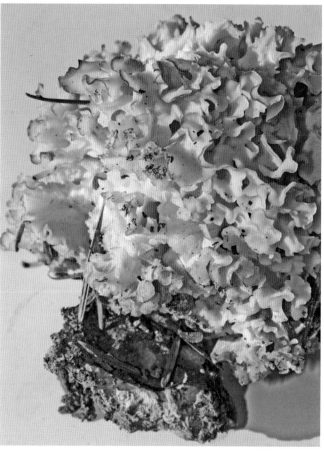

Sparassis – parasitic cauliflower fungus.

The larger Ascomycetes are divided into two groups.

1. Discomycetes – the cup fungi, morels, truffles. In this group the *asci* cells form in a layer on the surface of the fungus fructification.

2. Pyrenomycetes – cramp balls, dead man's fingers, coral spot fungi. In this group the asci cells line sunken, chamber-like structures that open to the surface through small holes, called *ostioles*. When mature, the spores escape through these holes and may be of a different colour to the rest of the fungus.

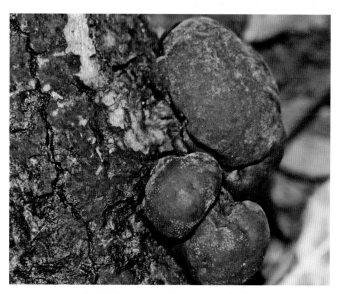

Daldinia concentrica – Cramp balls.

Xylaria hypoxylon – Stag's horn fungus.

Parts of a typical mushroom (fructification)

These consist of a stalk (*stipe*) and a cap made of massed, compacted thread-like hyphae (rather like a mass of damp cotton wool fibres). The fructifications grow from the food source (substrate) that its parental thread-like hyphae have been feeding on. The cap develops spore-producing structures, such as gills, veins, tubes or spines/teeth, which are covered in cells where the spores are formed. These spores are microscopic and numerous and each will grow into a new fungus 'plant' (*mycelium*) if it lands in a suitable habitat. All the different shapes of fungi are designed to help them to disperse their spores most efficiently – depending on their particular strategy.

During their development some capped fungi have very obvious 'veils of tissue', e.g. the *Amanita* genus, which includes death caps and fly agarics (red, spotted caps that are cheerfully obvious).

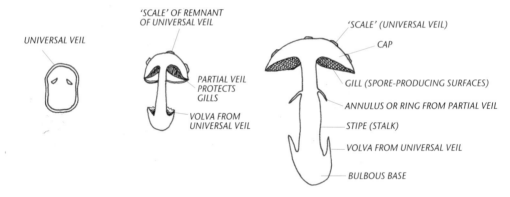

Development of a basidiomycete showing veils.

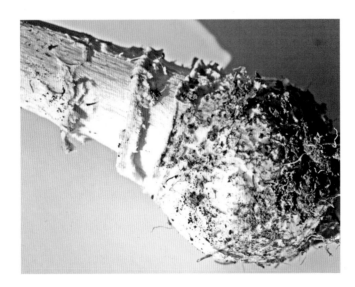

Amanita muscaria – bulbous base with volva, warty remains of universal veil.

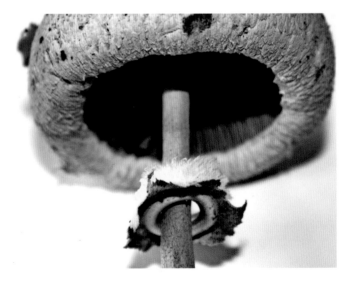

Parasol mushroom with free moveable ring – white scales above and brown below.

There are two types of veil:

1. The universal veil covers the whole 'baby' fungus fruiting body. It tears as the stalk extends and the cap separates as the fungus grows. The remains of the universal veil are often found as large scales on the cap e.g. the white bits on the red fly agaric's cap and at the base of the stalk or stipe. In some species it remains as a cup-like *volva*, e.g. *Amanita*. Fungi with a volva are usually deadly poisonous! This is why you must always collect the base of the stalk of every mushroom – especially if you intend to eat it. However, many fungi show no evidence of the universal veil when mature.

2. The partial veil covers the developing gills and stretches from the margins of the cap to the stalk. As the cap grows, and expands, the partial veil tears away and in some species remains as a membranous ring or annulus around the stalk. Whether there is an annulus, or not, is characteristic of a species.

DISTINGUISHING FEATURES TO LOOK OUT FOR WHEN OBSERVING A 'CAPPED' FUNGUS

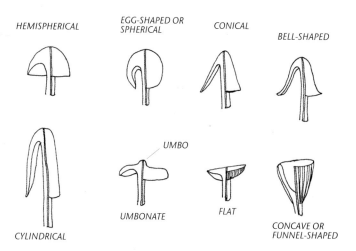

Cap shapes in the basidiomycetes.

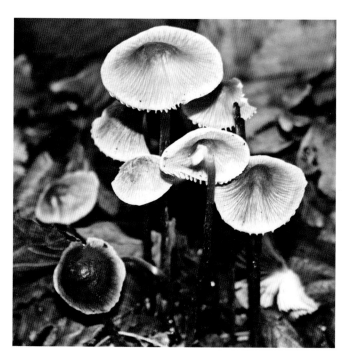

Mycena fagetorum with wart-shaped umbo on conical cap.

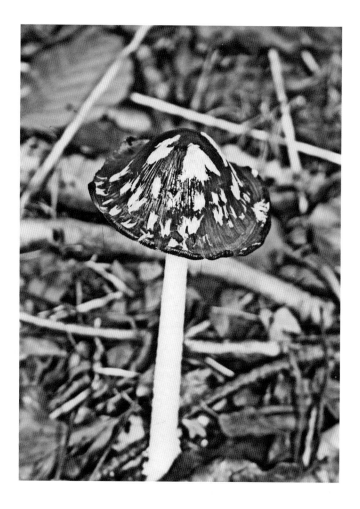

Coprinus picaceus, Magpie ink cap, with bell-shaped cap and up-rolled inky margin.

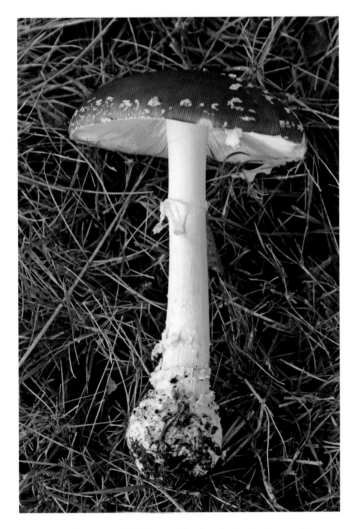

Macrolepiota procera, Parasol mushroom – spherical cap when young, coarse scales. Drumstick shape.

Amethyst deceiver – gills thick, adnate and noticeably distant.

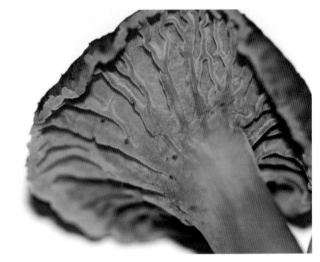

Cantharellus tubaeformis – far apart branching veins and in-rolled cap margin.

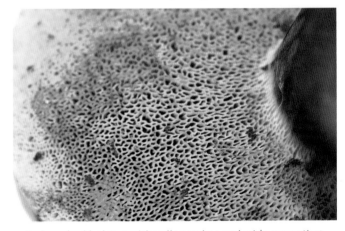

Amanita muscaria, Fly agaric – hemispherical cap with white scales.

Red cracked boletus with yellow tubes and wide pores that stain blue when bruised.

GILLS

SPINES

SPINES

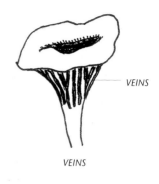

VEINS

VEINS

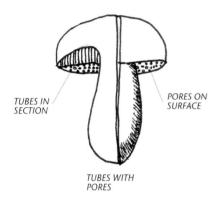

TUBES IN
SECTION

PORES ON
SURFACE

TUBES WITH
PORES

Types of spore-producing surfaces in the basidiomycetes.

MAKING A SPORE PRINT

Make spore prints to identify the colour of the spores produced. These may differ from the colour of the gills, tubes or spines and are characteristic.

Break the stalk cleanly off the cap and then put the cap, gill side down, onto a piece of paper or card. (If you think the spores may be white, use a dark coloured paper so the spores show.) Leave the cap on the paper for at least twenty-four hours, so that the spores have time to be shed. Then carefully lift the cap and see the outline of the spore-producing surface – made by millions of microscopic spores. If there is no print – perhaps the cap had already shed them or was too immature – use a younger or older cap and try again.

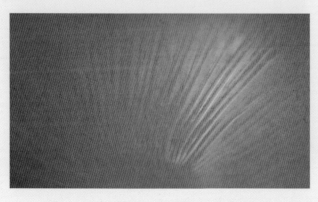

Fly agaric – white spore-print on pink paper.

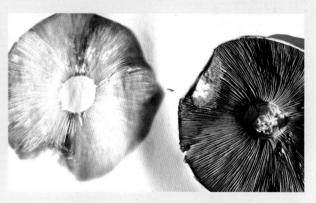

Agaricus xanthoderma – spore print.

LOOKING AT GILL ATTACHMENTS TO THE STALK

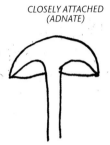

CLOSELY ATTACHED (ADNATE)

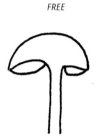

FREE

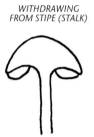

WITHDRAWING FROM STIPE (STALK)

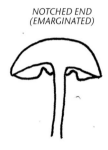

NOTCHED END (EMARGINATED)

Types of gill attachment.

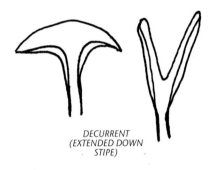

DECURRENT (EXTENDED DOWN STIPE)

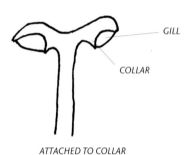

GILL

COLLAR

ATTACHED TO COLLAR

Gills run from the cap margin and their inner attachments, to the stalk, vary in several ways. In some instances they are too short to meet the stalk.

THE STALK OR STIPE
This supports the cap and raises the spore-bearing surfaces into the air for efficient dispersal by wind currents, insects etc. The shape of the stipe varies depending on the type of fungus. Beware of fungi with bulbous bases surrounded by a cup-like membrane (volva) – they are often deadly if eaten.

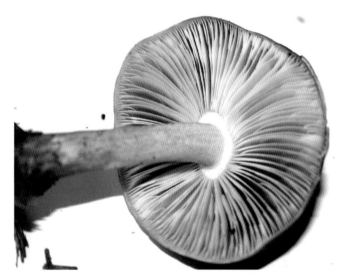

Fawn pluteus fungus – gills thin, crowded and free (unattached).

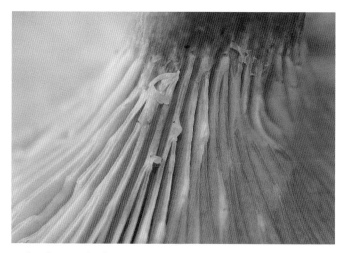

False chanterelle fungus – gills narrow and thick-ridged with a blunt edge. Gills are also branched and decurrent (grow down the stalk).

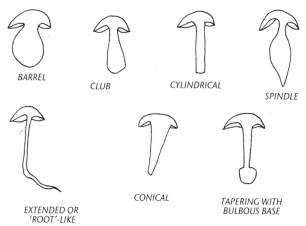

BARREL

CLUB

CYLINDRICAL

SPINDLE

EXTENDED OR 'ROOT'-LIKE

CONICAL

TAPERING WITH BULBOUS BASE

Types of stipe/stalk shape.

Emarginate, sinuate or notched gill attachments.

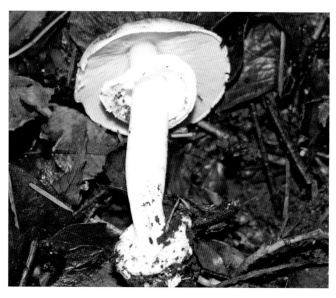

Agaricus xanthoderma (young) – with bulbous base, pink gills and wide ring.

Fungus with felted, root-like base to stipe.

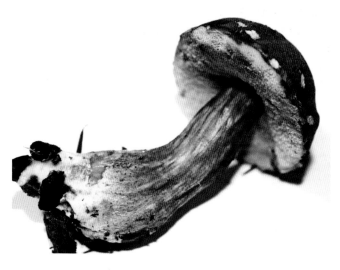

Boletus with club-shaped stipe.

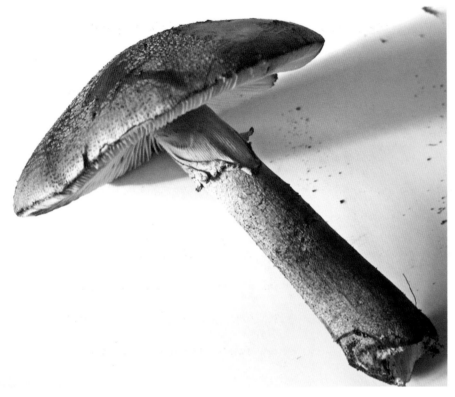

Observations of 'The Blusher'.

1. *Amanita rubescens* showing tapered stipe and grooved ring. Cap with scales that wipe off.

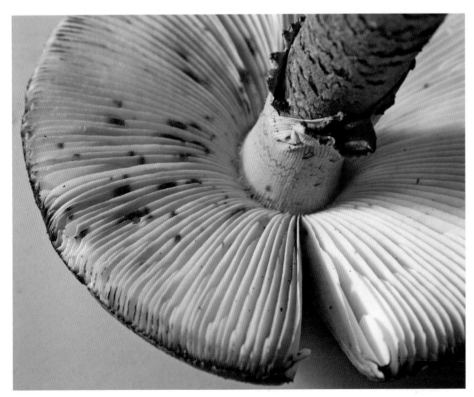

2. *Amanita rubescens* – detail of gills, grooved ring and scales on stipe; they are red when ripe.

HELPSHEET 7: A "Capped" Fungus (Mushroom, Toadstool or Bracket) – Collecting and Observing.

Note the habitat – where you found it e.g. grassy meadow, woodland margin, beech wood, near a birch tree etc. *Mixed conifer and deciduous woodland on chalk.*

Is it growing in the form of a "fairy ring"? *No*

If it is a Bracket or tuft of fungi growing from dead wood – note the type of wood e.g. oak, silver birch etc. *Not attached to wood or tree.*

Note the date or time of year that you found it. *October / September*

Make sure you collect the "whole" fungus – right down to the base of the stem, but avoid damaging the thread-like mycelium from which it has grown! Also collect a spare cap to use for making a spore-print – to see what colour the spores are. Try to collect young and mature specimens, as they may differ markedly.

Habit. - Is it growing singly or in groups? *Singly or in small groups.*

Type. - Is it a bracket? *No*

 Does the bracket emerge singly or in tufts? *——*

 Are they obviously stalked or lacking an obvious stalk? *Stalked.*

The Cap Shape - Is it hemispherical , egg-shaped, conical, bell-shaped, cylindrical, flat, funnel-shaped or flattish with a knob in the centre (*umbonate*)? *hemispherical → convex → flattened.*

The Cap Surface - Is it smooth, dimpled, wrinkled, rough, bare, hairy, velvety, fibrous, covered in scales, sticky, dry, dull, shiny, streaked? *Covered in warty scales that are easily rubbed off.*

The Cap Colour - *Remember this may vary depending on whether the fungus is wet or dry.*

reddish-brown/reddish grey. Warty scales reddish-grey on cap.

The Size range of the Caps - There will be a maximum and minimum range for typical specimens (in mm, cm) *5 – 15 cm in diameter*

Completed Helpsheet 7. The Blusher.

The Cap Margin - regular, wavy, turned up, turned in, turned down, sharp or rounded edges,

fragments of veil attached.? *Regular cap margin*

Peeling the Skin off the Cap - Easy, difficult, doesn't peel? *Doesn't appear to peel.*

Colour of the Flesh - Immediately on exposure to air...... *White*

After 5-10 minutes exposure *Slowly reddening → dark red-brown.*

Does the flesh yield *latex* ?...... *No*

If yes, what colour ?

Diagram.

hemispherical
reddish warty scales
broad groove ring (yellowish)
white-reddish flakes on stem (stipe)
gills
tall, thick, tapering stem
bulbous base

The Spore Bearing Surfaces.

i) Gills:

Gill attachments from the stalk (*stipe*) to cap – closely attached, extending down the stem, attached

to a collar, free, withdrawn (gap between gills and stalk), attached end of gill notched?

...... *gills free of stalk, broad,* *broad, free gill.*

Gill's Free Edges - smooth, scalloped, toothed or saw toothed?...... *appear smooth*

Diagram.

Line of free edge of gills
stem
cap margin
gills
gills crowded.
Underneath of cap, showing gills.

Gill Texture - soft, flexible, hard, brittle?...... *slightly brittle.*

Gill Colour - this may vary as the fungus ages.

Young *White* Mature *White with dark red blotches where damage has occurred.*

ii) Teeth /Spines:

Description of Teeth/Spines - short, long, sharp or blunt ended, thick, thin, crowded together, scattered, brittle, flexible etc. ...

Tooth/Spine Colour - ...

iii) **Veins:**

Description of Veins - single, branched or forming a network, thin, thick, dense or widespread?

...

Vein Colour -...

iv) **Tubes:** *Not Applicable To This Fungus.*

Description of Tubes- *These open as pores at the surface of the spore bearing layer.*

Tubes may be short, long, attached to the cap or extended down the *stipe*, in one or more layers? ...

Colour of Tubes - In young fungus ...

In mature fungus ...

Pore Size and Shape - large, small ? Diametermm

Pore Colour - This may vary from the colour of the tubes! ...

Does the colour changes when the pores are bruised e.g. to blue, brown, red etc?

...

The Stalk (Stipe):

Stipe Attachment to Cap - This may be central or off centre. It is characteristic for each species.

..... stipe attachment central.

Shape of the Stipe – cylindrical, club-shaped, barrel-shaped, spindle-shaped, conical (wider at top), base extends and looks root-like, bulbous base narrow at top, tapered to bulbous base.

If the base is bulbous: Is it enclosed in a cup-shaped membrane (*volva*)?.. Not Obviously.
 Some scales look like remains
If yes, do not eat under any circumstances! of volva.

Surface of the Stipe- smooth, grooved, dimpled, fibrous, scaly, slimy, sticky, shiny, dull, ribbed etc ?

..... scaly, dull and looks fibrous due to ragged scales.

Colour of the Stipe - *This may vary throughout its length from cap to base.*

White going reddish brown as it ages – due to scales

Is there a **Membranous Ring (*Annulus*) persisting**? yes

Is it wide, narrow, wavy, ridged, ragged etc? Very wide and drooping with distinct vertical grooves.

This may be very characteristic for a particular fungus.

Inside Detail of the Stipe- solid, hollow, or of varied textures? Solid, → hollow

Diagram of Stipe. (See diagram of whole fungus)

Scales on Stipe

top of stipe (meeting cap)
long, broad, grooved ring
Wrinkled edge of ring

You now have enough information to positively identify the fungus in a book!

Common Name: The Blusher

Latin Name Amanita rubescens.

Attach drawings of all the features.

Spores white
Poisonous when raw; edible when cooked (but discard cooking water!)

(May be confused with 'The Panther' A. pantherina) — Similar but flesh does not discolour, and ring not ridged.

Observations of All Other Fungi:

Adapt the above mentioned criteria to help you describe it in detail. i.e.

Habitat;

Description of Overall Shape and how the spores are released;

Making observations of all other fungi

Adapt the above-mentioned criteria to help you describe the fungus in detail, i.e. habitat; description of overall shape and how the spores are released; colour; size; texture; smell.

The lichens

Lichens are a distinct group of 'plants' which, fascinatingly, actually consist of an association between two quite distinct types of organism – a fungus and a green alga, or a fungus and a cyanobacterium. The fungus, the *mycobiont*, is the main partner and is either one of the Basidiomycetes, forming basidiolichens, or one of the Ascomycetes, forming ascolichens, and surrounds the alga, the *photobiont*. In combination, a fungus and an alga form a particular lichen with a distinct, constant and recognizable pattern of growth which means that they can be classified into different genera and species of lichen.

The hyphae of the fungal partner surround the photobiont and anchor the lichen to whatever it is growing on, also protecting the alga from desiccation and from damaging exposure to the elements. The fungus absorbs water from the environment, the soil and the air, and collects and provides minerals which it also absorbs from its surroundings and brings to the *symbiotic* partnership. The algal partner is therefore able to live and survive in an environment which would have been hostile to it when living on its own. The alga is green and can therefore photosynthesize to make sugars out of carbon dioxide gas, water and sunlight energy. This sugary food is shared with its fungal partner and thus enables it to survive in an environment lacking in other food sources.

Where cyanobacteria are the photobionts or a third party within a lichen, they provide important nitrogen compounds by trapping atmospheric nitrogen from the surrounding air. These nitrogen-containing compounds can then be used as the basis for manufacture of other important compounds, such as proteins, by the fungus or alga in environments lacking in usable nitrogen.

These symbiotic partnerships that make up lichens mean that they can grow where little else survives and gives them an ecologically important role as primary colonizers, similar to that of the mosses and liverworts but in even more extreme circumstances. Where they grow on bare rocks they gradually erode the rock beneath and add compost when they die – thus forming soil for other plant life, such as mosses, to grow. Lichens may be specific to a particular habitat, substrate, or may be non-specific and widespread, depending on the species. Like mosses they may stabilize some habitats, such as sand-dunes, help the development of soil and prevent erosion. They can endure and survive extremes of drought and temperature and are found in all climatic and geographic regions on earth; however, lichens are generally very slow growers.

Lichens are important as a food source for some animals such as reindeer – 'reindeer moss' is actually a lichen. Many invertebrates also use lichen as a food source and habitat, whilst other animals may use it as nesting material. The more lichens there are in a habitat, the longer it has remained undisturbed and the higher the biodiversity index (the number of different species found).

Some lichens are also important as indicators of pollution as

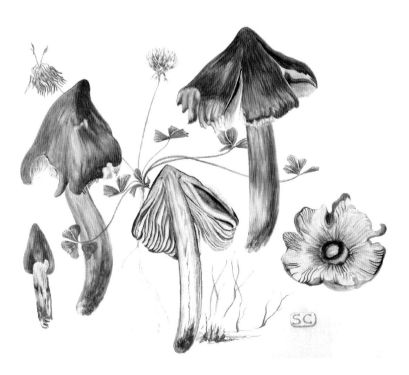

Hygrocybe nigrescens on vellum.
(Sheila Clarke)

they readily absorb compounds from the air and accumulate them. Many cannot survive in polluted areas although a few species are remarkably tolerant. This is obvious when you compare the number of lichens growing in a town with the number growing in the countryside. Pollution indicator species of lichen have been identified and are used by ecologists as indicators of air quality.

Other uses of lichens include the extraction of natural dyes and pigments. Litmus is derived from a lichen and has been used by us all in chemistry to tell an acid from an alkali. Other lichens have been used as an ancient remedy, as compresses and 'antibiotic' dressings for wounds.

Growth forms

Lichens do not have conventional leaves, stems and roots and are made up of a relatively formless plant body called a thallus, which is also typical of the algae such as seaweeds and the thalloid liverworts. If lichens are circular in shape they grow from the edges – increasing the diameter of the lichen 'plant'.

There are four main growth forms that occur amongst lichens: *crustose, squamulose, foliose* and *fruticose*. However, a genus may contain more than one growth form and in other cases intermediate growth forms may be found between the four basic forms.

CRUSTOSE
Crustose lichens are the most simple forms and have a flattened thallus that is closely stuck to, or even partially immersed in, the substrate that it is growing on. In some cases they look just like discoloured areas on rocks and tree trunks and are easily missed. In others the crust-like thallus may look smooth, roughened, cracked, segmented, weakly lobed, radiating outwards

from the centre, or granular. More than 60 per cent of all British lichens are crustose.

SQUAMULOSE
Squamulose lichens consist of scale-like outgrowths of just a few millimetres in size, which may be overlapping or pressed together closely. *Squamules* are found in *Cladonia* species. These squamulose lichens may be difficult to tell apart from crustose ones.

FOLIOSE
Foliose lichens have more or less horizontal leaf-like lobes (similar to thalloid liverworts) which are often attached to the substrate by hair-like root structures called *rhizines*. The upper and lower surfaces are often of different colours.

FRUTICOSE
These may be shrubby, beard-like, tufted, branched, erect, upright or pendulous. They do not have different upper and lower surfaces like the foliose lichens. Some lichens may have more than one growth form, such as in *Cladonia* species where one form of thallus is squamulose and the other has upright structures and is therefore fruticose. In some instances, for example in the shrubby lichens, the original basal thallus may be lost early on. Other fruticose lichens may be unattached to a substrate and just mixed with other plants like mosses, or they may arise from a disc or from a cluster of rhizoids (like those found holding seaweeds onto rocks).

Some crustose, foliose and fruticose lichens may be gelatinous when wet and shrivelled and shapeless when dry, such as lichens in the genus *Collema*.

Crustose lichen on rocky cliff by the sea, Donegal.

Cladonia pyxidata. Squamulose lichen with 'foliose' cups.

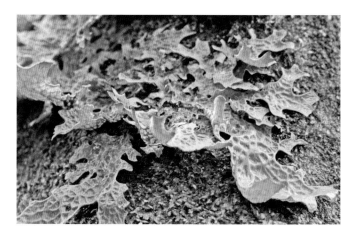

Lobaria pulmonaria. Foliose lichen with different upper and lower surfaces, on tree near Fort William, Scotland.

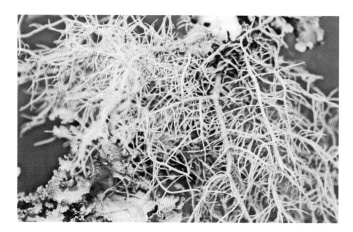

Usnea subfloridana. Filamentous lichen on branch in Scotland.

Reproductive strategies and structures in lichens

Due to the fact that lichens are made up of two unrelated organisms, reproduction is only really effective if it is by vegetative multiplication. In most cases a new lichen grows from bits of the original thallus that have broken off and been dispersed. Many lichens produce minute bud-like outgrowths called *soredia*, which consist of one or more of the photobiont algal cells surrounded by some fungal hyphae. They may be found covering the centre of a crustose thallus or at the tips of the lobes of a foliose lichen thallus. These 'dusty' soredia break off and can grow into a new lichen 'plant'.

Many of the individual fungal partners, mycobionts, in lichens produce sexually reproduced spores, which are either ascospores or basidiospores – depending on the type of fungus (*see* page 156). The problem is that the fungal spores are dispersed but will not grow into a lichen unless they germinate near an appropriate algal cell to associate with and to grow. This

is a chancy business and is not a very efficient method of reproducing a lichen. You will quite commonly find oddly shaped structures on the 'basic lichen' structure and these are specific for a particular species of lichen.

The ascospores are either contained in flask-shaped structures, *perithecia*, which release the spores through tiny holes called ostioles (like the Pyrenomycete group of fungi) or the asci are formed in a layer in structures called *apothecia* which are indented or on the surface of the thallus (like the Discomycete group of fungi). These apothecia may be very varied in shape and size. Most of the lichens you will find produce apothecia.

The basidiospores are formed on small capped 'mushrooms' which grow out of the thallus. These are found in tropical lichens.

This is by no means an exhaustive description of lichens but is intended to help you, the artist, to be aware of various structures that you may find and to depict them with greater accuracy. Strange markings on the bark of a tree may well turn out to be caused by lichens. Keep an open mind.

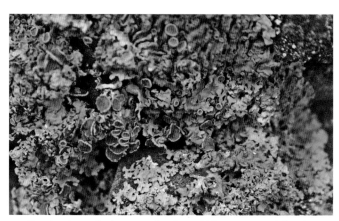

Xanthoria parietina. Apothecia on lichen on a rock by the sea in Northern Ireland.

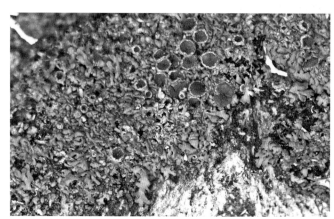

Possibly *Collema crispum* – apothecia on lichen. Donegal, Ireland.

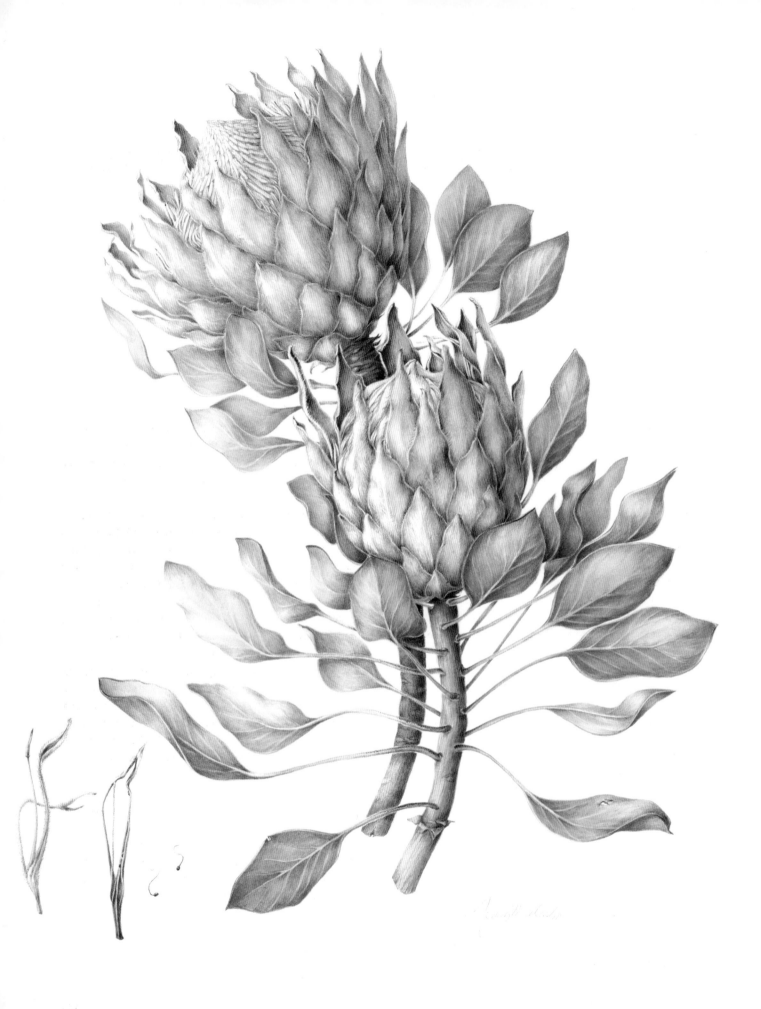

GENERAL TOPICS OF INTEREST TO BOTANICAL ARTISTS

The Linnaean system of plant classification and the binomial system of Latin names

In the 1700s, Linnaeus (Carl von Linné) was the first person to classify plants according to their unchanging sexual systems and to rationalize their naming. Until that time plant names were unreliable, as are common names to this day, and often unwieldy in being varying descriptions of a plant. For example, the Latin name for dog rose was *Rosa sylvestris inodora seu canina* (odourless woodland dog rose) or *Rosa sylvestris alba cum rubore, folio glabra* (pinkish-white woodland rose with smooth leaves).

Plants were also grouped on unreliable features that often varied markedly like size and colour. Linnaeus' classification and his rationalizing of names led to a greater interest in all things scientific and botanical and this in turn led to a golden age of botanical illustration. One edition of his book *Systema Naturae* listed 4,235 species of animals and 6,000 species of plants. However, he continued to publish prolifically and collected plants sent to him from all over the world. *The Species Plantarum* (1752) lists the oldest plant names and most of these are still accepted as valid and used to this day.

Linnaeus based his classification system on the number and arrangement of the reproductive organs but himself admitted that it was an 'artificial classification' that did not take into account all the similarities and differences between organisms.

The specific details of his classification have long been abandoned in favour of a wider system that uses flowers, seed and fruits and other parts of the plant. However, his method of hierarchical classification and his binomial system are used to this day.

Linnaeus' classification divided living things into kingdoms (plant and animal), which in turn were divided into classes – Algae, Bryophytes (mosses), Pteridophytes (ferns), Gymnosperms (naked seeded), and Angiosperms (flowering plants with enclosed seeds). These were further divided into Orders, which were divided into families. These were added later and are divided into genera (singular genus), which are divided into species (abbreviated to sp.). Some can be subdivided into subspecies. (or ssp.) (*see* flowchart p 174).

Linnaeus used the last two categories, the genus and species, to name plants and animals and this became known as the Binomial System, e.g. *Rosa canina* L., common name – dog rose. ('L.' denotes the fact that it was first named using the binomial system by Linnaeus himself.) More than 9,000 plant names were published by Linnaeus and are still valid and in use today.

The importance of binomial Latin names

All types of known living organisms have a Latin binomial (two-part) name which is made up of the genus name, to which the organism belongs, followed by its specific 'identifying' species name. Examples of this are *Helianthus annuus*, the sunflower,

LEFT: *Protea cynaroides*, The King Protea. (Jenny Malcolm)

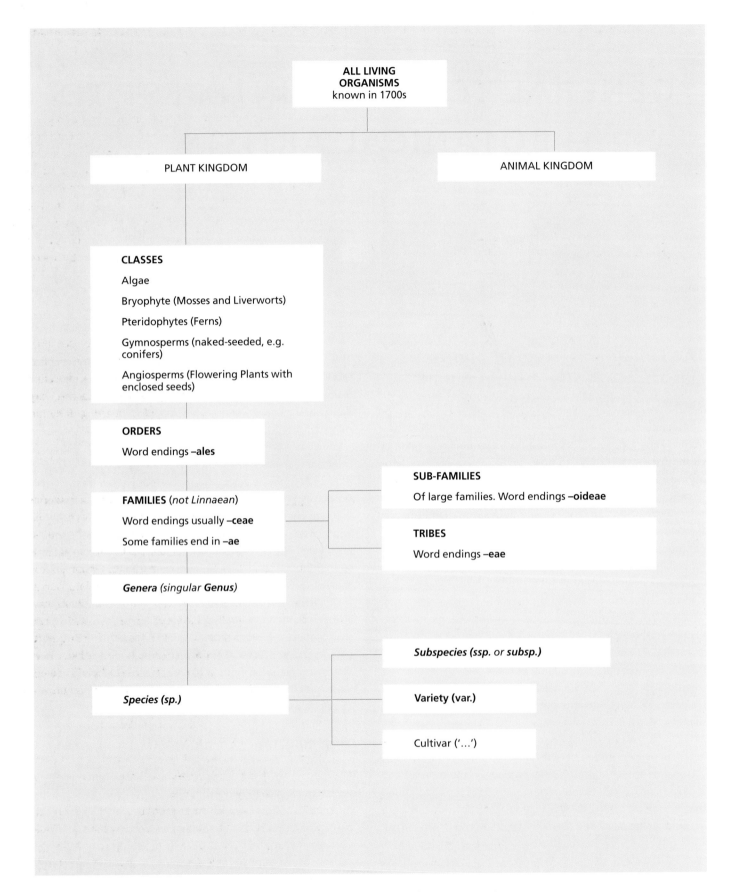

Flowchart showing hierarchy of classification categories.

and *Helix aspersa*, the garden snail. These Latin binomials are known the world over and understood by scientists, botanists, horticulturalists and gardeners of every nationality, regardless of their particular mother-tongue.

Conversely, common names in each country or region (of a country), are unreliable as they may well differ and are therefore very likely to lead to total confusion. For example, children in the far south-east of Kent call small garden creatures 'monkey peas' and do not necessarily recognize them as being the same as the 'woodlice' of other southern counties of England. Similarly, 'eggs and bacon', 'Tom Thumb', 'Granny's toenails', and 'birdsfoot trefoil' all refer to the small clusters of wild, yellow and orange pea-flowers of *Lotus corniculatus*, which are commonly found on dry grassland and verges.

Confusion also reigns when more than one type of plant has the same common name. Samphire is a prime example of this. Samphire is collected at low tide on saltmarsh mud in many areas and, fashionably, is eaten as an accompaniment to various fish dishes. Samphire traders may include annual seablite (*Suaeda maritima*), and several species of annual and perennial glasswort (*Salicornia* species) in together – superficially they all look the same to the untrained eye, and taste salty. On the other hand, the samphire (*Crithmum maritimum*) found on rocks and cliffs by the sea was used in Shakespeare's day for pickling and is more strong smelling and related to parsley and other Umbelliferae, like cow parsley. Golden samphire (*Inula crithmoides*) is a tough, yellow, daisy-like plant that grows up to a metre in height. Neither of the last two examples would be very appetizing if found on your plate.

Common names are great to use on a picture but should be accompanied by the Latin binomial to avoid confusion.

Getting plant names correct when naming your plant subjects

WRITING NAMES
When writing the Latin binomial name there are several conventions to be used. The genus always starts with a capital letter and the species name is all in lower case. When writing the names, both the genus and species names are underlined. When typewritten, the two names are in italics or underlined, for example Helianthus annuus or *Helianthus annuus*. Where you might list several closely related species of a particular genus it is quite acceptable to only write the genus name once in full and then to use only the capital letter together with the species name, e.g. *Helianthus annuus* (annual sunflower), *H.*

petiolaris (lesser sunflower), and *H. tuberosus* (Jerusalem artichoke).

THE NAME'S AUTHORITY
When you look up a plant's Latin binomial name you may see an additional letter or name after the species (e.g. *Myosotis scorpioides* L., water forget-me-not). In this case the 'L.' stands for Linnaeus and means that Linnaeus was the first person to name this plant and is therefore the authority. On the other hand you may see a name or initial(s) in brackets followed by another name (e.g. *Myosotis arvensis* (L.) Hill, common forget-me-not). This means that Linnaeus named it first and it has currently been reclassified by Hill – hence the L. is in brackets before the name Hill who is now the accepted authority.

SYNONYMS
Further complications arise when two people have both named a plant with different names. In this case the currently accepted first name and the namer (authority) is first and the superseded name or synonym and its authority follow in brackets, e.g. *Myosotis ramosissima* Rochel (*M. hispida* Schlecht.), early forget-me-not.

HYBRIDS
Hybrid plants are the result of two distinct and separate species mating together, by cross-pollination, to form a plant that is different both genetically and in looks to both parents. These did not often occur naturally, but in late and post-Victorian gardens the bringing together of related species from other parts of the world, or different, previously isolated, geographical areas, meant that hybrids became more common. Additionally, gardeners and horticulturalists have deliberately created hybrid plants as the first generation hybrid (F1) is often more vigorous and desirable than successive generations after plants have hybridized. Beware of disappointment: these F1 hybrids do not breed true – should you decide to collect the seed and grow it in the following year.

Hybrid plants are indicated by a multiplication sign '×' between the names of the two parents.

e.g. *Primula veris* × *P. vulgaris*. This represents a hybrid plant formed by the mating of a cowslip and a primrose, both of which belong to the genus *Primula*.

When hybridization leads to the production of many different-looking hybrids (due to genetic variation in each individual seed produced), the name consists of the genus and the new hybrid specific name. e.g. *Mahonia japonica* × *M. lomariifolia* = *Mahonia* × *media*.

Where the two plant parents are from different genera, and therefore less closely related than the primulas in the previous example, the resulting hybrid is given a new genus name and the capital hybrid sign 'X' is put before the completely new hybrid plant's name, e.g. *Amaryllis belladonna* × *Nerine bowdenii* = X *Amarine tubergenii*. Here *Amarine* is a new genus name and *tubergenii* is the new species name.

CULTIVAR (OR VARIETY) NAMES

Cultivars or varieties are groups of plants that differ from their ordinary species 'type' in one or more characteristic(s) such as colour, form, or resistance to disease. These 'new' characteristics are constant when the plant is propagated by some means. Cloning or asexual methods such as tissue culture, grafting, cuttings, and so on, mean the resulting plants are genetically identical to their parent. Some cultivars may be stable when produced by seeds resulting from sexual reproduction but this is less often the case.

Cultivars may develop naturally in the wild or may be the result of cultivation but are all the result of human selection. Those named before 1959 were often given a Latinate name whilst those named since are named in the language of the country where they developed. This change from Latinate names was brought in to avoid confusion between the cultivar name and the binomial name.

The cultivar name is always put between single quotation marks and each word starts with a capital letter. The font is normal and never in italics. For example, *Solanum tuberosum* 'Maris Piper' is the Maris Piper potato. To give another example, *Maho-*

nia × *media* 'Winter Sun', *Mahonia* × *media* 'Buckland', and *Mahonia* × *media* 'Underway' are all different selected hybrid cultivars of the *Mahonia japonica* × *M. lomariifolia* cross mentioned previously.

Choosing your typical, representative specimen

Choosing a representative flower, part of a plant or whole specimen, is becoming a more important issue when using mass produced, in-bred, chromosome enhanced (such as *triploids* or those with more than just one extra set of chromosomes), or double-flowered plants as these seem to produce 'oddities' on a more regular basis. These peculiarities can be extra petals or sepals, lack of stamens or carpels, and flower parts that are fused together or are partially leaf-like. Beware of the siren call of the unusual. Look at several examples and choose those with the most consistent number of parts and colour. Paintings should aim to represent the typical example of the plant or flower.

Always try to represent young and mature parts of the plant as these may differ in some way. Fern fronds differ markedly and some plants, such as eucalyptus trees, have distinct juvenile and mature foliage which led to some confusion in the early days when they were being named.

When looking at flowers, always try to have examples of buds, flowers in full bloom and remains of flowers where the

Eucalyptus. Two leaf forms – mature on the left and juvenile on the right.

Oak acorn deformed into a gall by insect damage.

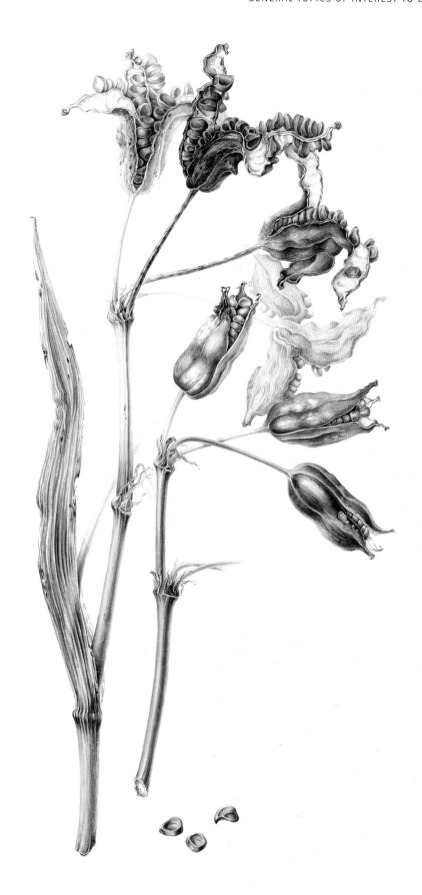

Iris pseudacorus with seeds. (Annie Patterson)

ovary is swelling, as well as mature fruits.

Beware of oddities caused by disease or the ravages of insects. Insect-induced galls, fungal blemishes (like rust pustules and black spot), and insect devourings (like lacy or mined leaves) can be very beautiful or interesting but are not representative unless you intend them to be and include the causal pest.

Keeping the plant or flower in good condition

Painting flowers and plants in general can be difficult to achieve before the specimen wilts, goes 'over' or dies. Flowers that wilt easily will remain fresh longer if you strip most of the leaves off the stalk, cut a bit off the stem and immerse the majority of the remainder in water, in a long container. Keep them cool and out of the sun.

Plants that produce milky latex (like the spurges) or coloured latex (like some poppies) will wilt less quickly if you seal the cut ends with a flame immediately after picking them – this prevents air being drawn up into the stem and causing an air-lock. An air-lock would stop water reaching the leaves and flowers once the plant is subsequently put in water. Because of potential air-locks in a stem, it is best to take a bucket of water or a fold-flat camping vase and some water with you when you go to cut your chosen flower or twig, so it can be immersed immediately. You will be amazed by the difference it makes – although a bucket is not as aesthetically pleasing or decorative as the more traditional trug. Failing this, a plastic box with a lid and wet tissue round the cut stem, or a plastic bag that you can inflate around the plant and its wet tissue and tie off to make its own little sealed container, will keep plants fresh until you put them in water.

Vase flowers that lose colour as the buds open generally keep their colour better with a spoonful of sugar or flower food in the water. Alternatively, non-diet fizzy clear lemonade instead of water certainly keeps carnations and pinks in super condition for a longer time.

If you want to slow down the development of the plant, flower, or buds, it can be a good idea to keep some of the specimen in the fridge. The 4°C cold slows down growth and means that you have more material for another day. However, ensure that the fridge is not turned up too high (enough to freeze your lettuce), as freezing turns non-woody plants into a slimy pulp when they thaw.

Alternatively, if you want to induce more rapid development of winter twigs so that the buds burst and the leaves and catkins or flowers develop early, bring them indoors and keep them warm and humid. I find that they love being near the sink. This

may take a couple of weeks but is worth the nuisance value of having to cook around them. This also works for conifers if you are trying to get the buds to grow out un-seasonally early.

Useful equipment and short cuts

The following is by no means an exhaustive list of useful equipment to aid the botanical artist, as these have been covered in many of the other books which concentrate on actual painting techniques. Rather, I have included those things that I could not do without and some odd things that I have found particularly useful – no matter how simple or technical.

For examining plants

- A white ceramic tile – for cutting on. Any tile will do to provide a resistant, waterproof surface for cutting and to protect the table or bench, but white allows you to see more clearly.
- Cutting tools – a Swann Morton scalpel handle with replaceable blades, or disposable scalpels – preferably with pointed blades, or single-edged razor blades (available from most DIY stores).
- Sharp-pointed dissecting forceps (tweezers) – for removing a stamen or other small structures without squashing the rest.
- Needles mounted in handles – a blunt one and a sharply pointed one. If it is a matter of choice, go for a blunt needle (also known as a seeker), in combination with the forceps. Very useful for moving aside small parts and structures without disturbing the whole flower or plant.
- A folding 'field' hand lens, minimum ×10 magnification or ×20 – very useful for looking at small structures close-up but requiring some practice. The lens is held up to the eye and the specimen is brought towards it until the required part, e.g. a moss capsule, comes into focus.
- A large magnifying glass on a long, flexible arm, that clips your drawing board or table. These can be used as you observe the plant or as you paint. Some people like head magnifiers, but they are more likely to lead to changes in scale as you draw and paint.
- A lamp with a long, flexible arm and a daylight bulb – for supplementing the daylight when necessary, without altering the colour balance as ordinary or fluorescent bulbs do.
- A high-quality dissecting microscope (×200 magnification or more) with an in-built light source – this is desirable if you are going to look at very small structures and details on parts of plants. However, beware of cheap or toy versions where

the lenses are poor and magnification compromised. Better no microscope than a frustratingly useless one. Dissecting microscopes are binocular and have two eye-pieces with lenses and a further lens over the stage. They are good for looking at bits of plants for small details. If you are tempted to get hold of an old brass monocular or conventional microscope, the lenses are usually of a high quality but they need very thin slices (a maximum thickness of 0.03mm) of plant material mounted on a slide with water and a cover-slip over the specimen before you have any hope of seeing something. These are best avoided unless you are really interested in the structure of the cells that make up the plant and are prepared to spend a considerable amount of money on a decent microscope.

• Dividers and proportional dividers – useful for measuring various parts of the plant and for helping you to keep to scale when drawing it.

Other equipment

DIGITAL CAMERA

A digital camera that takes 10+ megapixel images and has a close-up facility is exceptionally useful for recording all the various aspects and details of your plant or flower which you may not have time to pre-sketch and observe in detail. They are particularly useful where the flower fades or dies really quickly or a bud opens rapidly, e.g. the Queen of the Night cactus, which blooms and dies in one night. The images provide you with a permanent record of moments that will not be repeated for a long time. This type of equipment is a modern 'must have'!

Polypodium. Fern sori showing thickened bands of cells on each sporangium and spore sac. (Maximum zoom of macro image.)

Where very small structures are photographed, using an SLR digital camera with a really close-up macro lens and a tripod to give the required stillness, the images may be as useful as using a microscope. If the photo images are good enough, with high enough pixels, the resulting image can be enlarged on the computer to give a fair idea of an enormous level of unseen detail. The resulting image may not be wonderful but can be quite a revelation.

LIGHT BOX

This is very useful for transferring images from one drawing onto another piece of paper. The lighting under the glass, below the two pieces of paper, means that the image is easier to see and trace accurately onto the upper sheet. However, the light box can also be used directly for drawing round a fern frond, placed on the glass, onto a piece of paper – giving the shape and quite a lot of detail.

SCANNER OR PHOTOCOPIER

These can be very useful for simplifying confusing detail, like that of a fern frond. The part of the plant is put directly on the glass of the scanner or photocopier and a black and white or colour copy made. A scan or a photocopy can then be used on a light box or traced to get the shape. This makes daunting things simpler to tackle.

PLANT PRESS

A plant press is very useful for preserving a dried specimen for later examination and painting. These have gone out of fashion rather and are bulky and often too small to be useful, but can be improvised with a stack of white blotting paper, some wire or a wooden mesh top and bottom, and elastic bungee cords to put pressure on the paper and drying plant. The problem with drying plants is that they usually lose colour and fleshy plants and orchids have a tendency to go slimy before they dry which really wrecks the family bible you might have used as a make-shift plant press! The Kew painters often have to work from dried, pressed specimens but many of us are privileged enough to be able to work mainly with fresh specimens of our choice.

Indicating an appropriate scale on your drawing or painting

Magnification

For many years it was conventional to calculate the magnification represented by a diagram or picture in relation to the actual size of the flower or plant and to indicate this by a multiple such as ×1 for a diagram that was life sized, ×3 for a diagram that was three times as large as the actual flower, or ×0.5 for a diagram that was half the actual size of the flower. With this method there was no need to give the units of length on the picture, as a ruler placed on the diagram gave the units and multiplying this by the magnification told you its full size. Conversely, dividing the size of the drawing by the actual size of the flower gave you the magnification.

In more recent times, since the advent of photocopiers, scanners, computers and other reprographic aids which can enlarge or reduce an image, this magnification method has proved to be of little use. Using a ruler on an enlarged or shrunken image gives no real idea of the plant's actual size. In consequence, a more satisfactory and accurate method such as a bar scale is now advocated for floral pictures.

Bar scales

With this method a line is drawn somewhere on the picture to indicate the actual length of a part of the flower or plant, and the length of the line should also indicate the measurement units used such as millimetres, centimetres, metres, 10-metre units and so on. The scale must be appropriate to the scale of the flower or plant. Small flowers will be measured in millimetres whilst tall trees will be measured in units of e.g. 10 metres.

The advantage of this method is that the line or bar always represents the same standard length (for the measurement units chosen) and the relative lengths of this bar will always be correct whether the picture is later expanded or reduced in size.

CONSTRUCTING A BAR SCALE

Look at your 'painting subject' and choose some bit of it that is unmistakeable and reasonably small, such as the length or width of a mature leaf, the stamen, a particular petal, a leaf stalk or a trunk. Measure this part in appropriate units such as centimetres (cm). This is the actual life-size scale and can be drawn and labelled with the appropriate number of units, e.g. 1cm, somewhere near the plant on your accurately sized life-size drawing.

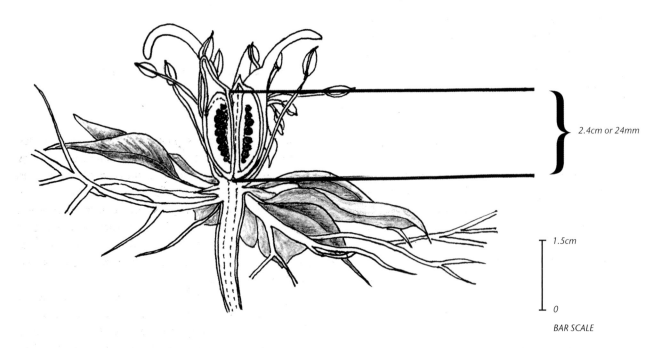

Actual original measurement of ovary height is 1.5cm (15mm); size on picture of same measurement is 2.4cm (24mm). Draw scale bar 2.4cm long and label it 0–1.5cm (15mm).

Half flower of love-in-a-mist – adding a scale bar.

However, if your drawing is either smaller or larger than in real life, then the bar scale must be smaller or larger respectively. In this case, measure the same feature on your drawing and make the bar scale this length but label it with the original number of units, e.g. 1 cm, as this is what the bar represents.

The bar scale should be placed so as to not dominate your picture but, by the same token, it ought to be clearly visible. The bar scale can be vertical or horizontal and can have end bars, like those found on maps e.g. 0 ⊢ 1cm , or be just a plain line, e.g. 0 ——— 1cm , which I find less obvious and rather strange looking unless the line is quite definite.

Using the Internet for accessing information about 'your' plant or flower

Getting hold of the plant

Having decided on exactly which plant you are going to paint, it can be difficult to locate a reputable supplier near you. The RHS Plant Finder website is an excellent site that allows you to type in the plant name and then search a database of over 600 nurseries that stock the plant. You can narrow the search to broad, geographic areas of the UK and thus obtain the nearest contact name and address. This site also gives much useful information on a wide range of topics. Other nursery and stockist sites can be found by searching on the plant's name (see below).

CHECKING A PLANT'S NAME
When you suspect there has been a possible mis-identification or mis-naming of a plant or you have a complete unknown that you have picked up on your travels, you can contact Kew Gardens, and send an identification query by email, attaching photographs if possible, and eventually you should receive an answer. You can also contact the nearest Herbarium or Natural History Museum and send them a photograph or pressed specimen.

FINDING OUT IMPORTANT DETAILS
BEFORE YOU START TO PAINT
A good way of going about this task is to use a search engine such as Google, typing in the **genus**, **species** and **family**, if it is known. If you are in doubt about the family, just type in the

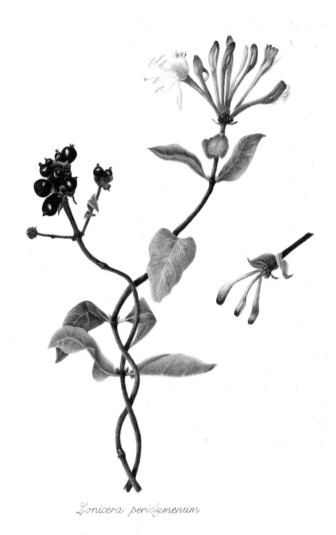

Lonicera periclymenum

Lonicera periclymenum, Honeysuckle. (Liz Leech)

binomial name. Generally such a search will yield lots of less useful or dubious sites but there will be useful sites amongst them. Sites with 'edu' or 'ac' in the address are often university sites, where the information should be more reliable.

After much deliberation, I have decided that the best way to help you to find good, useful sites is to do some searches at different parameter levels and to comment on the results. As an example, I searched for *Lonicera periclymenum*. The first page of results yielded lots of sites.

After a time you will recognize really useful sites. A search such as this may well help to source your plant subject as several growers' sites usually appear. However, they are dubious on the sort of botanical detail that you require. In our case, Wikipedia is a good place to start as it generally gives some salient details and gives you the plant family, but be sure to double-check the information. Plant-identification.co.uk is worth a look but rather thin on detailed information and not necessari-

ly a reliable site. It is also worth looking at the images to see if all parts of the plant, e.g. fruits, are shown – this may help you to identify what you have got. Looking at subsequent pages might possibly yield other useful sites – but not necessarily. Cut your losses and refine your search criteria.

For this example I then typed '*Lonicera periclymenum* **Caprifoliaceae**' into the search engine. Some sites are repeats of items on the first search. Some sites are still not specific enough, but are worth a minor look. However, Plantsystematics.org images gives lots of photos of different aspects of different species of Lonicera. This could be useful and helpful information. Otherwise this has not really narrowed down the search enough. It is time, therefore, to re-refine the key words to include words, such as **Flora** and **Description**, which will elicit more specific details.

I expanded the search criteria to include *Lonicera periclymenum Flora Description Caprifoliaceae*. This search found a description of the family Caprifoliaceae at *delta-intkey* – this may be too much information and not specific enough to your species. However, this site is useful for general characteristics although the language is very botanical and somewhat daunting. Another site elicits some helpful photos of the plant to help check that you have the right species! Some sites give good examples of earlier plant portraits and photos which may be of interest; however, another looks really hopeful but is trying to sell you a photo and has no real information except the search keywords – the clue was in the title!

All in all, this search is promising and produces some useful sites. Look at further examples on subsequent pages of this search and you will undoubtedly find more helpful sites such as:

Lonicera periclymenum

Species: **Lonicera periclymenum**. Family: **Caprifoliaceae** Genus: Lonicera Species **description**: Deciduous. Glabrous or somewhat pubescent or glandular-pubescent www.morphle.org/**flora**/**Caprifoliaceae**/**Lonicera**/L.**periclymenum**.html
Lonicera periclymenum (English Wild Honeysuckle)
Lonicera periclymenum (European Honeysuckle, Honeysuckle, Woodbine) ... Family: **Caprifoliaceae** () - A.I. De Jussieu,

Camellia. (Sara Bedford)

1789 The **flora** of the Alps: being a **description** of all the species of flowering plants indigenous to Switzerland ... zipcodezoo.com/Plants/L/**Lonicera_periclymenum**/

Both these sites yield good, accurate, brief descriptions of *Lonicera periclymenum*.

Obviously, this combination of key words (**binomial Latin name** + **'flora description'** + **family name**) is a good basis on which to do an internet search when researching a particular plant. If you wish to research details about a particular cultivar, enter the **binomial name + cultivar name**, e.g. *Lonicera periclymenum* 'Graham Thomas'.

Using similar sites to those listed above and any other infor-mation, you are in a good position to observe the salient features of your plant subject as you draw and paint it. Searches like these are tedious but well worth the effort in order to inform the accuracy of your observation and painting.

This final chapter has set out to provide useful information which could make your task of drawing and painting a plant easier, more accurate and better informed. I hope that this information, together with a more detailed knowledge of the various groups of plants and what to look out for (using the observation helpsheets), will help you to hone your botanical knowledge and thus enhance your future paintings and drawings.

Solanum jasminoides var. "Album"

Potato vine. (Liz Leech)

BLANK HELPSHEETS

Helpsheet 1: Collecting and looking at a flowering plant

Be sure to collect a bud, a newly opened flower, a dying flower or one where the flower has shrivelled (so that the swelling ovary is more obvious), any ripe fruits, and enough of the plant to show the leaf arrangement.

Plant identification

Common name: ...

Latin name:...

Plant family: ..

Habitat (where does the plant grow?) ...

..

Habit (how does it grow?) ..

..

Any obvious features (spines, thorns, hairs, swollen joints?) ..

..

Leaf shape (simple, compound?) ...

..

Leaf veins (parallel, net-veined?) ..

..

Is the leaf stalked or does it grow directly from the stem joint? ...

..

Leaf arrangement (phyllotaxy – opposite, alternate, spiral?) ..

..

Shape of the stem (round, oval, square?) ...

..

Type of stem (is it ridged or smooth; does it have pores?) ...

..

Arrangement of flowers (solitary or in an inflorescence?) ..

..

Type of inflorescence (if flower not solitary) ...

..

Which flowers open first (top, middle or bottom of the inflorescence)? ...

..

Number of petals in each flower?

..

Are flowers are borne on old or new wood? ...

..

Any other obvious features:

..

Monocotyledon or dicotyledon? ..

Drawing of any interesting features

Helpsheet 2: Recording flower details while sketching and annotating

Where possible, take a bud, a newly opened flower, an older flower and a dead flower to examine in detail. The range of ages allows you to check that bits haven't already fallen off, or are undeveloped and not obvious. Always choose a typical flower – not one that looks interestingly different.

Plant name

Common name: ..

Latin name: ..

Plant family: ..

Bracts

Working from the outside of the flower, start at the bracts – leaf-like structures that come off the stem where the flower stalk (pedicel) arises.

Description: ...

Drawing

Sepals

Then look at the outside of the flower and work your way inwards from layer to layer. Count the sepals (calyx) and look at whether they persist or whether they drop off really early (K in floral formula).

Number: ...

Persistent or not? ..

United or free? ...

If united, only at base, or forming a tube? ..

Colour: ...

Hairy or smooth? ...

Shape: ..

Drawing

Petals

Count the petals (corolla) and look at how they are arranged (C in floral formula).

Number: ...

Arrangement: ..

Are they all the same or different? ...

United or free or partly united? ...

Are the stamens attached to them? ...

Is a nectary obvious? ...

Describe it and its position: ...

Are there obvious, different coloured guidelines? ...

Is the flower scented? ...

Drawing

Note: perianth parts are the sepals and petals (P in floral formula). Where the sepals look like petals or the petals look like sepals the perianth parts are called tepals in modern texts.

Stamens

The stamens (male part collectively called the androecium) consist of a stalk called a filament and a pollen-box called the anther, where pollen grains are made (A in floral formula).

Number: ...

Arrangement in relation to position of petals and sepals: ...

Where are they are attached in the flower? ...

Filaments free of each other or fused? ...

Anthers free or fused? ...

How does the anther open (dehisce) to let out pollen – a pore, or slit opening outwards or inwards?

...

Where does the filament attach to the anther (top, middle or bottom)? ...

Colour of anthers and of pollen grains: ...

Drawing

Ovary/carpels

The female parts collectively called the gynoecium. G in a floral formula. A carpel is made up of the stigma (receptive surface for pollen), the style (which ends in the stigma), and the ovary containing the egg cells (in 'pearl-like' ovules that become seeds after fertilization). The best way to observe details of the ovary is to look at all ages of a flower – including a withered one where the ovary is developing and is bigger and easier to see. Cut across the ovary (transverse section) and count the chambers (number of carpels) and cut the length of the ovary (longitudinal section) to see how the seeds are attached (placentation).

Is the ovary inferior (below the flower parts) or superior (arising above the flower parts) or neither?

..

Drawing of half flower (cut longitudinally)

How many carpels (chambers) are there? ...

Are they free or united? ...

Are the carpels many-seeded or one-seeded? ..

How are the ovules/seeds attached to the ovary/carpels? ..

..

Drawing of ovary/carpels (cut across), to show placentation (seed attachment)

Stigmas

How many stigmas are there? ...

Is the stigma lobed/divided? ...

The number of lobes of a stigma often reflects how many carpels (sections in an ovary) there are.
Do the stigmas ripen before the anthers, or at the same time or after the anthers shed their pollen?

..

Are the styles (stalks that attach the stigma to the ovary) non-existent, short, long?

..

Any other obvious features: ...

Helpsheet 3: A winter twig

The bark

What colour is the bark on the twig? ...

Is it smooth, ridged, shiny, powdery or warty? ...

Is it hairy? ..

 If yes, where? ...

What colour are the hairs? ...

The twig

Slender or thick? ...

Angular, oval or round? ..

Are there spines or sharp points present? ...

If spines are present, what length are they (cm)? ...

Do they have buds on them? ...

Are catkins present in winter? ..

Are cone-like structures present? ...

Is the pith in the centre of the twig chambered (with spaces) or not? ...

Arrangement of the leaf scars

What shape are the leaf scars? ...

Are they flush with the bark or on projecting 'brackets'? ...

How many leaf scar veins can you see and how are they distributed? ..

Buds

Are they single and arranged alternately or in a spiral? ..

Or are they single, spirally arranged with clusters of buds near the tip of the twig or clustered near the centre of the twig with single terminal buds? ...

Are they in opposite pairs? ...

Are the terminal buds (at tip of twig) single, double, or other? ..

Are the terminal buds larger than the others? ..

Are the buds large or small in relation to the size of the twig? ...

Are the buds pressed tightly to the twig or at an angle to it? ..

Are the buds directly over the leaf scar or distinctly to one side? ..

Do the leaf scars almost encircle the bud, or spread almost half way round the bud?

...

Are the buds on short columns or stalks? ...

Colour, shape and size of the buds

Are the buds ragged and half open or lacking bud scales? Or are they closed with compact bud scales?

...

Are they sticky? ..

What colour are the buds? ...

Are all the buds egg-shaped, pointed, rounded, flattened, or are some pointed and some rounded?

...

What size are the side buds (cm)? Height: Width:

What size are the terminal buds (cm) Height: Width:

Are the buds four times as long as broad or less than four times as long as broad?

Bud scales

Are some bud scales present or none? ..

If bud scales present, how many bud scales are apparent? ...

Do they make the bud look lop-sided? ..

Are the bud scales covered in hairs? ..

Or are the tips of the bud scales a different colour or hairy? ..

Name of tree: ...

Drawing of twig and its features

Helpsheet 4: Looking at a conifer (gymnosperm)

Always select a mature side branch to look at, so that you are sure to have a representative part of the tree. New and upright growth near the tips of branches should be ignored as they are probably atypical.

Beware of trees that have different leaves when young and when mature e.g. juniper. Try to pick a bit of each foliage type to look at so you can decide which is mature and which is juvenile.

Also, try to find an older mature female cone and keep it warm and dry so that it opens and releases some seeds for you to look at. True cedars have their pollen-bearing male cones and new female cones in the autumn, whilst other conifers may have their male and new female cones in the spring or early summer. You may have to visit the tree more than once to find all the necessary, characteristic features.

All these things help with identification and may need to be included in your picture.

Don't forget to sketch parts as well as describing them on this sheet.

Branching

Are the branches in rings (whorls) or are they differently arranged in spirals or frond-like?

..

Are the lateral branches like the main ones or are they obviously very short or knob-like?

..

If they are knob-like, are the leaves in tufts or clusters at its tip?

..

Leaves

Are the leaves **scale-like** and flattened? ...

If yes, do they completely hide the stem of a frond-like twig? ..

Using a hand-lens, do they have obvious stomata or ridges, or neither? ..

Does the plant have both scale-like and needle-like leaves, like the juniper? ..

If yes, which type of leaf is linked to juvenile growth and which to mature growth?

Are the leaves **needle-like**? ..

If yes, are they single or in fixed numbers in groups or in tufts? ...

Are the leaves flat or angular? .. Pointed or blunt?.................................

Are the leaves rounded or tapering at the base? ..

Are the leaves held together in bundles (fascicles) by a thin membrane and with a scale-leaf at their base, like the pines?

..

If yes, how many leaves occur in each bundle? ...

Are the leaves **spirally arranged**? ..

If yes, are they single, in threes or twisted to appear in two rows? ..

Are there **leaf stalks** present or not? ..

If present, are they short or long? ..

Leaf attachments to stem

Are there **projections** or **pegs** on the twig? ..

If yes, are they short, small, or forward-angled? ..

Do they persist? ..

Are the leaf-stalks extended (decurrent) down the twig, leaving ridges as found in yew?

..

Are there **cushion-like pegs** separated by grooves, as in spruce? ..

Are there no projections? ..

If none, are there **scars** left on the twig where old leaves have been shed? Are the scars small and round, round and

concave, or other? ..

Bud shapes

Sharply pointed, oval and blunt, or other? ..

Male pollen-cones and their position on the tree

These may not be obvious for much of the year as many trees produce them and then drop them once the pollen is shed. Remember, depending on the species, they may occur at different times of year.

Are the cones long and catkin-like, large and cylindrical or rounded or ovoid? ..

What is the number of pollen-sacs on each cone-scale leaf or sporophyll? ..

Are the male cones solitary or clustered? ..

Are the male cones lateral, axillary or terminal on the branches, or on spur-like side shoots?

..

Colour of male cones? ..

Female cones

Remember that you may find several, differently aged, female cones on some trees. Some persist for many years as they mature slowly. Others mature and are shed in a year.

YOUNG, IMMATURE FEMALE CONES

Not woody and lacking scale leaves? Inconspicuous and consisting of ovules surrounded by bracts?

...

More conspicuous with woody scale leaves arranged spirally in the cone? ...

Positioned on terminal, lateral or side-shoots (spurs) on the branches? ...

Are the cones solitary or in groups? ...

Colour of young cones? ...

MATURE FEMALE CONES

Seeds erect and surrounded by a pink, fleshy aril (e.g. yew)? ...

Woody scales become dark and fleshy and cone looks berry-like as in juniper?

Or do scales remain obviously woody? ..

If yes, cone scales with umbo (raised knob) at free end or no umbo? ..

Or are there distinctive long bracts on the outside of the scales, as in Douglas fir?

Describe shape of cones – erect, rounded, cone-shaped, cylindrical, large, small, hanging etc.:

...

Number of seeds per cone scale? ...

Colour of seeds? ...

Seed wings firmly fixed to seed, or seeds in a cup on the wing, or wing held onto seed by claws?

...

Common name: ...

Latin name: ...

Annotated sketch of various diagnostic features

Helpsheet 5: A fern

Take care to find a representative piece or plant when drawing or painting a fern. Young or sterile plants are difficult to identify and there may be considerable variation in leaf size and shape. In mature plants there is less variation. Try to make sure that you have a fertile leaf with sori on the under-surface and that you have the fronds' attachment to the stem (usually underground). Hold leaves up to the light to observe veins.

This helpsheet for observing ferns can be adapted for use with the other groups.

Plant name

Common name: ...

Latin name: ..

Habitat: ...

Describing a typical frond or leaf

Are the fertile leaves different to the vegetative leaves? ...

Is the leaf blade entire, or divided into segments or into pinnae? ...

If pinnae are present, are they further divided into pinnules? ...

Does the arrangement of segments, pinnae and pinnules vary with the position on the frond?

...

Shape of whole leaf-blade, pinnae or segments

Ovate, narrow, oblong, lanceolate, triangular, linear, or other? ..

Shape of the tip of the leaf-blade, pinnae or segments

Sharply pointed, blunt or rounded, recurved, incurved, drawn out to a point, ending in a short straight

point? ...

Shape of the base of the leaf, segment or pinna

Tapering, asymmetrical, at right angles to the mid-rib, running down the mid-rib on one side, attached by its whole width to the

mid-rib, or other? ...

Shape of margins of the leaf, segment or pinna

Toothed (large or small teeth?mm), scallop-edged, smooth, entire, waved, reflexed, inflexed, curled, in-rolled?

...

Detailed diagram of a couple of typical segments or pinnae

Spacing of the segments or pinnae

Are they widely spaced or close together on the mid-rib? ...

Measure the distance between them:mm gap.

Diagram

Are the pinnae stalked or not? ...

Are the pinnae opposite each other or alternate? ..

Drawing of a whole frond or leaf

Arrangement of veins in leaf, segments or pinnae

Simple, forked or double forked? ...

Free at tips or linked at the margins? ..

Scales or hairs on the stem of the main frond and/or on the leaf

Pale, dark, thick, widely spaced, colour? ...

Mainly on young parts of the plant or elsewhere? ...

Do they persist as the part of the plant matures? ...

Number, shape and position of sori (on underside of fertile leaves)

Position: on veins or at edges? ..

Number? ...

Shape? ..

Naked or protected by a flap of tissue (indusium)? ..

Is the indusium persistent or does it shrivel or fall off when sori are ripe (brown)? ...

Size of underground stems (rhizomes): ...

Is the fern growing on another plant (epiphytic) e.g. tree? ...

Other noteworthy features:

...

Diagram

Helpsheet 6: A moss

Try to collect the plants and also some bits with the stalks and capsules sticking out.
You will need a dissecting microscope or a very good hand lens to help you see and record details.

Plant name

Common name (if there is one): ..

Latin name: ..

Habitat and what it was growing on: ..

Leaves

Leaf shape: rounded, lance-head shaped, tongue-like, divided at the tip, folded or wrinkled?

Leaf margin: smooth, toothed, or otherwise strengthened by specialised cells? ..

Leaf mid-ribs:

Present or absent? ..

Short (not reaching the tip of the leaf), or extending beyond the leaf-tip as long colourless hair?

Leaf cell shape: covered in protuberances, or with long, narrow cells, or hexagonal cells, or clear cells with pores that may be

water-filled (*Sphagnum*)? ..

Branching habit (shape of plant)

Plant erect without branches or branched? ..

Type of branching: forked into two, opposite pairs of side branches, side branches alternate, tree-like branches, rings of branches?

..

Drawing

Rhizoid system

Thick and felt-like covering on the stem, and/or well developed anchoring system embedded in substrate?

..

Not obvious, weak system with few rhizoids? ..

Capsule stalk (seta)

At tip of main shoot or on side branches? ..

Length:mm (may be diagnostic)

Strong or weak? ...

Persistent? ...

Colour?...

Spore capsules, at tip of stalk

Shape e.g. cylindrical, rounded, short, curved? ...

Position (how they are held at tip of seta) e.g. erect, dangling, horizontal, inclined, swan-necked, other?

Colour when developing? ..

Colour when ripe?...

'Hat' of tissue (calyptra), on unopened capsule

Shape? ...

Colour?..

Teeth surrounding the mouth of the capsule (peristome)

No teeth (*Sphagnum*)? ...

Double or single ring of teeth? ...

Are hairs present arising from the membrane between the rings of teeth? ..

Outer ring of thickened teeth, upright, twisted or reflexed (bent backwards)? ..

Drawing

Helpsheet 7: A 'capped' fungus (mushroom, toadstool or bracket)

Make sure you collect the 'whole' fungus – right down to the base of the stem, but avoid damaging the thread-like mycelium from which it has grown. Also collect a spare cap to use for making a spore-print – to see what colour the spores are. Try to collect young and mature specimens, as they may differ markedly.

Habitat

Note where you found it, e.g. grassy meadow, woodland margin, beech wood, near a birch tree, etc.: ...

...

Is it growing in the form of a 'fairy ring'? ...

If it is a bracket or a tuft of fungi growing from dead wood, note the type of wood e.g. oak, silver birch, etc.:

...

Note the date or time of year that you found it: ...

Habit

Is it growing singly or in groups? ..

Type

Is it a bracket? ..

Does the bracket emerge singly or in tufts? ...

Are they obviously stalked or lacking an obvious stalk? ...

Cap shape

Is it hemispherical , egg-shaped, conical, bell-shaped, cylindrical, flat, funnel-shaped or flattish with a knob in the centre

(umbonate)? ...

Cap surface

Is it smooth, dimpled, wrinkled, rough, bare, hairy, velvety, fibrous, covered in scales, sticky, dry, dull, shiny, streaked?

...

Cap colour

(Remember this may vary depending on whether the fungus is wet or dry.)

...

Size range of the caps (mm, cm)

There will be a maximum and minimum range for typical specimens.

..

Cap margin

Regular, wavy, turned up, turned in, turned down, sharp or rounded edges, fragments of veil attached?

..

Peeling the skin off the cap

Easy, difficult, doesn't peel? ...

Colour of the flesh

Immediately on exposure to air? ..

After 5–10 minutes' exposure? ..

Does the flesh yield latex? ..

If yes, what colour? ..

Diagram

Gill attachments from the stalk (stipe) to cap

Closely attached, extending down the stem, attached to a collar, free, withdrawn (gap between gills and stalk), attached end of gill

notched? ..

Gill's free edges

Smooth, scalloped, toothed or saw-toothed, thick, thin, branched? ..

Diagram

Gill texture

Soft, flexible, hard, brittle? ..

Gill colour (this may vary as the fungus ages)

Young: ...

Mature: ..

Teeth/spines

Short, long, sharp- or blunt-ended, thick, thin, crowded together, scattered, brittle, flexible etc.: ...

...

Tooth/spine colour: ...

Veins

Single, branched or forming a network, thin, thick, dense or widespread? ...

...

Vein colour: ..

Tubes

These open as pores at the surface of the spore-bearing layer.
Short, long, attached to the cap or extended down the stipe, in one or more layers:

...

Colour of tubes – young fungus: ...

Colour of tubes – mature fungus: ...

Pore size and shape – large or small? (Diameter:mm)

Pore colour (this may differ from the colour of the tubes): ..

Does the colour change when the pores are bruised e.g. to blue, brown, red etc.?

...

Stalk (stipe)

Stipe attachment to cap: this may be central or off-centre. It is characteristic for each species.

...

Shape of the stipe: cylindrical, club-shaped, barrel-shaped, spindle-shaped, conical (wider at top), base extends and looks root-like,

bulbous base? ...

If the base is bulbous, is it enclosed in a cup-shaped membrane (volva)? ...

If yes, do not eat under any circumstances!

Surface of the stipe: smooth, grooved, dimpled, fibrous, scaly, slimy, sticky, shiny, dull, ribbed etc.?

..

Colour of the stipe (this may vary throughout its length from cap to base): ...

Is there a membranous ring (annulus) persisting? ...

Is it wide, narrow, wavy, ridged, ragged etc? ...

(This may be very characteristic for a particular fungus.)
Inside detail of the stipe: solid, hollow, or of varied textures? ...

Diagram of stipe

You now have enough information to positively identify the fungus in a book!

Common name: ..

Latin name: ...

Drawings of all the features

Observations of all other fungi

Adapt the above-mentioned criteria to help you describe it in detail, i.e. habitat, description of overall shape and how the spores are released, colour, size, texture, and smell.

Red Dead Nettle flowers showing
four stamens (detail).

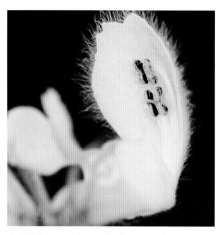

White Dead Nettle flowers showing
four stamens (detail).

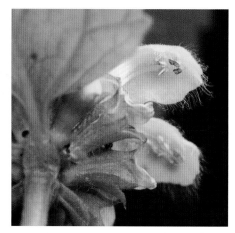

Yellow Archangel flower showing
stamens and stigma.

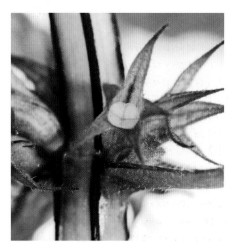

Red Dead Nettle showing four
nutlet-like fruits.

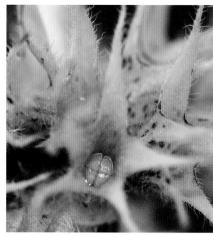

White Dead Nettle showing four
nutlet-like fruits.

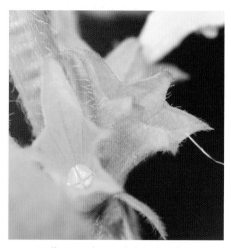

Yellow Archangel showing four
nutlet-like fruits.

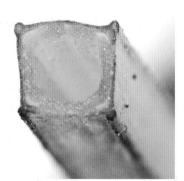

Red Dead Nettle showing hollow
square stem.

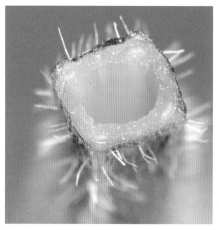

White Dead Nettle showing hollow
square stem.

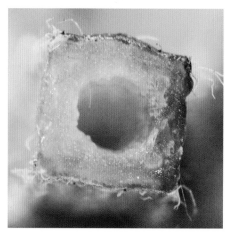

Yellow Archangel showing hollow
square stem.

CLASSIFICATION SYSTEMS AND PLANT FAMILY GROUPINGS

Classification systems

Chapter 13 has already given details of the Linnaean-type classification system which divides the plant kingdom into classes, orders, families, genera and species, depending on how similar plants are, and uses the binomial system for actually naming species of plants. In those days, there was no question of plants being related by evolution so they were grouped on perceived similar characteristics – a discipline known as taxonomy (see below).

Since Linnaeus' time, botanists have continued to try to improve the way in which plants are classified and grouped. The fungi are no longer considered to be plants and have been placed in their own separate kingdom. Meanwhile single-celled 'animals' (the protozoa) and 'plants' (the single-celled and other algae) have been assigned to another new kingdom – the Protoctista. Bacteria, which were unknown until the twentieth century, have been assigned to the Kingdom Prokaryotae. This leaves the mosses and liverworts, the ferns, the gymnosperms and the angiosperms (flowering plants) in the Kingdom Plantae. These changes have been brought about by the quest for a perfect system, the addition of new species and advances in scientific knowledge.

Since Darwin introduced the theory of evolution, classification and taxonomy have led to the development of a related discipline – systematics. There is often some confusion over these terms, as taxonomy and classification are closely interlinked, while systematics is reliant on taxonomy. The following definitions attempt to distinguish between the three terms.

- Systematics is the study of living things and shows their evolutionary relationships, over time, in the form of evolutionary trees – this is a hierarchical approach and rises from the most primitive to the most highly evolved, at the tips of the branches of the 'tree'.
- Taxonomy is the actual grouping of living things based on the study and description of each type of organism or species. This in turn allows the naming of organisms and their recognition and subsequent classification.
- Classification involves the sorting of organisms into groups depending on how closely they are related by various attributes. Thus, plants grouped in a 'kingdom' may be very different and share few attributes; conversely plants grouped in a 'species' are virtually identical in all but the most trivial aspects such as colour, wavy rather than flat petals, and so on.

The understanding and development of genetics from the early 1900s supported the methodology of classification systems, based on observable characteristics, used for grouping plants; but these different systems were dependent on how clever and 'how good' a botanist, the person developing a classification system was. Since the discovery of the molecular structure of DNA (deoxyribonucleic acid) in the 1960s, techniques to establish sequences of genes on the DNA in the 1980s, and latterly the discovery of the structure of RNA (ribonucleic acid) and related proteins, results have led to a review of the evolutionary ancestry of plants and this in turn has led to reviews of the classification of plants. Modern classification systems, like the APGII and APGIII, are heavily reliant on the use of computers and chemical analyses of DNA sequences in various genes, and are using genetic linkage mapping to re-group plants into evolutionary groupings. These analyses have provided, and are providing, a new dimension in the understanding of plant relationships, their classification and their evolution. The 'best' classification system of the future will group evolutionarily linked species into genera, families and orders.

Classification, plant families, and the painter

Whatever is happening in academic institutions, the recognition of plants in the garden or the 'field' still relies on observation and the noting of 'see-able' (phenetic), structural characteristics and it is this aspect that is of interest and most use to plant painters and illustrators. Various classification systems may have more or fewer families in the same or different orders but, regardless of these, the Linnaean binomial, genus and species names remain largely the same and provide a stability to any system.

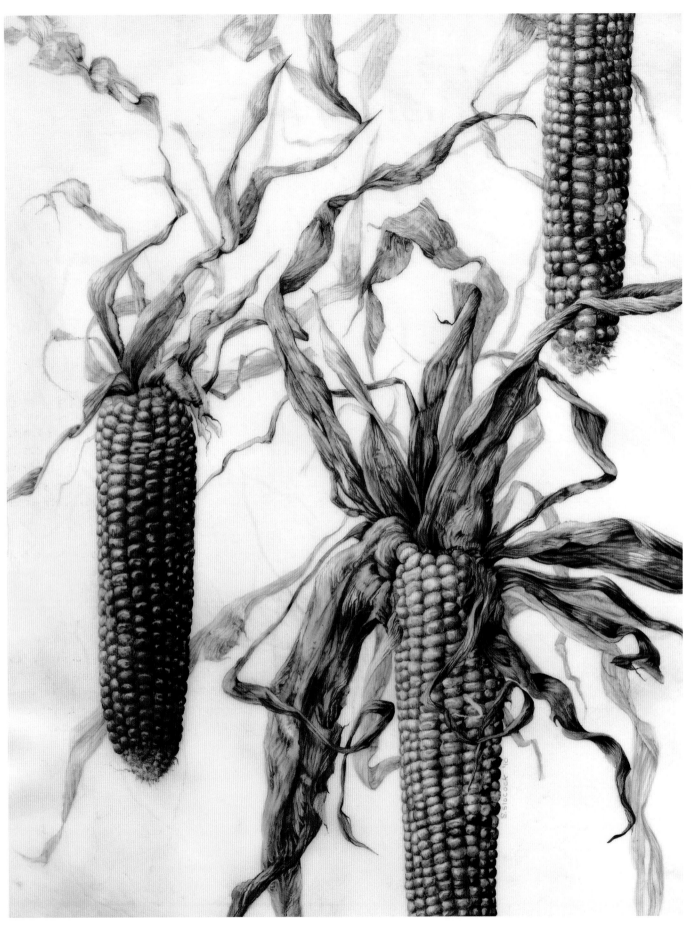

Maize. (Shirley Slocock)

HAMPTON COURT PALACE FLORILEGIUM SOCIETY

This Society was founded in 2004 by a group of artists who had all met as students on their botanical painting course and went on to gain a Diploma in Botanical Painting from the English Gardening School, in Chelsea. Since then a number of suitably qualified artists have accepted invitations to join the society and the membership is currently limited to twenty-five.

The aim of the HCPFS is to record the plants that grow at Hampton Court Palace and to build up an archive of pictures which Hampton Court Palace houses and retains for posterity. The archive contains over eighty paintings to date. The main thrust of the archive, so far, is to provide a record of Queen Mary's exotic collection of plants of historic interest. However, this is gradually broadening to include any plant growing in the glasshouses or gardens.

Members of HCPFS are obliged to submit at least one painting annually for assessment by a panel of RHS judges, established botanical artists, the Palace horticulturalists and the Director of the Royal Palaces. The archive can be viewed on the society's website:
www.florilegium-at-hamptoncourtpalace.com

Many members of the society have gained prestigious awards for their botanical paintings and have their work included in collections all over the world. The members who have kindly allowed me access to their botanical pictures, and also have paintings included in this book, are listed below.

List of HCPFS artists and their paintings included in this book

Sara Bedford: *Camellia; Lathyrus japonicus;* Parrot Tulips; Pine Cone

Maggie Cartmell: Two Figs – Study on Vellum; Hornbeam

Sheila Clarke: *Hygrocybe nigrescens,* on vellum; Chantarelles with Herb Robert, on vellum

Jackie Copeman: Cape Gooseberries; Orchid *Paphiopedilum; Wisteria;* Lily of the Valley

Leigh Ann Gale: Red Onion Study (*Allium cepa*) now in the Collection of the Hunt Institute for Botanical Documentation, Carnegie Mellon University, Pittsburgh, USA; Pansy on Vellum; *Cedrus atlantica* 'Manetti'

Jan Gibbs: Mixed Autumn Fungi

Maggie Hatherley-Champ: Acorn; Teasel; Sycamore Seedling

Lizabeth-Anne Leech:
Tropaeolum majus – Nasturtium, detail from picture; *Lonicera periclymenum* – Honeysuckle; *Passiflora caerulea; Phaseolus coccineus* – Runner Bean; *Clematis* 'Star of India'; *Anemone blanda*; Cactus *Schlumbergera* 'Wintermarchen'; Wild Daffodils; Orchid, Nelly Isler 'Swiss Beauty'; *Pisum sativum* – Pink Flowered Pea; *Solanum jasminoides* 'Album' – White, Potato Vine; *Spartium junceum*, Spanish Broom; Pineapple, pencil study; *Lathyrus latifolius*, Everlasting Pea, pen and ink

Jenny Malcolm: *Protea cynaroides*, King Protea; Mixed Fruit (pen and ink)

Angeline de Meester: *Heuchera/Heucherella*

Anne Patterson: *Acer* seeds; Sweet Chestnut; Green Fern – alive, Hart's Tongue Fern; Shuttlecock Ferns; *Rosa rugosa* hips; Pine Cone; *Iris pseudacorus* with seeds; Tree Paeony Bud

Beth Phillip: *Malus x domestica* 'Discovery' Apple; *Sarracenia hybrid w-f-e; Darlingtonia californica; Heliamphora nutans*

Shirley Richards: *Arum.* Pen and Ink; Beans. Pencil study

Lesley Ann Sandbach: Catkins

Shirley Slocock: *Magnolia soulangeana; Foeniculum vulgare,* Fennel; Maize

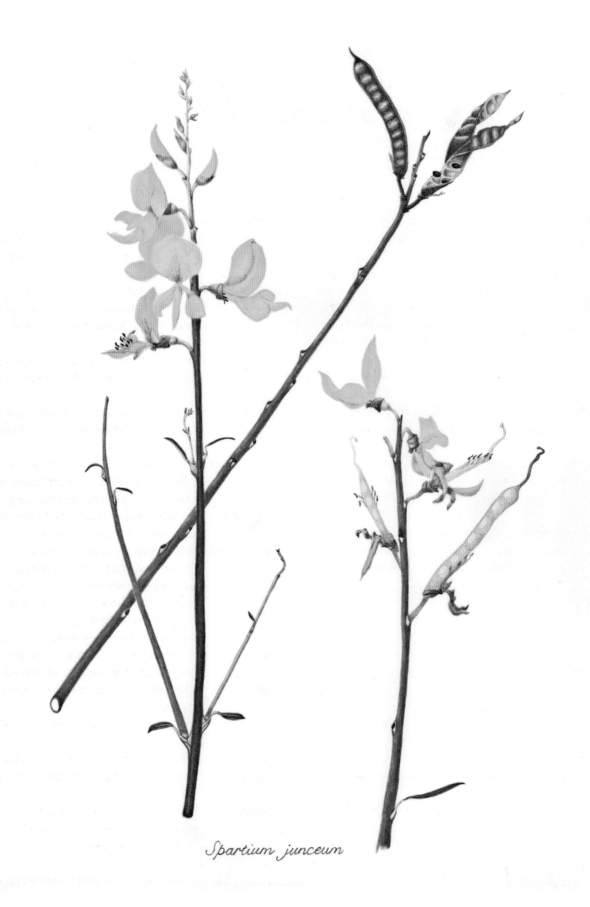

Spartium junceum

Spartium junceum, Spanish Broom. (Liz Leech)

GLOSSARY

Abscission Normal shedding from a plant of an organ
that is mature or aged, e.g. a ripe fruit or an
autumn leaf.

Achene Small, dry, indehiscent single-seeded fruit.

Acrocarpous In mosses, bearing the seta and capsule
from the tip of a plant.

Actinomorphic Of a flower that is radially symmetrical and
can be cut in any plane to give an identical
half flower.

Acuminate Where the tip of a leaf-blade draws out to a
point.

Adnate In ferns where the base of the leaf or segment
is attached to the mid-rib by its whole width.

Androecium All the male parts of the flower.

Androgynophore
Stalk bearing both the androecium and
gynoecium of a flower above the level of
insertion of the perianth, as in passionflowers.

Angiospermae Classification grouping of higher plants in
which the reproductive parts form a flower.

Annual Where the life-cycle is completed within
twelve months from germination.

Annulus Special, thick-walled cells forming part of the
opening mechanism of a fern sporangium,
often almost forming a ring. As the annulus
cells dry out they cause tension, which causes
the non-thickened cells to tear and thus open
the capsule.

Anther The part of the stamen that makes and con
tains the pollen.

Antheridium
(pl. antheridia) Male sex organs in ferns, mosses and liver
worts. They contain the male sex cells.

Anthers, apicifixed
Attached at the top.

Anthers, basifixed
Joined at the base.

Anthers, dorsifixed
Attached at the back.

Anthers, extrorse
Opening towards the outside of the flower.

Anthers, introrse
Opening towards the inside of the flower.

Apical Where the growing point is at the tip.

Apothecium (pl. apothecia)
Cup-shaped, often coloured, reproductive
structure, that contains the spore-producing
asci, on the thallus of some lichens.

Archegonium (pl. archegonia)
Female sex organs in ferns, mosses and liver
worts – vase-like structure containing egg
cells.

Areole Small, specialized, cushion-like area on a
cactus from which hairs, spines, branches or
flowers may arise.

Aril Fleshy, usually brightly coloured, cover of a
seed that develops after fertilization as an
outgrowth from the ovule stalk, e.g. yew.

Ascospores Spores produced and contained within the
ascus of an Ascomycete fungi.

Ascus (pl. asci) Specialized cell in fungi of the phylum
Ascomycota, containing two nuclei with half
the normal chromosome number (haploid or
n) which fuse during sexual reproduction and
then undergo division, giving rise to eight
ascospores contained within the ascus.

Asymmetric Where a flower cannot be cut in any direction
to give equal or identical half flowers.

Auricle 'Ear-like' projections on each side of the base
of a leaf-blade.

Awn Stiff, bristle-like projection from the tip or the
back of the lemma in grasses.

Axil The upper angle between a leaf stalk or
branch and the stem or trunk from which it is
growing.

Axillary bud Bud arising in the axil of a leaf or bract.

Basidiospores Spores produced by a basidium found in the
Basidiomycete fungi.

Basidium (pl. basidia)
Usually club-shaped structure that produces
basidiospores. Many basidia form a layer on
the fungal fruiting body, e.g. on the gills,

teeth and 'veins' and lining the tubes of Basidiomycetes.

Berry Simplest type of succulent, often many-seeded fruit.

Bifid Slit deeply in two.

Bipinnate A leaf in which the primary divisions are themselves pinnate.

Bract A modified leaf with a flower in its axil.

Bracteole Small bract or modified leaf.

Branched raceme Inflorescence in which the axils of the bracts give rise to further racemes.

Bryophyta Classification grouping of mosses and liverworts.

Bud scale Scaly leaf that is part of a protective sheath around a plant bud.

Burr (bur) Rough, prickly husk or covering surrounding the seeds or fruits of plants e.g. goosegrass, horse chestnuts.

Cactoid Cactus-like.

Calyptra Cap-like structure covering, or partly covering, the free end of the moss capsule as it ripens. It is derived from the neck of the female archegonium, from which the sporophyte grows.

Calyx All the sepals of a flower, typically forming a whorl that encloses the petals and forms a protective layer around the flower bud.

Capitate Head- or knob-like.

Capitulum Inflorescence where the free tip of the flower stalk is broad and flattened to form a platform where many reduced flowers are collected together in a head.

Capsule Dry dehiscent fruit composed of more than one carpel.

Carnivorous plant Any plant especially adapted for capturing insects and other tiny animals by means of ingenious pitfalls and traps and then subjecting them to the decomposing actions of digestive enzymes, bacteria, or both.

Carpel One of the units of which the female gynoecium is composed.

Chit Term for when a potato sprouts.

Cladode Green, flattened, leaf-like lateral shoot (stem) that performs similar functions to a true leaf.

Column A highly modified structure peculiar to orchids. The column includes the male anthers (pollinia) and the female stigma and style.

Compound leaf Type of leaf with the blade divided into two or more separate parts called leaflets.

Compound palmate A compound leaf composed of leaflets that all arise from a central point, like the fingers from a hand, e.g. horse chestnut leaf.

Compound pinnate Leaf with leaflets that are borne on either side of the continuation of the mid-rib vein, from the petiole.

Cone Spirally arranged, reduced, scale-like leaves that surround and protect the male or the female sex organs.

Convergent evolution A kind of evolution where organisms evolve with similar structures or functions in spite of their evolutionary ancestors being dissimilar or unrelated.

Corm Short, usually erect, swollen underground stem of one year's duration. The next year's stem arises from the top of the old one.

Corolla All the petals of a flower, forming a whorl within the sepals and enclosing the reproductive organs.

Corona Ring of tissue arising from the corolla or perianth of a flower e.g. daffodil trumpet.

Corymb Inflorescence where the flower stalk is longest at the bottom and becomes progressively shorter so that the flowers are held in a 'plate-like' mass rather than a spire.

Cotyledons The leaves of the embryo plant, found in the seed.

Crosier Of a young fern frond, coiled and hook-shaped like a bishop's crook.

Cross-pollination Where the pollen from the anther of one flower is transferred to the stigma of another flower.

Crustose Relating to a lichen whose thallus is thin, crusty and closely adherent to, or embedded in, the surface on which it grows.

Culm Flowering stem of a grass.

Cultivar Race or variety of plant that has been created or selected intentionally and maintained through cultivation.

Cupule Plant structure made of hardened, cohering bracts resembling a cup, e.g. acorn cup.

Cyathium Inflorescence consisting of a cup-like cluster of modified leaves enclosing a reduced female flower and several reduced male flowers e.g. poinsettia, spurges.

Cyclic Circular in shape.

Cyme	An inflorescence where the flower stops the growth of a stem.
Deciduous	The shedding of parts, e.g. losing leaves in autumn or during drought.
Decurrent	Having the leaf base extending down the stem below the insertion of the leaf.
Decussate	Of leaves – opposite, but successive pairs orientated at right angles to each other.
Dehisce	Opening of an organ to shed seeds or pollen or spores.
Dichasium	A cyme in which two branches that are opposite and approximately equal arise and continue growth from either side of a stunted central flower.
Dichasium (*pl. dichasia*)	Name for each unit of a catkin and consisting of a large modified leaf or bract overarching mini-bracts (bracteoles) and a set number of reduced flowers.
Dicotyledon	Flowering plant with two seed leaves, net-veined leaves and in which the number of flower parts are not three or any multiple of three.
Dioecious	Having single-sex flowers on separate plants.
Disc florets	Tubular-shaped small flowers found in heads or the capitulum of a Compositae inflorescence.
Drupe	Fleshy fruit with one or more seeds, each surrounded by a stony layer, e.g. peach.
Drupelet	Small drupe, as of one of the many pulpy grains of the blackberry.
Elater	Elongated, spirally thickened structure, in the capsule of a liverwort, assisting in spore dispersal by twisting and moving as it dries out.
Endocarp	Innermost layer of the wall of a fruit; in a drupe, the stony layer surrounding the seed.
Endosperm	Nutritive tissue in the seed of a flowering plant, formed after fertilization.
Enzyme	Catalyst or chemical produced by cells to speed up a specific chemical reaction.
Epicalyx	A smaller, calyx-like structure outside the whorl of sepals.
Epicarp	Outermost layer of the pericarp – 'skin' of a fruit, e.g. plum.
Epigynous	The other parts of a flower are attached above the ovary, which is inferior.
Epiphyte (*adj.* epiphytic)	Plant that derives moisture and nutrients from the air and rain; usually physically grows on another plant (not the earth) but is not parasitic.
Falcate	Curved and sickle-shaped.
Fascicles	Small bundles of needle-like leaves, e.g. in pine.
Fertilization	The moment when the DNA from the male sex cell (pollen grain) joins together with the DNA from the female sex cell (in the ovule). The cell formed becomes the embryo plant and the seed.
Filament	Stamen stalk holding the anther in its correct position, in the flower.
Floral symmetry	Where the parts of a flower are evenly arranged.
Floret	Reduced flower in a Compositae flower 'head' or in a grass spikelet.
Foliose	Of or relating to a lichen whose thallus is flat and leafy and often of different colours on the upper and lower surfaces.
Follicle	Dry dehiscent fruit formed of one carpel, dehiscing along one side.
Frond	'Leaf' of a true fern.
Fructifications	'Fruiting bodies' or specialized structures on which a fungus or a lichen produces its reproductive spores.
Fruticose	A lichen with branches that are rounded in cross-section and are the same on all sides, e.g. bearded, hair-like or shrubby lichens.
Gametophyte	Generation of an organism that bears the sex organs. It only has half the normal chromosome number (n).
Gemmae	Small, vegetative, units of tissue that can grow into new plants.
Genus (*pl.* genera)	Classification grouping that gives first part of binomial. All plants in a genus share many, common attributes.
Germinate	When a seed starts to sprout, grow and develop.
Girdle scar	Circular area of scars on a twig where the bud scales have dropped off from last year's terminal bud. It marks the beginning of a year's growth on a twig.
Glume	Scale-like bract surrounding immature spikelet in grasses.
Gramineae	Family to which grasses belong.
Guidelines	Contrasting coloured markings on petals that guide pollinators to the female stigma and to the pollen in the anthers.
Gymnosperm	Phylum grouping of plants with naked seeds, e.g. conifers.
Gynoecium	All the female parts of the flower. Made up of

units called carpels – an ovary, style and stigma.

Habit — Growth form of a plant, comprising its size, shape, texture and orientation.

Herbaceous — Plant that has a non-woody stem.

Hermaphrodite — With both male stamens and female carpels in a bisexual flower, or being both male and female.

Hyphae — Fine, branching threads which make up the 'body' of a multicellular fungus.

Hypogynous — The flower parts arise from below the superior ovary.

Indehiscent — Not opening to release its seeds.

Indusium — Protective umbrella or flap of tissue covering the sorus of a fern.

Inferior ovary — The other flower parts arise from above the ovary.

Inflorescence — Many-flowered part of a stem or a branch.

Infructescence — An inflorescence which becomes fleshy and fruit-like, e.g. pineapple.

Insect-pollinated flowers
Flowers that rely on insects and other animals to transfer their pollen from an anther to a stigma.

Internode — That part of the stem between two adjacent nodes.

Involucre of bracts
Bracts forming a calyx-like structure round or just below the base of a usually condensed inflorescence, e.g. in members of the Compositae, like dandelion or thistle.

Kingdom — Main grouping of living things, e.g. plant kingdom.

Labellum — The often enlarged lip-like petal found opposite the column in an orchid flower.

Lamina — Leaf-blade; a thin, flat piece of tissue.

Lanceolate — Shaped like a lance-head.

Latex — Viscous liquid that can be a milky or coloured juice that exudes from damaged parts of a plant. This latex coagulates when it meets the air and seals the damaged part, e.g. rubber from the rubber tree, poppies, spurges.

Leaf scar — Mark left on a twig showing where a leaf had been attached, after a leaf falls.

Legume — Member of the pea family.

Lemma — The lower of two bracts enclosing a grass flower.

Liane — Climbing, woody vine, e.g. clematis.

Lignin — Tough, waterproof lining material which makes xylem vessels like 'pipes' and other cells strong and woody.

Ligulate — Strap- or tongue-shaped.

Ligule — Membrane arising between the blade and the leaf-sheath of a grass leaf.

Linnaeus — Latinized name of Swedish botanist Carl von Linné (1707–78) who introduced a system of binomial nomenclature in the classification of animals and plants.

Loculus (*pl.* loculi)
Compartment(s) of an ovary.

Lodicule — One of a pair of tiny reduced structures in a grass floret, between the lemma and the fertile parts of the flower.

Membranous — Thin, dry and flexible – not green.

Mesocarp — Middle, usually fleshy layer of a fruit wall, e.g. in a drupe such as a cherry.

Mid-rib — Central, and usually the most prominent, vein of a leaf.

Monochasium — A cyme in which the branches are spirally arranged or alternate or one is more strongly developed than the other.

Monocotyledon — Flowering plant with one seed leaf, parallel-veined leaves, and in which the flower parts are in threes or multiples of three.

Monoecious — Having single-sex flowers with both male and female flowers or catkins on the same plant.

Monopodial — Of a stem in which growth is continued from year to year by the same apical growing point.

Monosymmetric
Where a flower can only be cut in one plane to give two identical half flowers. The same meaning as zygomorphic or bilateral.

Mucilage — Moist, soft, slimy liquid composed of soluble carbohydrates.

Mucronate — Where the tip of a leaf-blade ends in a short, straight point.

Mycelium (*pl.* mycelia)
Vegetative 'plant' of a fungus which is made up of thread-like hyphae.

Mycobiont — Symbiotic fungal constituent of a lichen.

Mycorrhiza — Symbiotic association of the mycelium of a fungus with the roots of certain plants.

Nectary (*pl.* nectaries)
Gland(s) in flowers that produce a sugary liquid, called nectar, to attract pollinators.

Net-veined — Where the veins are branched and form a net-like structure in the leaves.

Node — Point on a stem where one or more leaves arise.

Nutlet — Small nut.

Operculum — Lid or cover over the moss capsule's opening which becomes detached, when the spore

capsule is mature.

Ostiole (*pl.* ostioles)
Small pore in the reproductive bodies of certain algae and fungi through which ascospores pass.

Ovary The female part of the plant that contains the ovules, with their egg cells.

Ovule Structure that contains the egg cell and develops into the seed after fertilization.

Palea Upper, or inner, thin membranous bract enclosing the flower, in grasses.

Panicle Inflorescence which is a branched raceme.

Papillose With small elongated projections on the surface of a stigma, petal or leaf.

Pappus Modified calyx composed of scales, bristles, or feather-like hairs, in plants of the Compositae family, e.g. dandelion.

Parallel-veined Where the veins are not branched and run parallel to each other, from the bottom to the top of a long leaf.

Parasite (*adj.* parasitic)
Plant that derives its food from another living organism.

Pedicel Flower-bearing stalk.

Peduncle Stalk of an inflorescence.

Peltate Of a flat organ with its stalk inserted on the under surface, not at the edge, like the handle of an umbrella.

Perennating organ
A part of the plant that stores food and allows the plant to survive in a dormant state from one growing season to the next, e.g. bulb, corm, rhizome.

Perennial Living for more than two years and usually flowering each year.

Perianth Collective name for the sepals and petals.

Pericarp The part of a fruit that develops from the ovary wall of a flower.

Perichaetial Of a ring of leaves or bracts that surround the female sex organs of a moss. The seta and capsule grows out of this ring of leaves.

Perigonial Of a ring of leaves or bracts that surround the male sex organs of a moss.

Perigynous Where the flower parts are on the top edge of a ring of tissue, arising from around the ovary.

Peristome Single or double ring of teeth surrounding the opening of a moss capsule.

Perithecia (*s.* perithecium)
Flask-shaped structures embedded in the thallus of a lichen. These perithecia contain asci which release their ascospores, dis-

charged from an apical pore on the surface of the thallus.

Petal Each of the parts of the corolla of a flower.

Petaloid Petal-like.

Petiole Stalk of an ordinary dicotyledonous leaf. It connects the leaf-blade to the stem.

Pheromone Sex hormone.

Phloem Conducting tissue made up of elongated, tube-like, living cells that transport food made in the leaves down through the stem, to the roots, and up through the stem, to the flowers and developing fruits and seeds.

Photobiont Photosynthetic partner of a symbiotic pair of organisms, such as the algal component of the fungal-algal association in lichens, or the fungal-cyanobacterium association in other lichens.

Photosynthesis Process by which green plants transform light into chemical energy (sugars) using carbon dioxide and water. This process releases oxygen into the air. The light energy is captured by light-absorbing pigments, such as chlorophyll.

Phyllode Modified petiole in some plants in which the petiole is characteristically flattened, resembling and performing functions similar to a true leaf.

Phyllotaxy The arrangement of leaves on an axis or stem so that they all receive maximum light for photosynthesis.

Phylum (*pl.* phyla)
Major subdivision of a kingdom.

Pin-eyed Stigma held above the anthers in a primula. This ensures cross-pollination.

Pinna (*pl.* pinnae)
In a fern, primary division of a pinnate leaf-blade into distinct sub-divisions.

Pinnate Branched or divided into distinct leaflets borne to the right and the left of a central vein in a leaf or rachis in a frond.

Pinnatifid Pinnately cut, but not into separate portions, the lobes connected by lamina as well as midrib or stalk.

Pinnule Secondary subdivision of a fern pinna when the divisions are quite distinct.

Placenta Part of the ovary to which an ovule is attached or part of a leaf to which a fern sorus is attached.

Placentation Position of the placenta in the ovary.

Placentation, axile
In the angles formed by the meeting of the

partitions in the centre of the ovary.

Placentation, apical Where the ovules arise from the upper edge of the single-chambered ovary.

Placentation, basal Where the ovules arise from the base of the single space in the single-chambered ovary.

Placentation, free central Where the central column or axis of tissue, to which the ovules are attached, does not extend to the top of the ovary wall.

Placentation, marginal Where the ovules are attached to the edges of the carpels.

Placentation, parietal Where the ovules are attached to the middle of the wall of the carpel.

Pleurocarpous In mosses, bearing the seta and capsule on short side branches – not the main stem (cf. acrocarpous).

Plicate Of a moss leaf that is longitudinally folded or wrinkled into pleats or furrows.

Plumule The growing stem tip of the embryo of a seed, above the place of attachment of the radicle (root).

Pod Two-valved fruit, as in a pea pod.

Pollination The transfer of pollen from the anther to a stigma.

Pollinator The insect or animal or agent (like wind) that physically transports pollen from the anther of one flower to the stigma of another flower.

Pollinia Coherent masses of pollen grains in an orchid flower.

Pome False fruit, e.g. apple, where the seeds are surrounded by a tough (but not woody) 'core' formed from the ovary wall. This is in turn surrounded by the fleshy receptacle.

Pore A hole.

Propagate To grow.

Protandrous Of a flower, in which stamens mature before the stigma.

Protogynous Where the stigma is receptive before the pollen is shed from the anthers of the same flower.

Pseudobulb A thickened, fleshy bulb-like stem of an orchid plant, located above the ground.

Pteridophyta Classification grouping of ferns and their close allies.

Pulvinus (*pl.* pulvini) Swelling on a twig, at the base of the stalk of a leaf or a leaflet.

Pyxidium (*pl.* pyxidia) Fruit capsules that open via a hemispherical lid, e.g. scarlet pimpernel.

Raceme Inflorescence with a strong, upright stem with single-stalked flowers arising from the axil of a leaf-like bract.

Radial symmetry Where a regular flower can be cut in half in any direction to produce identical halves.

Radicle The part of a plant embryo that develops into a root.

Ray florets Strap- or tongue-shaped reduced flowers in the Compositae.

Receptacle Flat, concave or convex uppermost part of the stem from which the parts of the flower arise and to which they are attached.

Reticulate Marked with a network, usually of veins.

Rhizines Hair-like growths that anchor the lower surface of the thallus, of a foliose lichen, to the substrate.

Rhizoid In liverworts and mosses – a short, thin filament attaching the gametophyte to the substrate. These root-like structures facilitate the absorption of minerals and water.

Rhizome Underground stem lasting more than one growing season.

Root, adventitious Root that arises from any plant part other than the primary root or its branches (lateral roots).

Root, buttress Thick roots that flare out from the base of large canopy trees to provide support as well as nutrients.

Root, contractile Any of the modified adventitious roots that develop from the base of the stem of a bulb or corm. These roots contract to pull the bulb or corm beneath the soil.

Root, prop Modified root that arises from the stem of a plant to provide extra support.

Root, stilt Root that arises from the lower part of the trunk and runs obliquely to the ground, in mangroves.

Rostellum Small, beak-like projection of the stigma in orchids.

Runner Form of stem, consisting of an aerial branch that roots at the free end forming a new plant which eventually becomes detached from the parent.

Samara Dry indehiscent fruit, part of the wall of which forms a flattened wing, e.g. sycamore.

Saprophyte (*adj.* saprophytic)
 Plant that derives its food from dead organic matter.

Scarified When a seed coat becomes softened and weakened by digestive juices or abrasion.

Schizocarp A dry fruit that splits at maturity into two or more one-seeded parts.

Segment Where a leaf-blade in a fern is subdivided, whether completely to the mid-rib or not.

Self-pollination Where the pollen from the anthers of a flower pollinates the stigma in the same flower.

Sepal Each of the parts of the calyx of a flower, enclosing the petals.

Sepaloid Sepal-like.

Septum (*pl.* septa)
 A dividing wall, e.g. of an ovary.

Sessile Without a leaf-stalk.

Seta (*pl.* setae) In mosses – sporophyte stalk that links the capsule with the moss 'plant'.

Silicula Short siliqua, not more than twice as long as its width.

Siliqua Long, dry dehiscent fruit formed from a superior ovary of two carpels, with two parietal placentas and divided into two loculi by a false septum between the placentas.

Simple leaf A leaf having one blade, or a lobed leaf in which the separate parts do not reach down to the mid-rib.

Soredia (*s.* soredium)
 Specialized asexual reproductive units of lichens consisting of algal cells surrounded by fungal hyphae. When dispersed, soredia grow into new lichen 'plants' when they reach a suitable habitat.

Sorus (*pl.* sori) Group of sporangia attached to a mound of tissue called a placenta on a fern frond.

Spadix Central spike of tightly packed 'insignificant' male and female flowers found in the Araceae, e.g. *Arum*.

Spathe Large bract surrounding the spadix in the Araceae, e.g. *Arum*.

Spike Inflorescence where the flowers are borne directly on the main stalk, in the axil of a bract.

Spikelet Collection of grass florets.

Spine Stiff, sharp-pointed structure, formed by modification of a plant organ, e.g. a stem.

Sporangia Spore-producing capsules.

Sporangiophore
 Modified spore-bearing organ that is not leaf-like.

Sporophylls Fertile leaves that bear spores, or fertile leaves that bear male and female organs which contain egg cells and pollen cells.

Sporophyte Generation of an organism that results from fertilization of an egg and a sperm and therefore has the 'normal' (2n) full chromosome number. In lower plants, like ferns and mosses, the sporophyte produces spores.

Spur Hollow projection that arises from the petals and/or sepals and forms a collecting structure for the nectar.

Squamule Scale-like lobe forming part of a squamulose lichen.

Squamulose A lichen which has a thallus consisting of minute scale-like outgrowths. Similar to the crustose lichen growth form.

Stamen Male sex organ of a plant, made up of the anther and the filament.

Stigma Receptive part of female organs, which the pollen grains stick to at pollination.

Stipe Stalk, especially of fungal fruiting bodies or of large brown algae.

Stipule Scale-like, or leaf-like appendage usually at the base of the petiole.

Stolon Creeping stem of short duration produced by a plant which has a central rosette or erect stem.

Stoma (*pl.* stomata)
 Tiny pore in a plant leaf surrounded by a pair of guard cells that regulate its opening and closure. Stomata are where gases and water vapour enter and leave the leaf.

Style A female part of the plant that connects the ovary with the stigma.

Substrate Material on which an organism lives, or the surface or medium on which an organism grows.

Succulent Water-retaining, usually thick, fleshy plant that has developed some physical adaptations enabling it to survive long periods of water-shortage.

Superior ovary The ovary grows out (arises) from above the insertion of the other flower parts.

Symbiotic Relationship between individual of different species in which both individuals benefit from the association.

Sympodial Of a stem in which the growing point either terminates in an inflorescence or dies each year, growth being continued by a new lateral growing point.

Tendril Thread-like climbing organ often formed

from the whole or part of a stem, leaf or petiole.

Tepal Another name for a perianth part, a sepal or petal, especially when they are all similar.

Testa Tough outer coat of a seed.

Thallus *adj.* Thalloid
A thallus is a plant that is undifferentiated into root, stem and leaves. In ferns and liverworts – small, flat, green structure bearing microscopic male and female sex organs.

Thrum-eyed Anthers held above the stigma in a primula. This ensures self-pollination.

Tissue culture Where seeds or small bits of plant tissue are grown in a nutrient jelly in a laboratory.

Tripinnate Of leaves pinnately divided three times.

Triploid Having an extra set of chromosomes (3n) rather than the normal number (2n).

Truncate In ferns where the base of the leaf or segment is at right angles to the mid-rib.

Tussock Grassy mound formed by a grass plant.

Umbel Inflorescence where flowers are massed on the same level but the flower stalks all arise from the same point at the tip of the flower stalk

Umbel, compound
Inflorescence where the umbel flower stalks each give rise to more stalks and another umbel of flowers.

Umbo *adj.* umbonate
A raised, round structure, e.g. on a fungus cap or on a pine cone sporophyll (like the

knob in the centre of a roman shield).

Unilocular Having a single cavity in the ovary.

Vascular Tissue that conducts water and nutrients within a plan, e.g. mineral salts, sugars.

Vascular bundle A group of conducting tissues, called xylem and phloem, which transport water, sugars and minerals throughout the plant, in veins.

Vegetative Without flowers or asexual.

Velamen Whitish, spongy sheath of dead empty cells that surrounds the aerial roots of epiphytic plants, e.g. orchids.

Volva Sack-like envelope surrounding the base of the stalk of certain toadstools. The remains of the universal veil.

Whorl (*adj.* whorled)
Ring of similar parts or where two or more parts of the same kind arise from the same level of a flower.

Wind-pollinated flowers
Flowers that rely on the wind and air currents to transfer their pollen from an anther to a stigma.

Xerophyte Plant adapted for life with a limited supply of water or adaptations to prevent water loss.

Xylem Conducting tissue made up of continuous tubes, of hollow, dead cells, which transport water and dissolved minerals up the plant from root to stem, flowers and leaves.

Zygomorphic Of an irregular flower, having only one plane of symmetry. The flower can only be cut in one plane to give two identical half flowers.

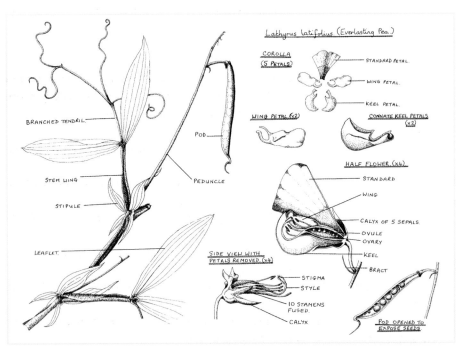

Pen and ink sketch of *Lathyrus latifolius*, Everlasting Pea. (Liz Leech)

BIBLIOGRAPHY

BRYOPHYTES: MOSSES AND LIVERWORTS

Atherton, I., Bosanquet, S., and Lawley, M. (eds), *Mosses and Liverworts of Britain and Ireland: a field guide*, British Bryological Society, 2010. (Good field key and useful diagrams; detailed photographs of many species.)

Hill, M.O., revised Hodgetts, N.G. and Payne, A.G., *Sphagnum: a field guide*, joint Nature Conservation Committee, 1992. (Helpful key for identifying Sphagnum species.)

Watson, E.V., *British Mosses and Liverworts*, Cambridge University Press, 1968. (Useful diagrams and descriptions of British Bryophytes. Helpful for illustrators. No colour pictures.)

FERNS

Hyde, H.A., Wade, A.E., and Harrison, S.G., *Welsh Ferns*, National Museum of Wales Publication, Cardiff, 1969. (Old but very useful for details of British Ferns, such as sori and venation.)

Phillips, R., *Grasses, Ferns, Mosses & Lichens of Great Britain and Ireland*, Pan Books, 1980. (Good photos, mosses difficult to identify at times.)

Rose, F., *Colour Identification Guide to the Grasses, Sedges, Rushes and Ferns of the British Isles and North-Western Europe*, Viking, Penguin Group, 1989. (Useful keys and clear descriptions and illustrations of each species. Useful detail to help accurate paintings.)

GARDEN PLANTS

The Royal Horticultural Society, A-Z Encyclopedia of Garden Plants, Dorling Kindersley, 1998. (Useful reference book if you know the Latin names.)

The Royal Horticultural Society, Encyclopedia of Plants and Flowers, Dorling Kindersley, 1999. (Very useful reference book.)

The Royal Horticultural Society Magazine, *The Garden, Vol.135 (11), 2010*, RHS. (Monthly magazine, full of inspiring plants and what is trendy in the plant growers' world.)

GRASSES, SEDGES AND RUSHES

Hubbard, C.E., revised by Hubbard, J.C.E., *Grasses: a guide to their structure, identification, uses and distribution in the British Isles*, 3rd. edition, Penguin Science, 1984. (Excellent descriptions and detailed illustrations with a comprehensive identification key).

Hubbard, C.E., *Grasses*, Pelican Original, 1967. (Old, but excellent descriptions and diagrams helpful for British grasses.)

Jermy, A.C. and Tutin, T.G., *British Sedges*, Botanical Society British Isles (BSBI) Publication, 1968.

LICHENS

Duncan, U.K., *Introduction to British Lichens*, T. Buncle and Co., Arbroath, 1970. (Scholarly but heavy going and few pictures; dated.)

ORCHIDS

Harrap, A. and S., *Orchids of Britain & Ireland: a field and site guide*, 2nd Edition, 2009. (Good, clear photographs and useful descriptions of each species salient characteristics.)

Hessayon, Dr. D.G., *The Orchid Expert*, Transworld Publishers, 2009. (How to grow orchids and some details of different types.)

TREES

Edlin, H.L. and Darter, C., *Know your Broadleaves*, Forestry Commission Booklet No.20, HMSO, 1975. (Old but excellent diagrams of tree parts and flowers. Mainly British trees.)

Edlin, H.L., *Know Your Conifers*, Forestry Commission Booklet No. 15, HMSO, 1976.

Phillips, R., *Trees in Britain, Europe and North America*, Pan Books, 1981.

Pokorny, J. and Kaplicka, J., *Trees, Leaves, Bark and Fruit*, Octopus Books, 1983.

FUNGI

There are many publications available, but you need a range of books to definitely identify what you find — especially if you intend to eat them as well as illustrate them!

Dermek, A., *The Spotters Guide to Mushrooms and Other Fungi*, Byeway Books, 1982.

Dickinson, C. and Lucas, J., eds., *The Colour Dictionary of Mushrooms*, Orbis Publishing Ltd, 1982.

Ellis, E.A., *British Fungi, Book 1 and Book 2*, Jarrold Colour Publications, Norwich, 1976.

Hvass, E. and Hvass, H., *Mushrooms and Toadstools in Colour*, Blandford Press, 1961.

Jordan, P., *The New Guide to Mushrooms*, Anness Publishing Ltd, 1996.

Lange, M. and Bayard Hora, F., Collins *Guide to Mushrooms & Toadstools*, Collins, 1967.

Sterry, P., *A Photographic Guide to Mushrooms of Britain and Europe*, New Holland Ltd., 1995.

GENERAL BOTANICAL

Cadogan, A., ed., *The Five Kingdoms & Behaviour*, Thomas Nelson and Sons Ltd., 1994. (School text: brief general descriptions of main classification groups of plants and animals.)

Hickey, M., *Botany for Beginners*, Chelsea Physic Garden Florilegium Society, 1999. (A mixed collection of occasional articles on botanical topics written in response to students' questions. Pen and ink diagrams and illustrations.)

Mabberley, D.J., *Mabberley's Plant Book: A portable dictionary of plants, their classification and uses*, Cambridge University Press, 3rd edition, 2009. (Good reference work for looking up genera and their families.)

McLean, B., and Wise, R., *Dissecting Flowers*, Chelsea Physic Garden Florilegium Society, 2001. (A very helpful guide to dissecting flowers in order to add them to plant portraits. Many drawings and stylized diagrams to aid recognition and understanding of floral structures that are useful to botanists, includes floral diagrams.)

Phillips, R., *Grasses, Ferns, Mosses & Lichens of Great Britain and Ireland*, Pan Books, 1980 (Photographs of many species.)

Stace, C., *New Flora of the British Isles*, 3rd. edition, Cambridge University Press, 2010. (Good family descriptions and useful diagrams.)

BOTANICAL ILLUSTRATION AND PAINTING

Oxley, V., *Botanical Illustration*, Crowood Press, 2008. (Really useful, comprehensive reference book and guide to producing paintings.)

Swan, A., *Botanical Painting with Coloured Pencils*, Collins, 2010. (Really useful introductory guide to using this medium.)

West, K., *How to Draw Plants: the techniques of botanical illustration*, The Herbert Press in association with The British Museum (Natural History), 1983.

Pineapple pencil study. (Liz Leech)

INDEX